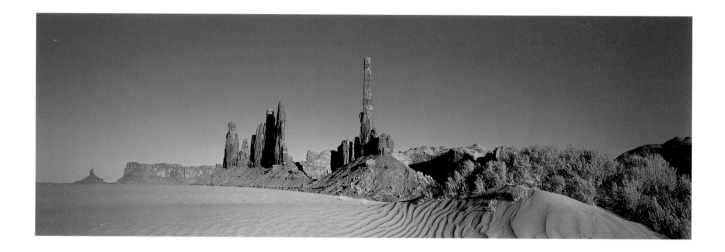

Spirit of America

This book is dedicated to the one I love, Jesus Christ, and to Dr Robert Schuller who helped lead me to Him.

P A N O G R A P H S ® B Y K E N D U N C A N

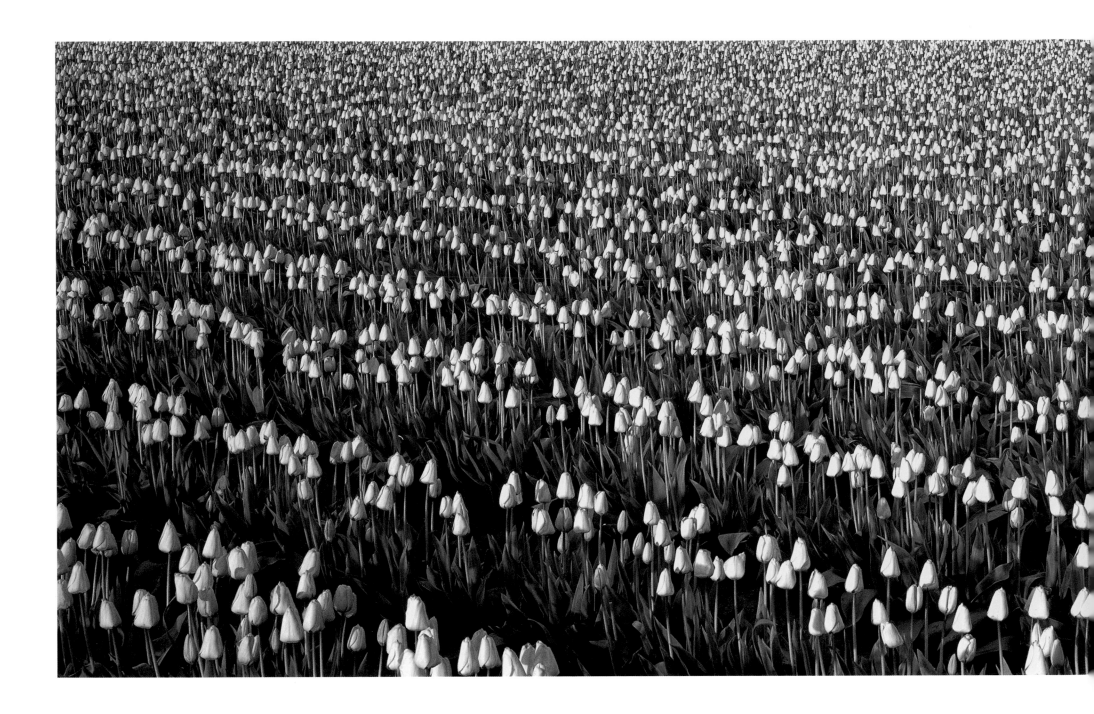

TULIPS, SKAGIT VALLEY, WASHINGTON

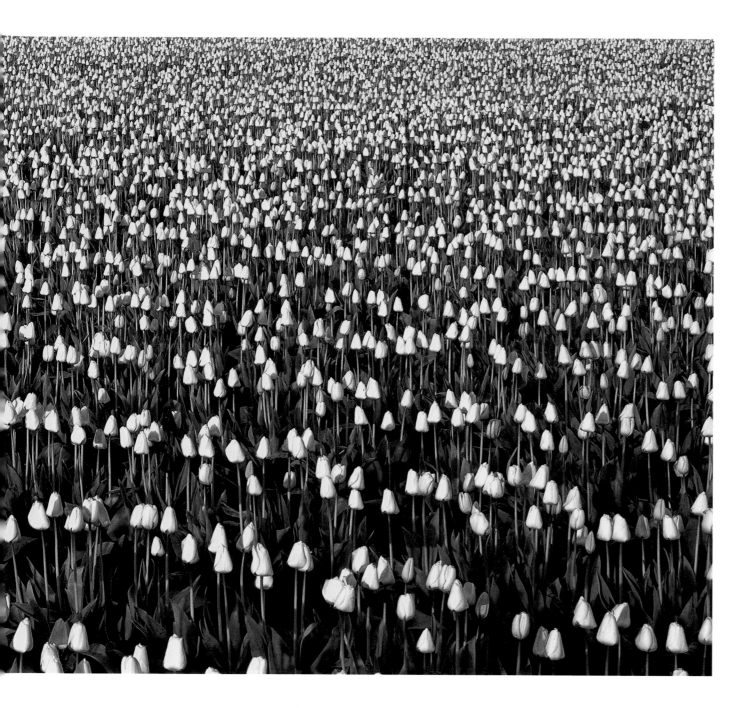

HOUR OF POWER
Spirit of America

SPIRIT OF AMERICA
FIRST PUBLISHED IN 2003 AND REPRINTED 2004
BY KEN DUNCAN PANOGRAPHS® PTY LIMITED
ABN 21 050 235 606
PO BOX 3015, WAMBERAL NSW 2260, AUSTRALIA.
TELEPHONE: 61 2 4367 6777.

COPYRIGHT PHOTOGRAPHY AND TEXT:
© KEN DUNCAN 2003
COPYRIGHT QUOTES: DR ROBERT H. SCHULLER 2003
PRINTED & BOUND IN CHINA
THE NATIONAL LIBRARY OF AUSTRALIA
CATALOGUING-IN-PUBLICATION ENTRY:
DUNCAN, KEN.
SPIRIT OF AMERICA: HOUR OF POWER.
INCLUDES INDEX.
ISBN 0 9580544 7 9.
1. UNITED STATES - PICTORIAL WORKS. I. TITLE.
917.300222

VISIT THE KEN DUNCAN GALLERY ONLINE
www.kenduncan.com

PANOGRAPHS® IS A REGISTERED TRADEMARK OF
KEN DUNCAN AUSTRALIA WIDE HOLDINGS PTY LTD.

Front Cover
OXBOW BEND, GRAND TETON
NATIONAL PARK, WYOMING
Previous Page
TOTEM POLE,
MONUMENT VALLEY, ARIZONA
Endpapers
DESTIN BEACH,
EMERALD COAST, FLORIDA

Faith is the natural blossom of someone who loves. ROBERT H. SCHULLER **3**

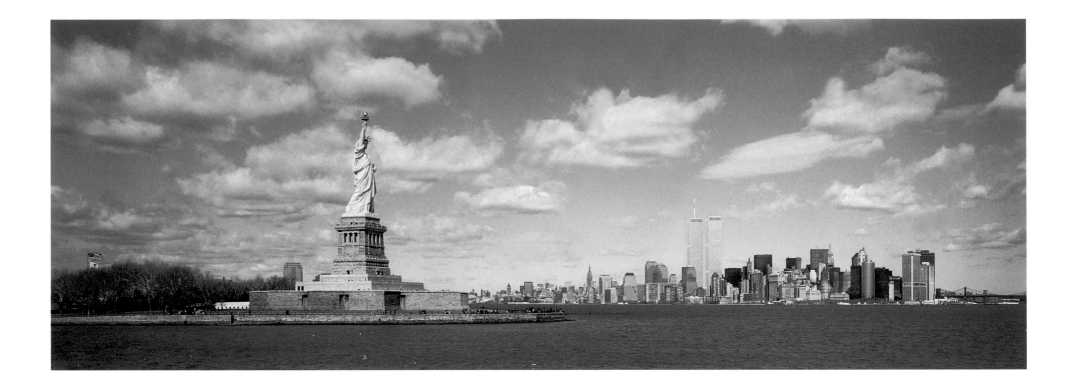

Introduction

Hear my cry, O God; Attend to my prayer.
From the end of the earth I will cry to You,
When my heart is overwhelmed;
Lead me to the rock that is higher than I.

PSALM 61:1-2

everal years ago, I was awoken at 3am one morning in my Australian home with words that seemed impressed on me from God: "If America removes the words In God We Trust from their currency, I will abandon them as a nation." It seemed a very bold statement, and also very surprising. My first thought was simply: Why tell me? I'm an Aussie. I wasn't trying to be disrespectful to God, but I was very happy in Australia and not particularly interested in America. I thought God should have been speaking to an American. After all, it would have been daytime in the US. I said, "Well Lord, if this really is You, let me remember this conversation in the morning." I then went back to sleep.

Sure enough, my first thought next morning was of that conversation in the small hours. I asked the Lord what He wanted me to do about it and He spoke again. "Go to America and walk the land. As you go, I will give you pictures and words to remind my people where their trust should be." "But how, Lord?" I asked. "Publish a book called *America Wide – in God We Trust*." I had some idea what it would take to produce a book on America and knew it would be a huge project. My final protest was, "But Lord, I'm comfortable here." The instant I had spoken I knew it was ridiculous. When we are comfortable, we are usually operating in our own abilities. In order to see miracles, we need opportunities beyond our abilities. When I told my wife about this dialogue with God, she said we had better do what He wanted.

So I flew to New York to meet with some leading publishers. One company that knew of my Australian successes was particularly interested in the concept. They were prepared to do a deal if I would change the book's title. The publisher loved the *America Wide* part, but said *In God We Trust* would have to go as it was politically incorrect. I was stunned. Those words are on the nation's currency. My pleas for reason fell on deaf ears. I knew if they denied God and His purposes, all that remained would be another book of pretty pictures. I declined their offer to publish a sanitized version. Since God had given me the vision for this project, I believed He would make a way for me to self-publish.

Back home in Australia I recounted the details of my trip to my wife. I knew that if we were to produce this book without a major publisher, everything we owned would have to be put on the line. She reminded me that all we have belongs to the Lord anyway, and we agreed to go for it. So began a journey that eventually took well over three years – with more than 35 trips to America. God was faithful throughout and we didn't lose our home.

That first book, *America Wide – In God We Trust*, was launched four days before the horror of September 11, 2001. A copy of the book was given to President Bush on September 10 by Australian Prime Minister, John Howard, as a gift from the Australian people. Remarkably, Prime Minister Howard permitted me to send a letter with the gift. In that letter I told President Bush why I had produced the book. I shared with him my belief that his nation's foundation of faith in God helped make America the superpower it is today and that it was its strength for the future.

On September 12, 2001, I awoke once again in the small hours and turned on the TV to see a plane being flown into one of the twin towers of the World Trade Center. As I struggled to digest the macabre footage, I witnessed the second plane plow into the other tower. How could this be real? When did the world change? For days I was in a state of shock, but I slowly came to realize why I had been called to show the beauty of God's creation in America. The Lord's power and divinity can be seen in His handiwork. The time was suddenly ripe for that message to help strengthen the American people.

God was under attack in America long before 9/11. Prayer in schools had been abandoned, political correctness was undermining the very fabric of the United States, and the Ten Commandments were under attack in the courts. If anything good has come out of 9/11, it is that a great number of Americans have returned to their faith in God. Once again it is okay to say 'God Bless America'. President Bush later sent me a beautiful letter thanking me for the timing of our book.

I have released this new book, *Spirit of America – Hour of Power*, because the enemy is still alive. America needs to stand strong, maintaining its trust in God and refusing to sanction further decay. America's greatest enemies are not outside her borders. They are working from within, undermining the nation's trust in God's sovereign protection.

I have spent years traveling throughout America and I know God has a special purpose for this nation. I believe the reason America is blessed with such abundant natural beauty is so her people will never deny God's wonder and power. Your forefathers made a covenant with God. He is your strength. As you lift Him up, He will lift you up. Stand strong, America, for your fight is not only for your own nation. You have been chosen to come against the darkness that seeks to engulf us all. America, this is your Hour of Power, and if you remain faithful no weapon that is fashioned against you will prevail.

Ken Duncan

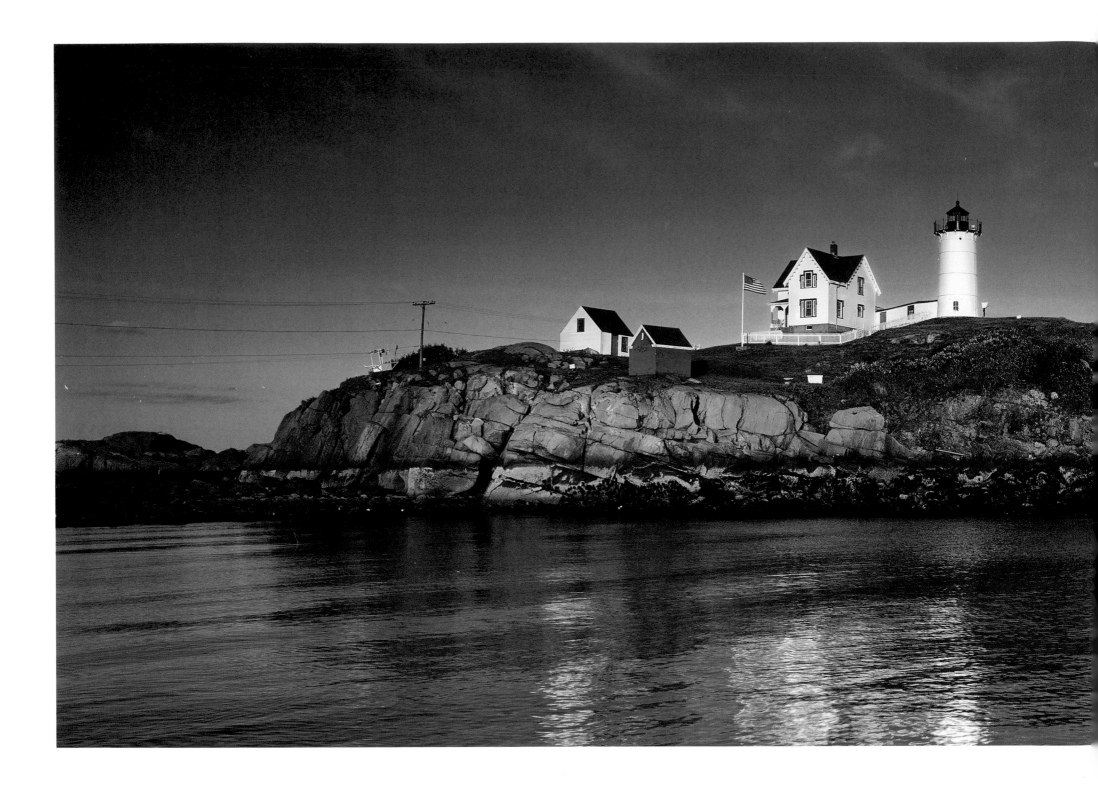

The only place where your dream becomes impossible is in your own thinking. ROBERT H. SCHULLER

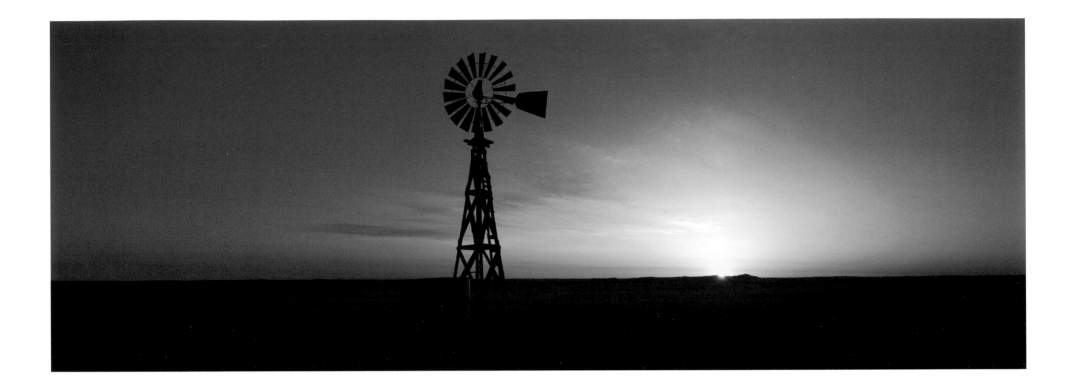

Contents

The wind blows where it wishes,
and you hear the sound of it,
but cannot tell where it comes from and where it goes.
So is everyone who is born of the Spirit.

JOHN 3:8

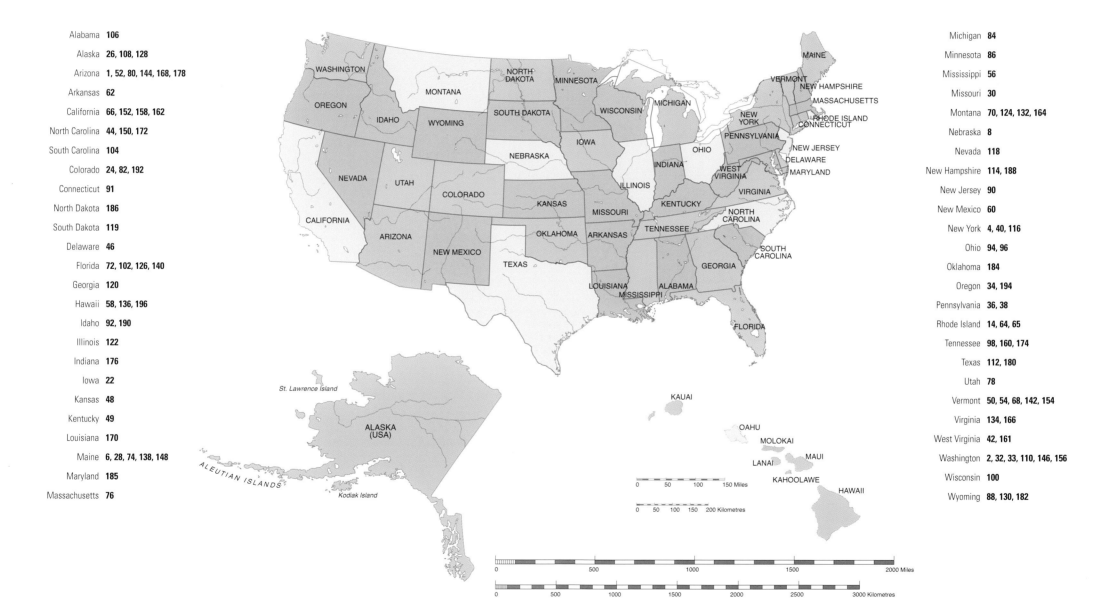

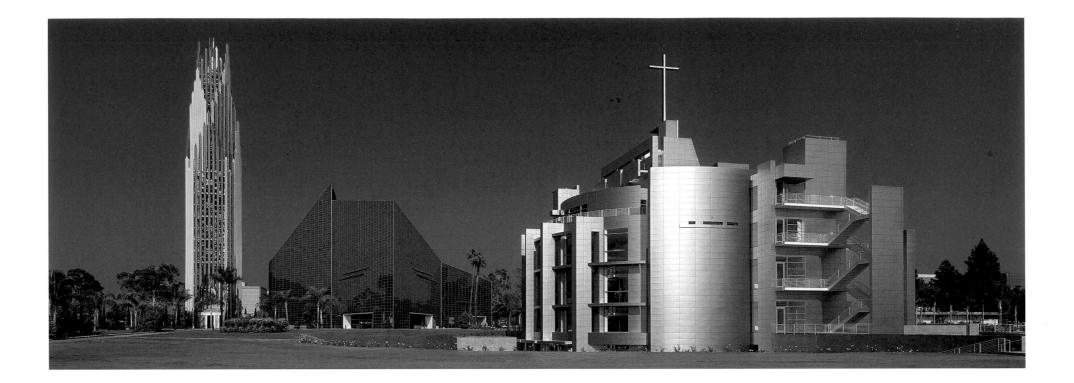

Foreword

The temple is not for man,
but for the Lord God.
For the house of my Lord
I have prepared with all my might.

<div align="right">

1 CHRONICLES 29:1&2

</div>

The Spirit of America!
It's the freedom to set a glorious goal
and dream a daring dream!

The Spirit of America!
It can be seen and sensed
"from the mountains, to the prairie, to the oceans white with foam!"

The Spirit of America!
It's been captured in all of its breathtaking beauty by Ken Duncan,
a wonderful friend of this ministry!

For 34 years the televised Hour of Power
has kept this Spirit of America alive
as we've brought the positive gospel message of freedom
to millions of lives in America and around the world
through faith in Christ week after week.
Now enjoy the glorious spirit in the beauty of America
as captured by the gifted eye of Ken Duncan.

ROBERT H. SCHULLER

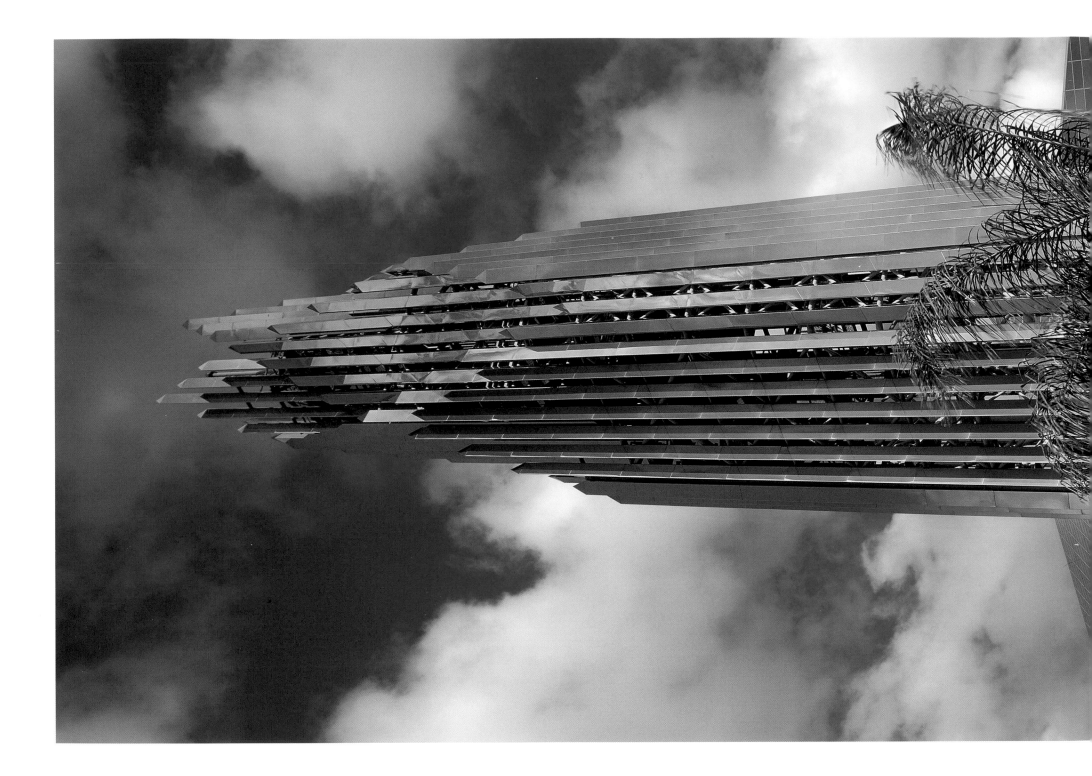

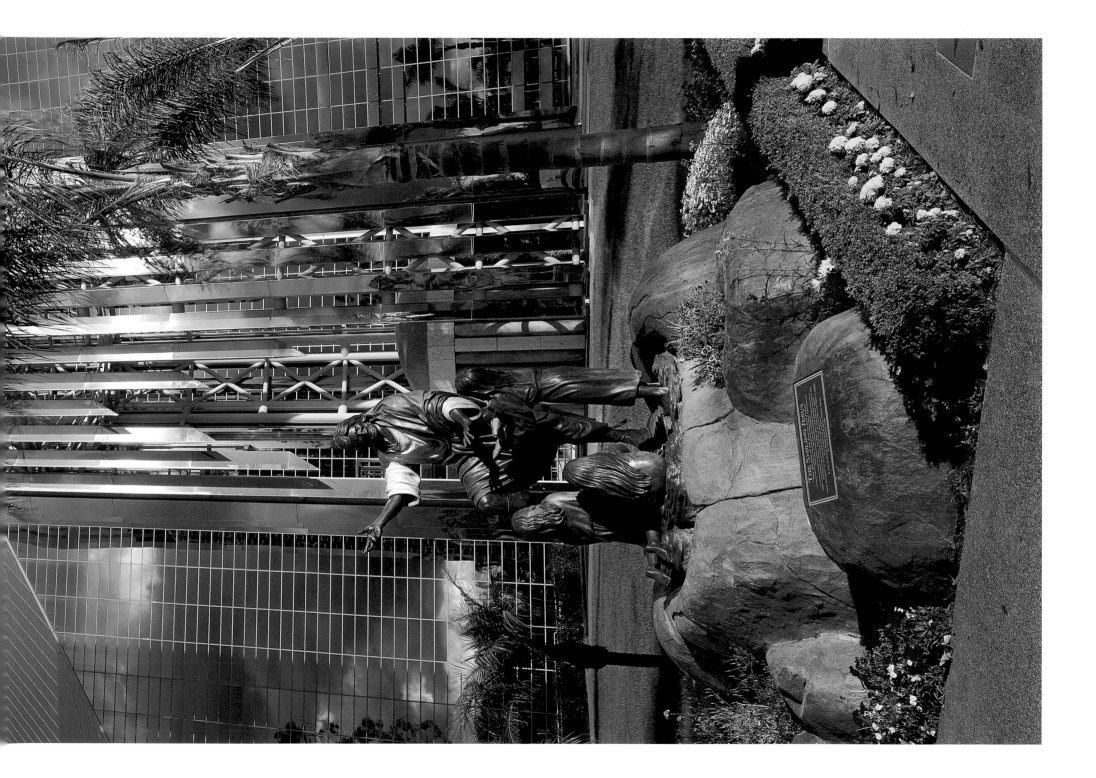

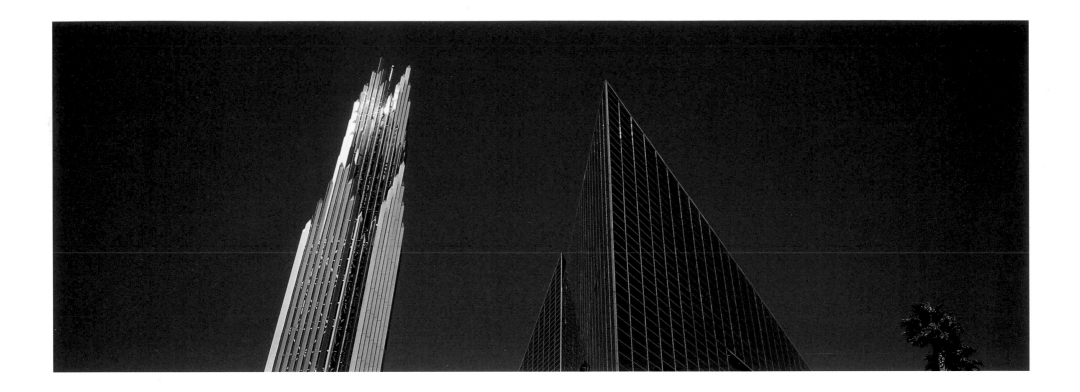

A Man with a Dream

Dr Robert H. Schuller is a man of great integrity. A minister of the Gospel of Jesus Christ for over 40 years, he lives what he preaches. Born in rural Iowa, at the dead end of a dirt road that had no name and no number, Dr Schuller has gone on to build one of America's greatest testimonies to God's glory, the Crystal Cathedral. He is a self-confessed possibility thinker whose positive messages have impacted multiple millions of people.

Dr Schuller has always dared to dream. Early in his ministry he said, "I cannot build just anything. It has to glorify God and qualify as a thing of beauty that will be a joy forever." In an age of prefabricated constructions, he has commissioned some of the world's leading architects to conceive buildings which are truly inspirational. First came the Tower of Hope, designed by Richard Neutra. His request for New York architect, Philip Johnson, to design a new sanctuary to seat 3,000 gave rise to the magnificent Crystal Cathedral, which was dedicated, debt-free, in 1980. Soon after came the brilliant Crean Prayer Spire.

I thought Dr Schuller's accomplishments to that point were extremely impressive. He would have been justified in resting on his laurels. But still he forged ahead to fulfill the entire dream. This has now culminated in the opening of a striking, stainless steel

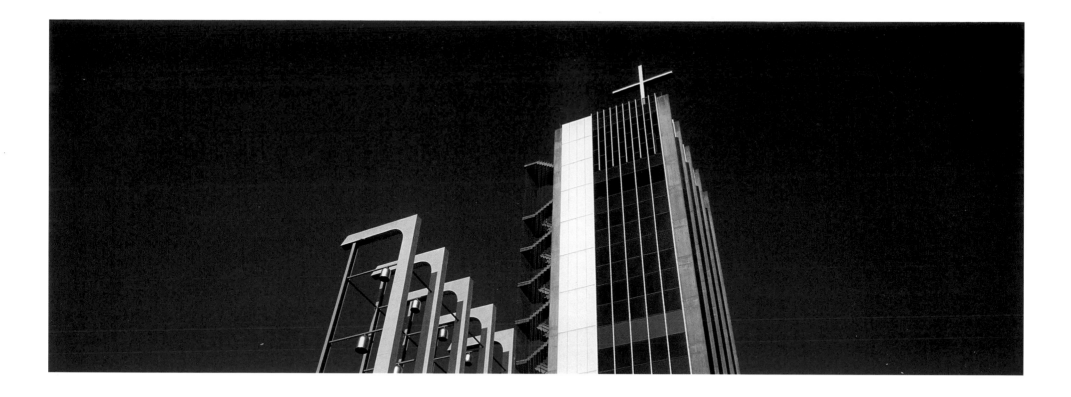

masterpiece, the International Visitor Center, which is a sermon in itself from the ground floor up.

There was a time during construction of the Crystal Cathedral when the dream seemed impossible and Dr Schuller was almost ready to succumb to the temptation to give up. But then he realized that if he quit, others might do the same, and he knew he had to go on. "Tough times never last, but tough people do," he said – and he proved it. He has never compromised his dream, always wanting to honor God with the very best.

When I was a young man, Dr Schuller's television show Hour of Power influenced me greatly. His possibility filled sermons were a tonic that helped raise me from my sick bed and led me on the road to having a personal relationship with the greatest possibility thinker ever, Jesus Christ. Over the years I have been encouraged and

inspired to see Dr Schuller continue to practice in his own life and ministry the possibility message he preaches. I admire the fact that Dr Schuller's focus in life is on helping people raise themselves up to believe in miracles, teaching them to look beyond their circumstances to realize their dreams.

The title of the sermon of Dr Schuller's life could well be: "If you can dream it, you can do it." His own story has proven his favorite Scripture, "I can do all things through Jesus Christ who strengthens me." I believe there has never been a more important time for the world to hear Dr Schuller's message. His possibility preaching will help people to rise up, cast off their shackles and fulfill their God-given potential.

Ken Duncan

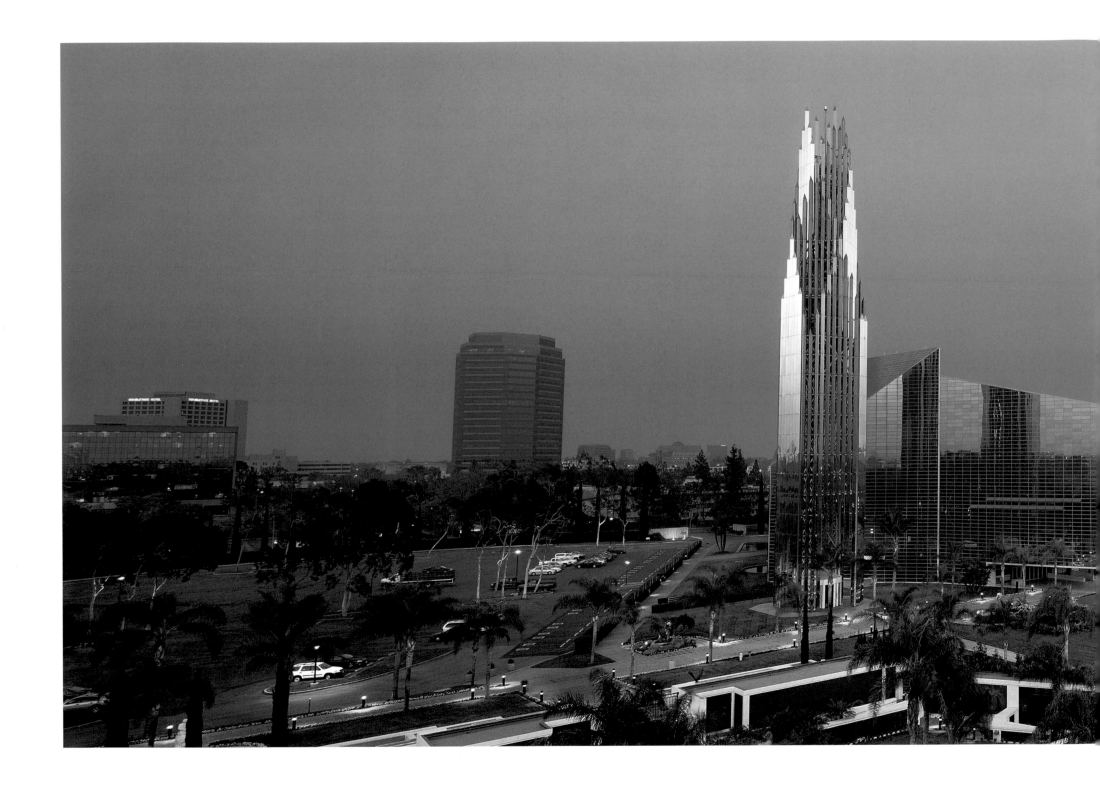

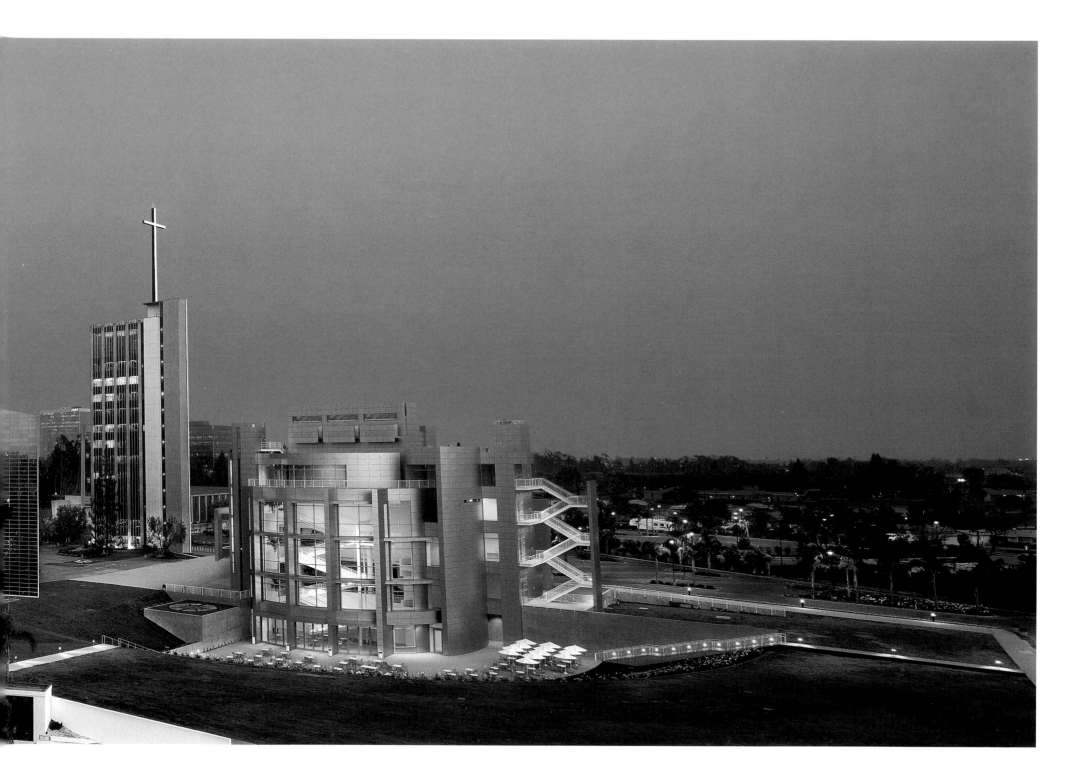

God performs miracles when we stop telling Him it's impossible! ROBERT H. SCHULLER **17**

Then the scribes and Pharisees brought to Him a woman caught in adultery. And when they had set her in the midst, they said to Him, "Teacher, this woman was caught in adultery, in the very act. Now Moses, in the law, commanded us that such should be stoned. But what do You say?" This they said, testing Him, that they might have something of which to accuse Him. But Jesus stooped down and wrote on the ground with His finger, as though He did not hear. So when they continued asking Him, He raised Himself up and said to them, "He who is without sin among you, let him throw a stone at her first." And again He stooped down and wrote on the ground. Then those who heard it, being convicted by their conscience, went out one by one, beginning with the oldest even to the last. And Jesus was left alone, and the woman standing in the midst. When Jesus had raised Himself up and saw no one but the woman, He said to her, "Woman, where are those accusers of yours? Has no one condemned you?" She said, "No one, Lord." And Jesus said to her, "Neither do I condemn you; go and sin no more."

JOHN 8:3-11

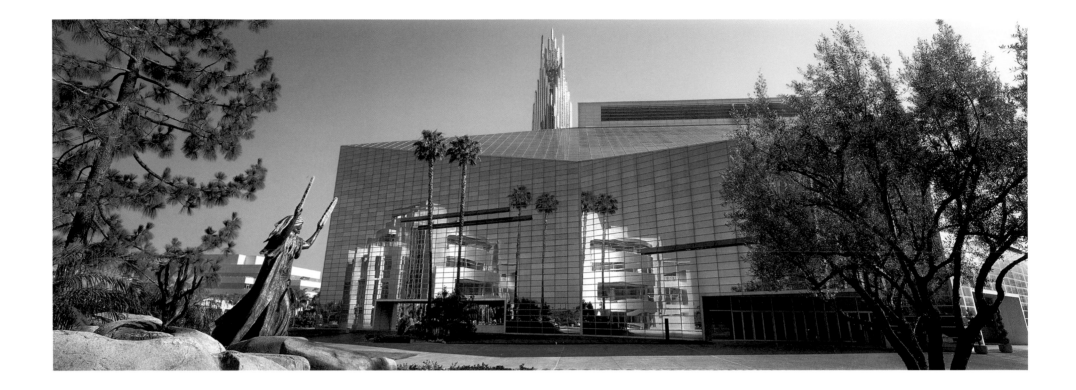

And when forty years had passed, an Angel of the Lord appeared to him in a flame of fire in a bush, in the wilderness of Mount Sinai. When Moses saw it, he marveled at the sight; and as he drew near to observe, the voice of the Lord came to him, saying, *"I am the God of your fathers—the God of Abraham, the God of Isaac, and the God of Jacob."* And Moses trembled and dared not look. *"Then the LORD said to him, 'Take your sandals off your feet, for the place where you stand is holy ground. I have surely seen the oppression of My people who* *are in Egypt; I have heard their groaning and have come down to deliver them. And now come, I will send you to Egypt.'"* This Moses whom they rejected, saying, "Who made you a ruler and a judge?" is the one God sent to be a ruler and a deliverer by the hand of the Angel who appeared to him in the bush. He brought them out, after he had shown wonders and signs in the land of Egypt, and in the Red Sea, and in the wilderness forty years.
ACTS 7:30-36

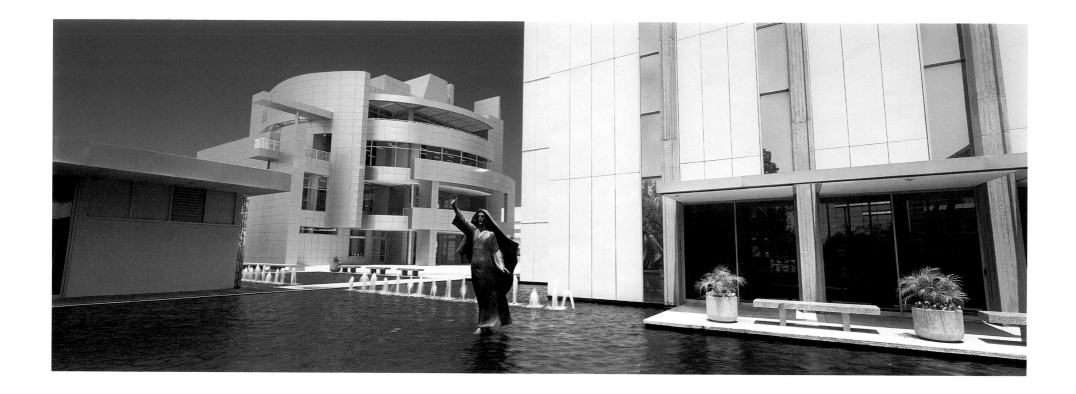

Immediately Jesus made His disciples get into the boat and go before Him to the other side, while He sent the multitudes away. And when He had sent the multitudes away, He went up on the mountain by Himself to pray. Now when evening came, He was alone there. But the boat was now in the middle of the sea, tossed by the waves, for the wind was contrary. Now in the fourth watch of the night Jesus went to them, walking on the sea. And when the disciples saw Him walking on the sea, they were troubled, saying, "It is a ghost!" And they cried out for fear. But immediately Jesus spoke to them, saying, "Be of good cheer! It is I; do not be afraid." And Peter answered Him and said, "Lord, if it is You, command me to come to You on the water."

So He said, "Come." And when Peter had come down out of the boat, he walked on the water to go to Jesus. But when he saw that the wind was boisterous, he was afraid; and beginning to sink he cried out, saying, "Lord, save me!" And immediately Jesus stretched out His hand and caught him, and said to him, "O you of little faith, why did you doubt?" And when they got into the boat, the wind ceased. Then those who were in the boat came and worshiped Him, saying, "Truly You are the Son of God."

MATTHEW 14:22-33

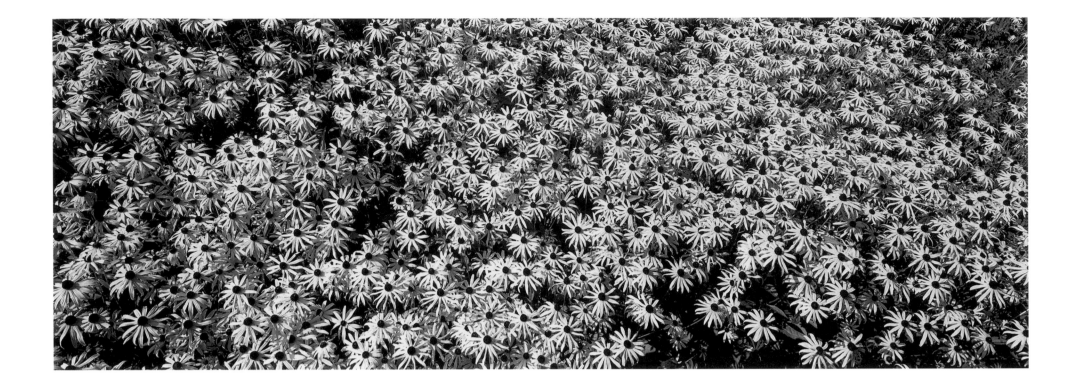

Freedom

Freedom – what a wonderful word. Just the mention of it can bring warmth and sunshine to the human spirit. In my mind the word Freedom conjures up the image of large open fields filled with spectacular flowers and endless opportunities, a place where dreams are nurtured and anything is possible. It reminds me of that classic scene from *The Sound of Music* where Julie Andrews is dancing and singing in the grandeur of the Austrian Alps. Freedom is a beautiful song that all should be able to sing.

Although virtually everyone would love to live in a realm of endless possibilities, not everyone is fortunate enough to experience true freedom. Some human beings are enslaved by others for the sake of personal gain or power. The American people enjoy great political and social freedoms, and yet how easily even the most free can become enslaved. Freedom – of thought and action – was a gift God granted the human race way back in the Garden of Eden. It is a gift that can be used for good or for evil. Freedom is something that we need to be vigilant about – and often fight for – as many things come to try and steal our liberty.

In recent times, terrorism has raised its ugly head as the number one threat to our freedom. Actual acts of terrorism have been few and far between, but the fear of what terrorists might do at any point in the future robs many of us of a sense of liberty in our everyday lives. We can easily wonder what new horror may happen tomorrow and shape our lives accordingly – restricting our own freedom of movement, putting our hopes and dreams on hold.

Other stories of doom and gloom in the evening news can have the same impact. We may fear the 'coming recession' or 'the breakdown of society's values' or any other of a myriad of bad news scenarios. Yet we need to realize that true freedom is not found in a place devoid of conflict. It is rather a state of mind in the midst of whatever storms may blow.

What can help us overcome the fears that try to ensnare us? What will break down the walls of terror that try to hold us captive? The answer is faith. Faith is the opposite of fear and the antidote to the sickness that terrorists and 'bad news' merchants feed on. The Bible says, "I can do all things through Jesus Christ who strengthens me" (Philippians 4:13) and I choose to believe that promise. My faith is not in my own strength but in the Creator of the world, who placed the stars in the skies. God has a purpose for each of our lives – all we have to do is believe and have faith in Him. If He can create the wonderful world in which we live, there is nothing He cannot do.

I will not allow fear to be my master, for to live in fear is to relinquish liberty. Better to live one day free than a hundred years as a slave. I will not permit fear to stop me from doing what is right, nor what the Lord has called me to do. I will confront my fears and walk one faith-filled step at a time, even though I may be trembling in my boots. Fear is nothing more than a toothless tiger when confronted with faith in the power of God for liberty. Let no man take away our God-given freedom.

For you, brethren, have been called to liberty;
only do not use liberty as an opportunity for the flesh,
but through love serve one another.

GALATIANS 5:13

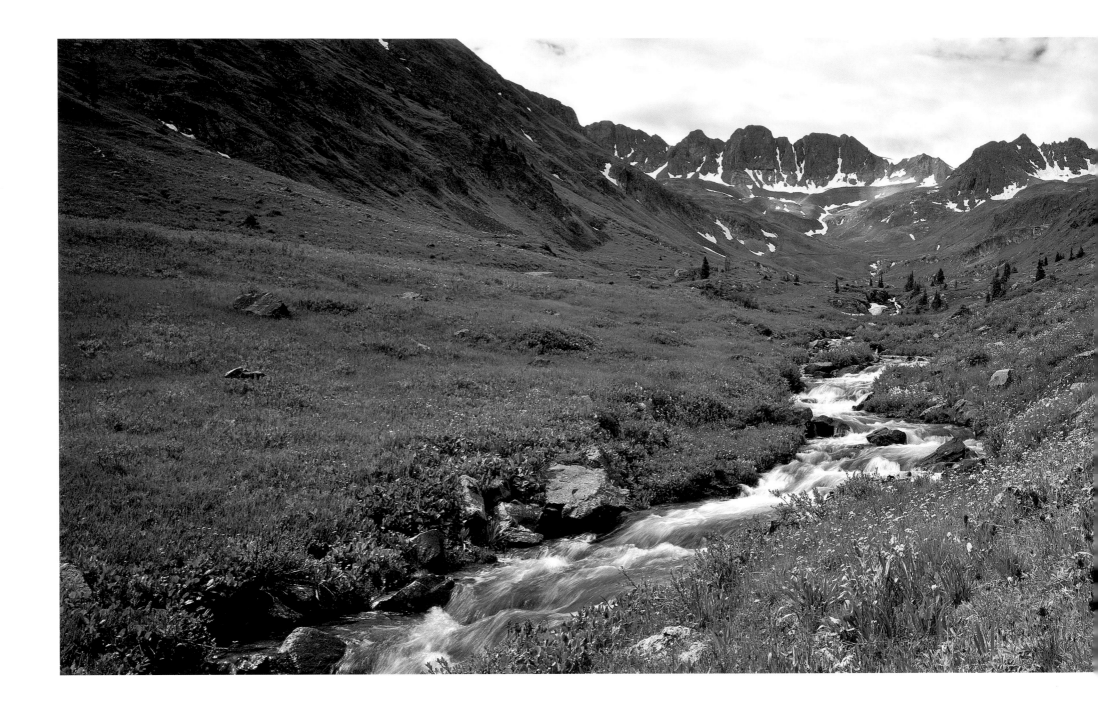

The LORD is my shepherd;
I shall not want.
He makes me to lie down in green pastures;
He leads me beside the still waters.
He restores my soul;
He leads me in the paths of righteousness
For His name's sake.
Yea, though I walk through the valley
of the shadow of death,
I will fear no evil;
For You are with me;
Your rod and Your staff, they comfort me.
You prepare a table before me
in the presence of my enemies;
You anoint my head with oil;
My cup runs over.
Surely goodness and mercy shall follow me
All the days of my life;
And I will dwell in the house of the LORD forever.

PSALM 23:1-6

Add up your joys and never count your sorrows. ROBERT H. SCHULLER **25**

God thunders marvelously with His voice;
He does great things which we cannot comprehend.
For He says to the snow, "Fall on the earth";
Likewise to the gentle rain
and the heavy rain of His strength.
He seals the hand of every man,
That all men may know His work.
The beasts go into dens,
And remain in their lairs.
From the chamber of the south comes the whirlwind,
And cold from the scattering winds of the north.
By the breath of God ice is given,
And the broad waters are frozen.
Also with moisture He saturates the thick clouds;
He scatters His bright clouds.
And they swirl about, being turned by His guidance,
That they may do whatever He commands them
On the face of the whole earth.

JOB 37:5-12

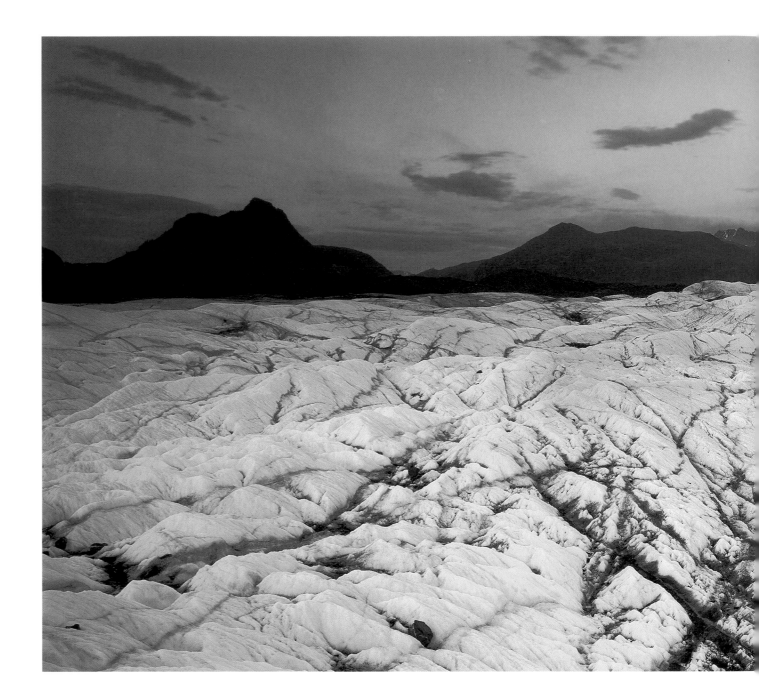

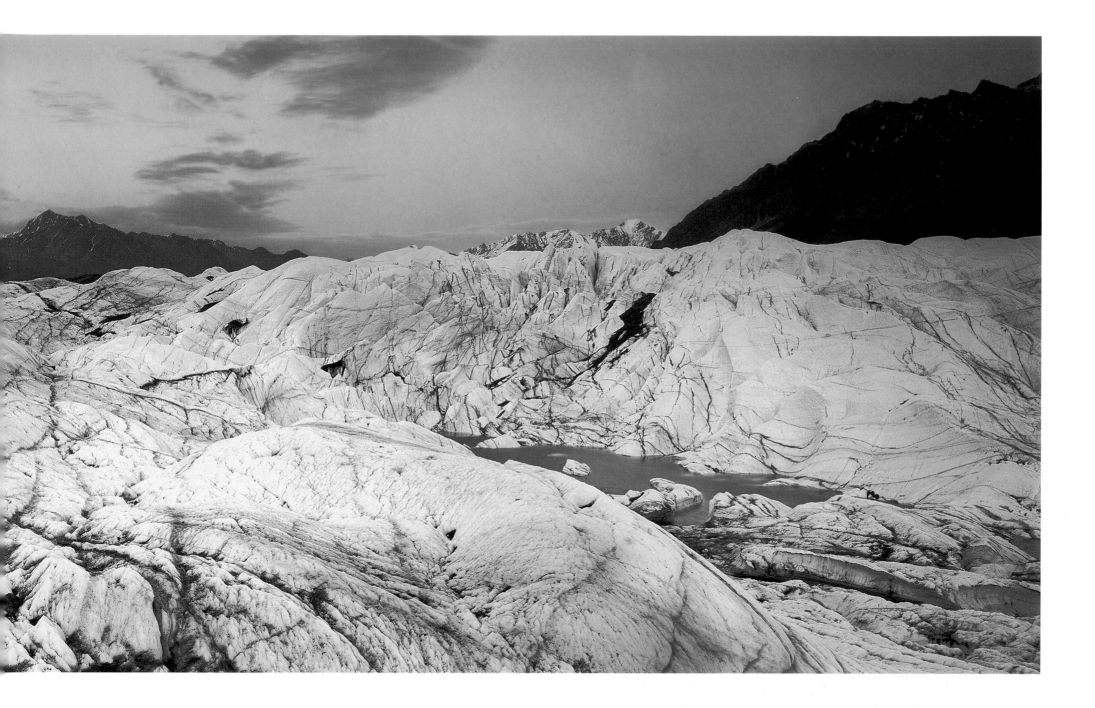

Never allow a fractured experience to shape your future. ROBERT H. SCHULLER **27**

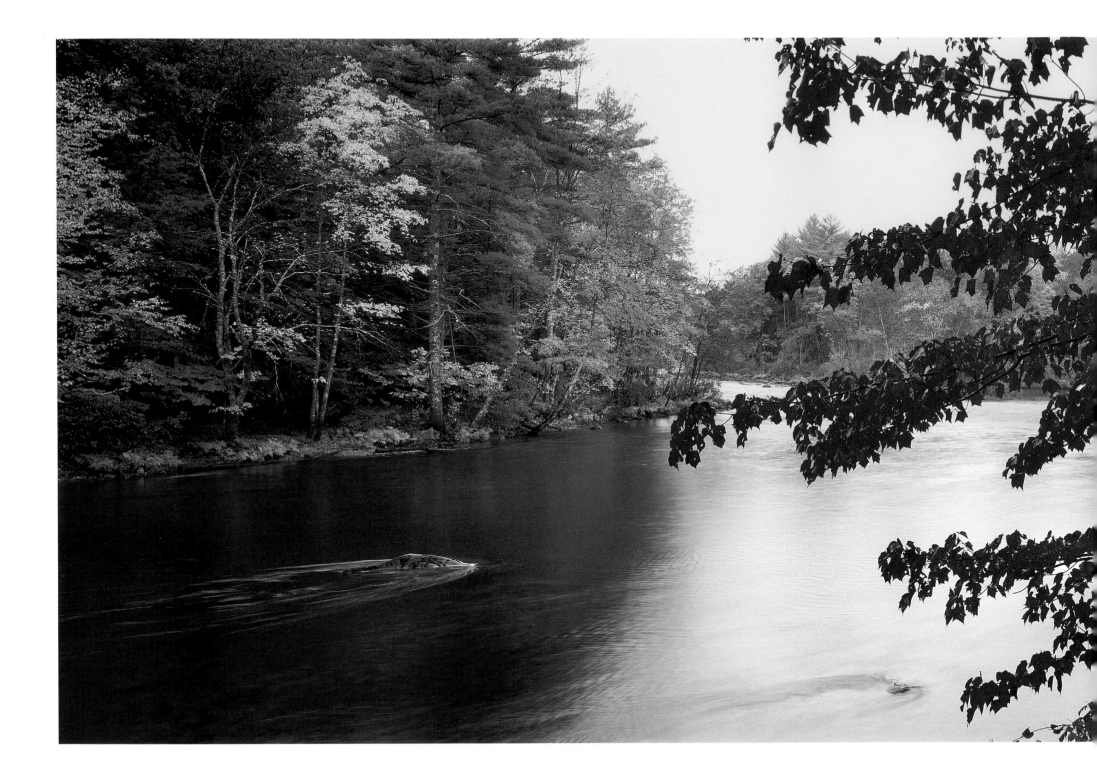

God's love blooms when we love each other. ROBERT H. SCHULLER **29**

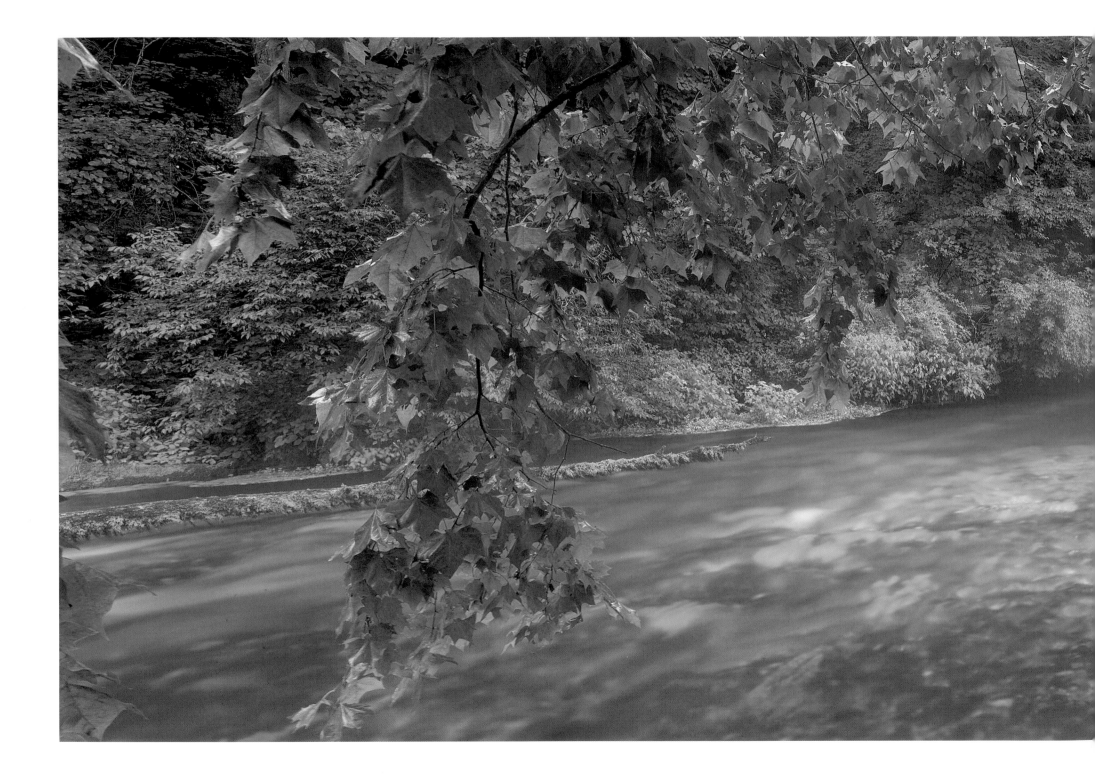

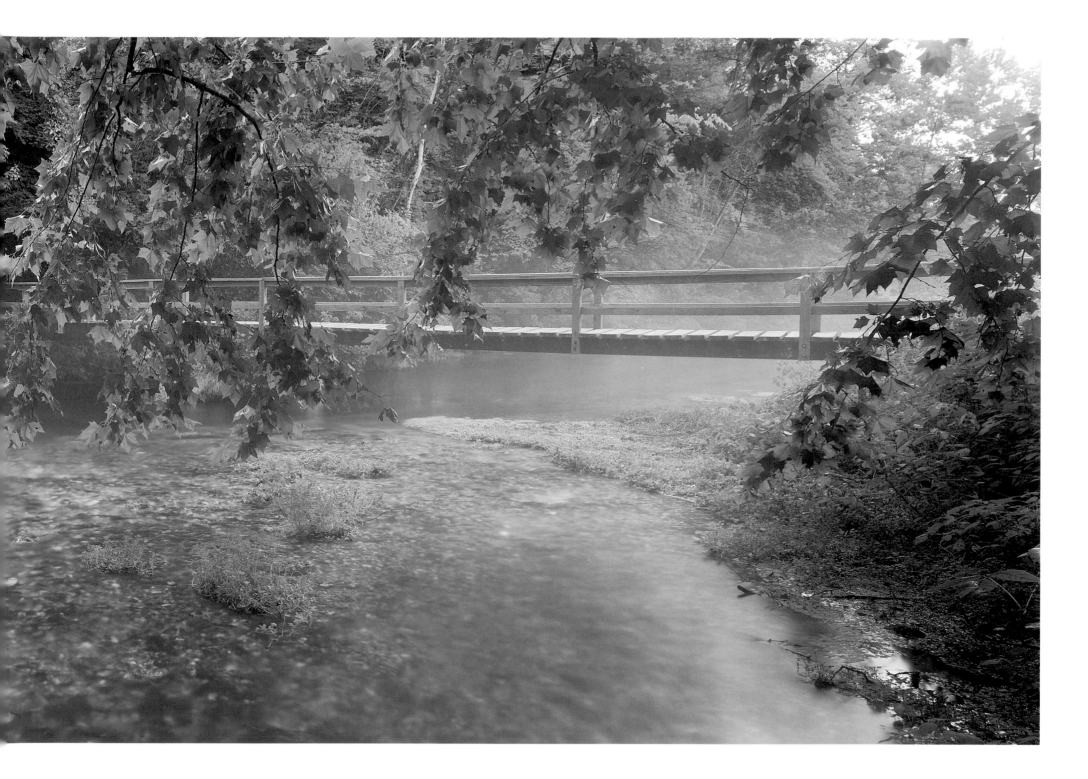

When God sees a breach, He builds a bridge. ROBERT H. SCHULLER **31**

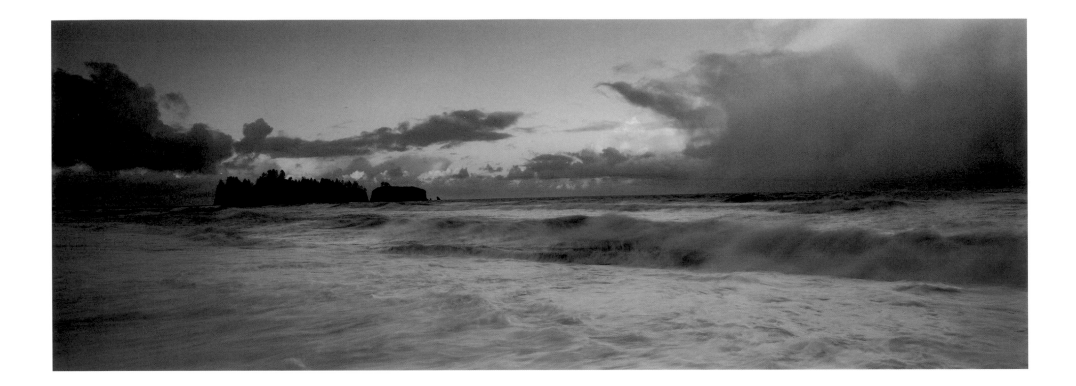

This far you may come, but no farther,
And here your proud waves must stop!

JOB 38:11

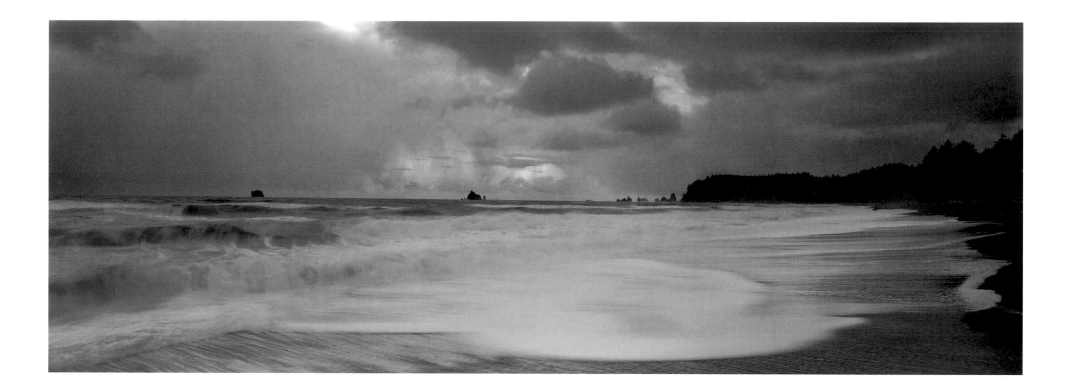

Have you commanded the morning since your days began,
And caused the dawn to know its place?
JOB 38:12

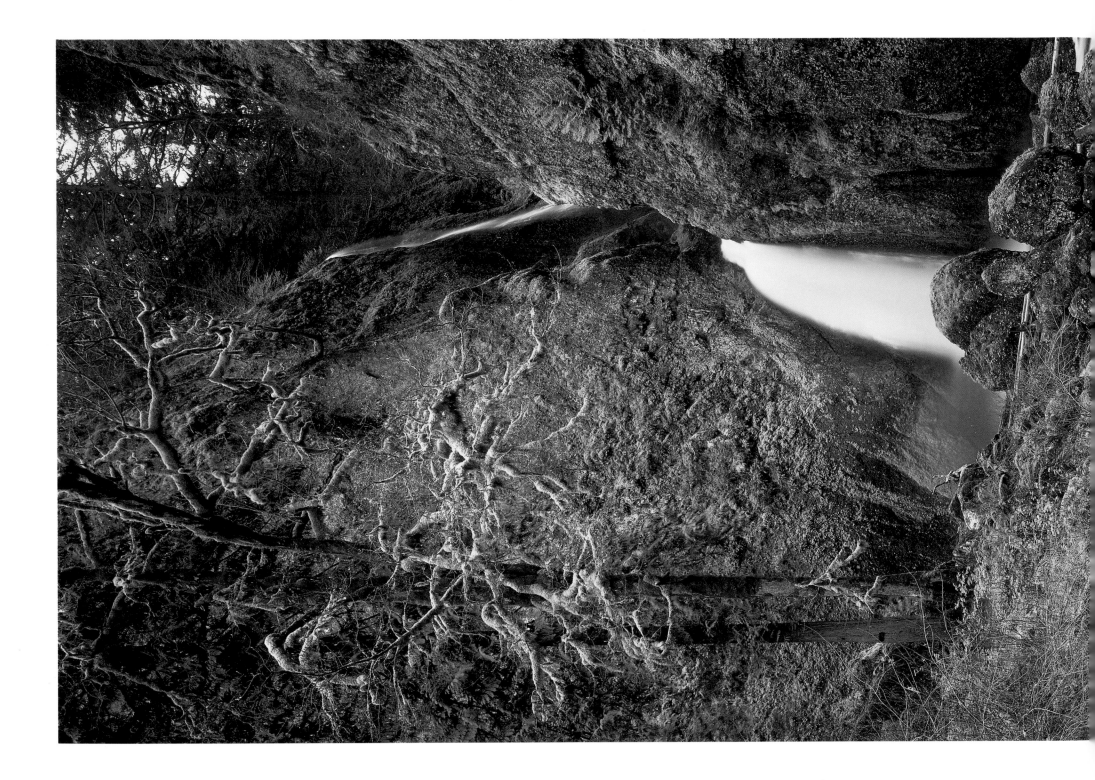

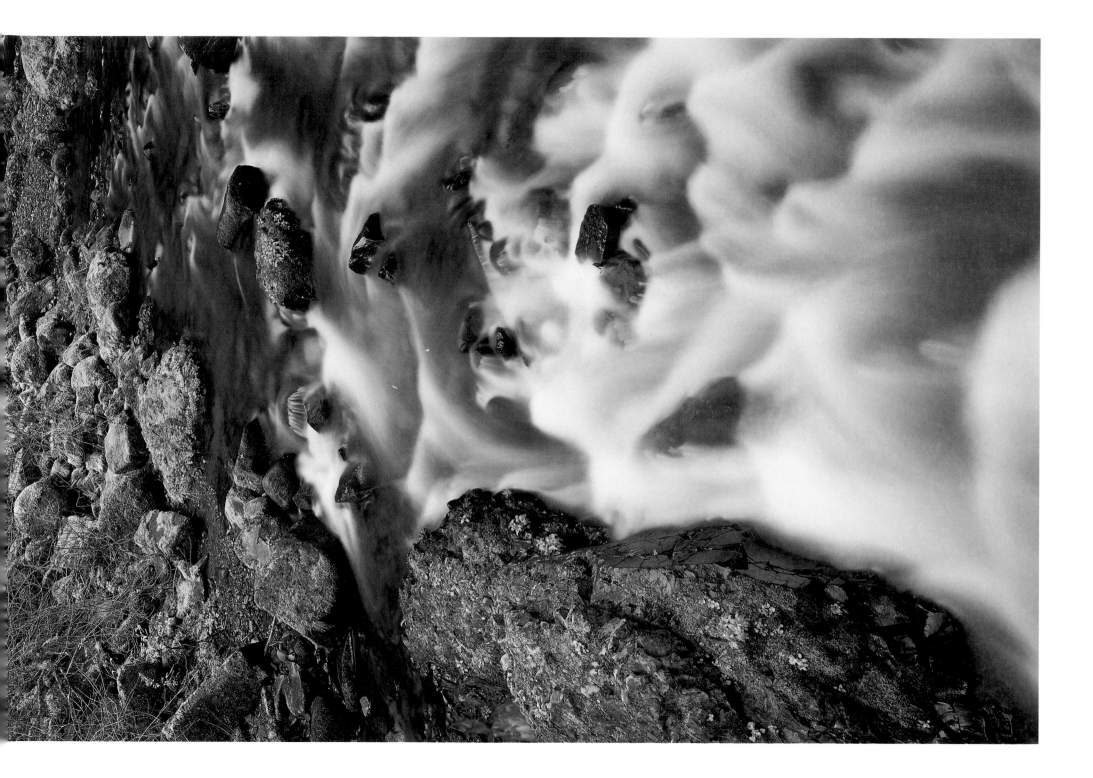

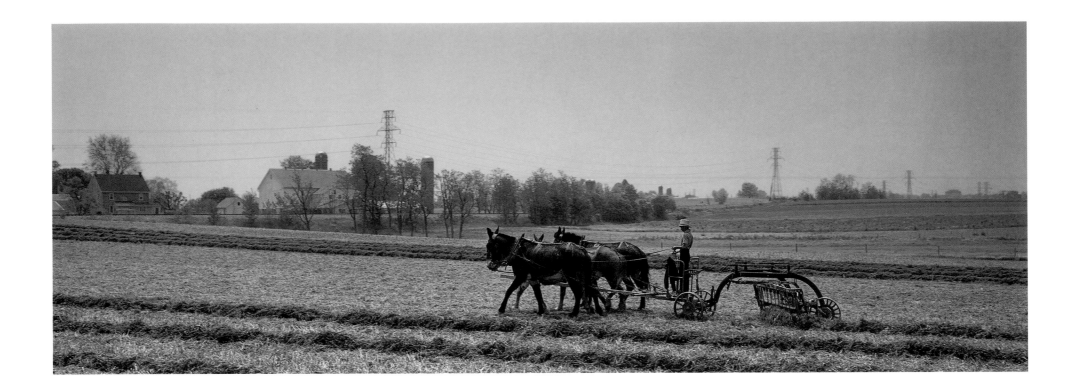

The Value of Simplicity

In an age when it can be difficult to get our children to carry out even easy chores diligently, I was impressed to see this young Amish boy hard at work maneuvering his team of ornery donkeys to plow a field. I was even more impressed when I met some other Amish people and looked more closely into their culture. I discovered that their basic beliefs are simply: "There is one God eternally existing as Father, Son and Holy Spirit. Jesus Christ, the only Son of God, died on a cross for the sins of the world. Salvation is by grace, through faith in Christ – a free gift bestowed by God on those who believe and repent." These are people who refuse to be manipulated by the world and its changing mantras. They value simplicity and self-denial over comfort, convenience and the pursuit of leisure. Relationship with God and family is their highest priority and their lifestyle is a deliberate act of separating from the world to build a virtually self-sufficient community.

As I pondered the simplicity of their lifestyle, I could not help but be confronted by the complexity of my own. Life in the twenty-first century is certainly a wonderful thing. The medical and scientific advances we enjoy are an enormous improvement on the standard of living our grandparents endured. Yet all this technology results in such a fast-paced existence that we can often feel like we are on a merry-go-round, with someone continually increasing the speed. We suffer constant bombardment from the media to buy an endless list of things we are told we need, and our consumption of Earth's resources is increasing more quickly than the planet can replenish itself. Everything seems to be blurring into a kaleidoscope of color where change is constant and stability is lacking.

Too often right and wrong are now considered suggestions rather than absolutes. I once heard a New Age guru say he thought the Ten Commandments should be viewed as suggestions rather than rules, because he felt the words "Thou shalt not" were too negative. That line of thinking strikes me as dangerous. The reason God said "Thou shalt not" is so that humanity can clearly discern between right and wrong. Imagine if our road rules said, "We suggest you stop at a red light, if you feel like it." The result would be utter chaos on our roads. Commandments, like road rules, must be absolutes. There are rules in this life. Whether or not we wish to obey them is up to us. (We can try to ignore gravity and jump off a cliff but our downward plummet will quickly tell its own story.) We exercise our free will and make choices. We may break the law, inadvertently or intentionally, but we will have to face the consequences of our choices.

One Scripture often quoted in Amish worship services is, "Be not conformed to this world, but be transformed by the renewing of your mind that you may prove what is the good, acceptable and perfect will of God." I was encouraged to see a group of people prepared to live by their beliefs rather than be led by the changing morality of the world. God bless the Amish. Although the totality of their lifestyle may not be for me, it makes me see my own life for the merry-go-round that it can be. The good news is that I can take control of the speed of my life and I can embrace simplicity if I really want to. And, life should be simple if we trust in God.

Sow for yourselves righteousness,
reap in mercy;
break up your fallow ground,
for it is time to seek the LORD,
till He comes
and rains righteousness on you.

HOSEA 10:12

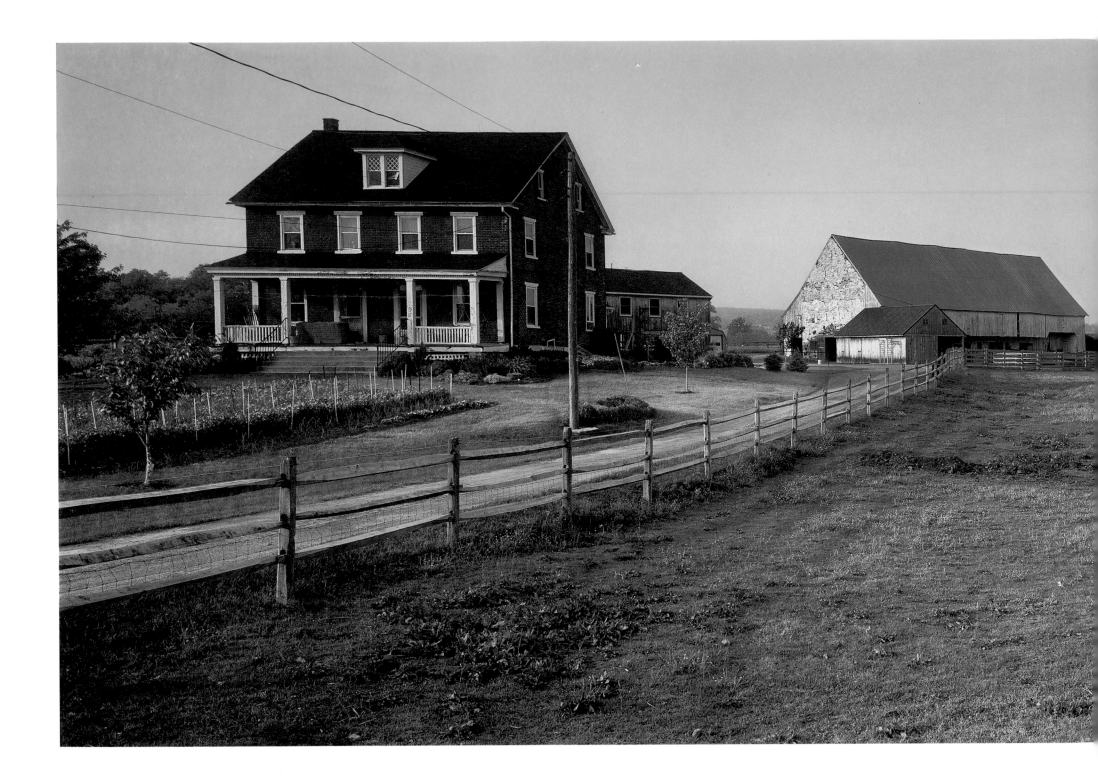

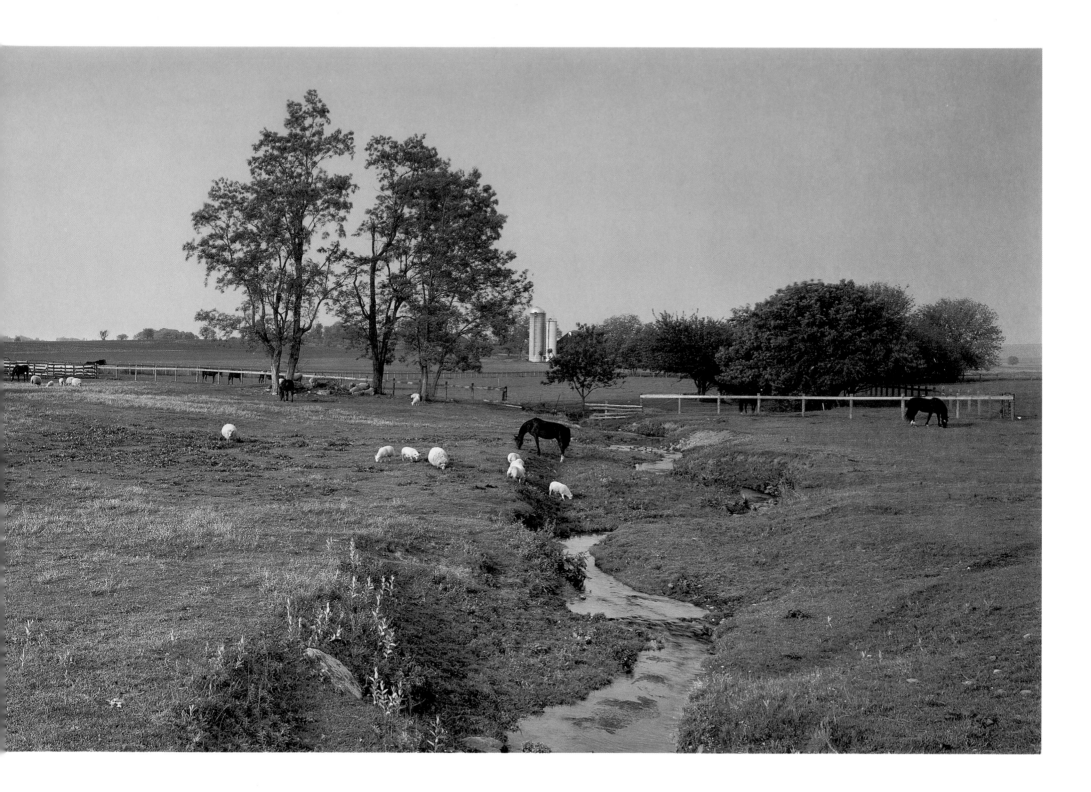

A man's life consists not of what he has, but of what he is. ROBERT H. SCHULLER **39**

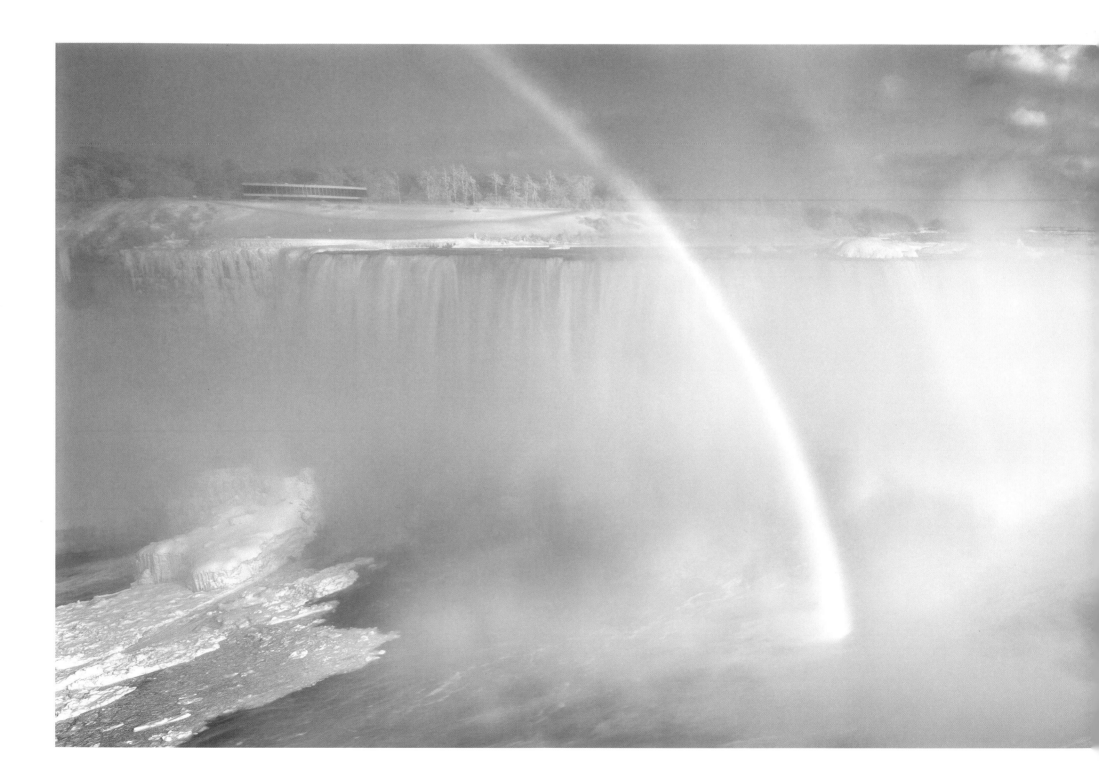

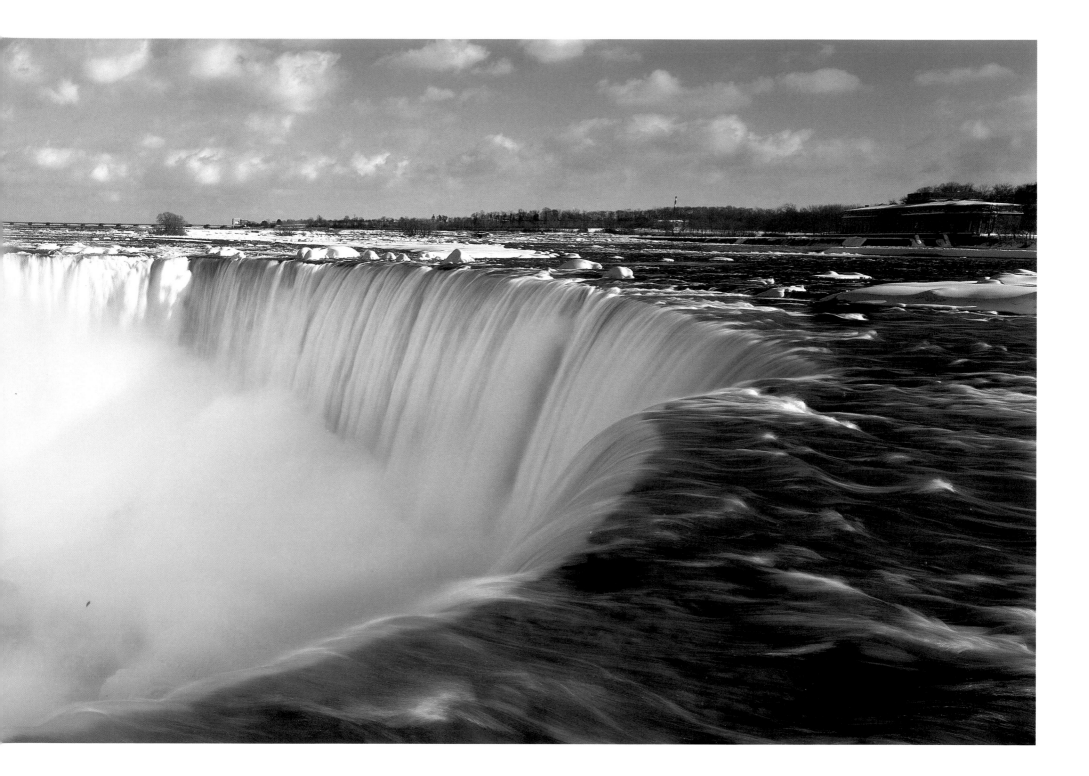

No problem is too big for God's power; no person is too small for God's love. ROBERT H. SCHULLER **41**

Mercy and truth have met together;
Righteousness and peace have kissed.
Truth shall spring out of the earth,
And righteousness shall look down from heaven.
Yes, the LORD will give what is good;
And our land will yield its increase.
Righteousness will go before Him,
And shall make His footsteps our pathway.

PSALM 85:10-13

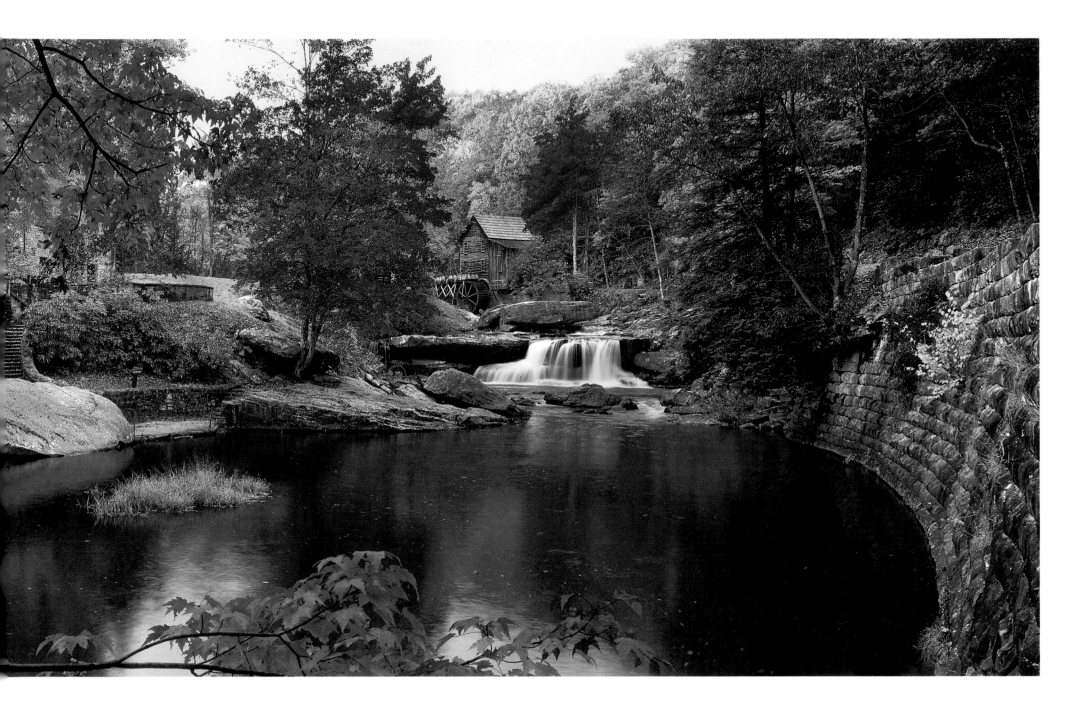

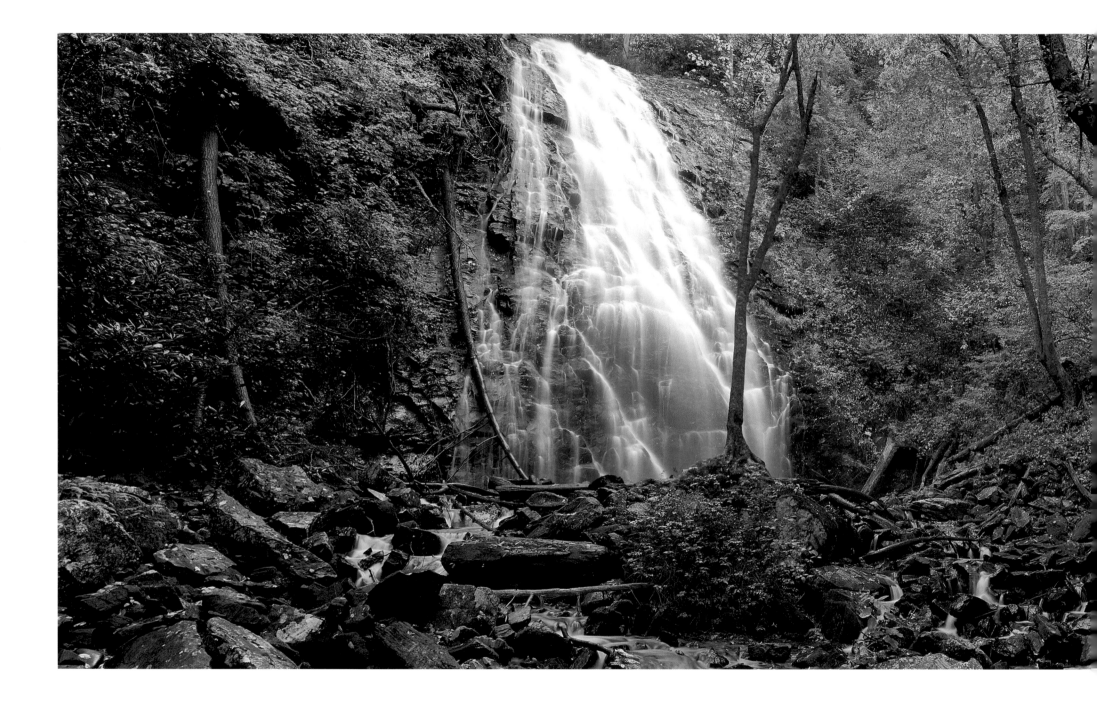

Have you not known?
Have you not heard?
The everlasting God, the LORD,
The Creator of the ends of the earth,
Neither faints nor is weary.
His understanding is unsearchable.
He gives power to the weak,
And to those who have no might
He increases strength.

ISAIAH 40:28-29

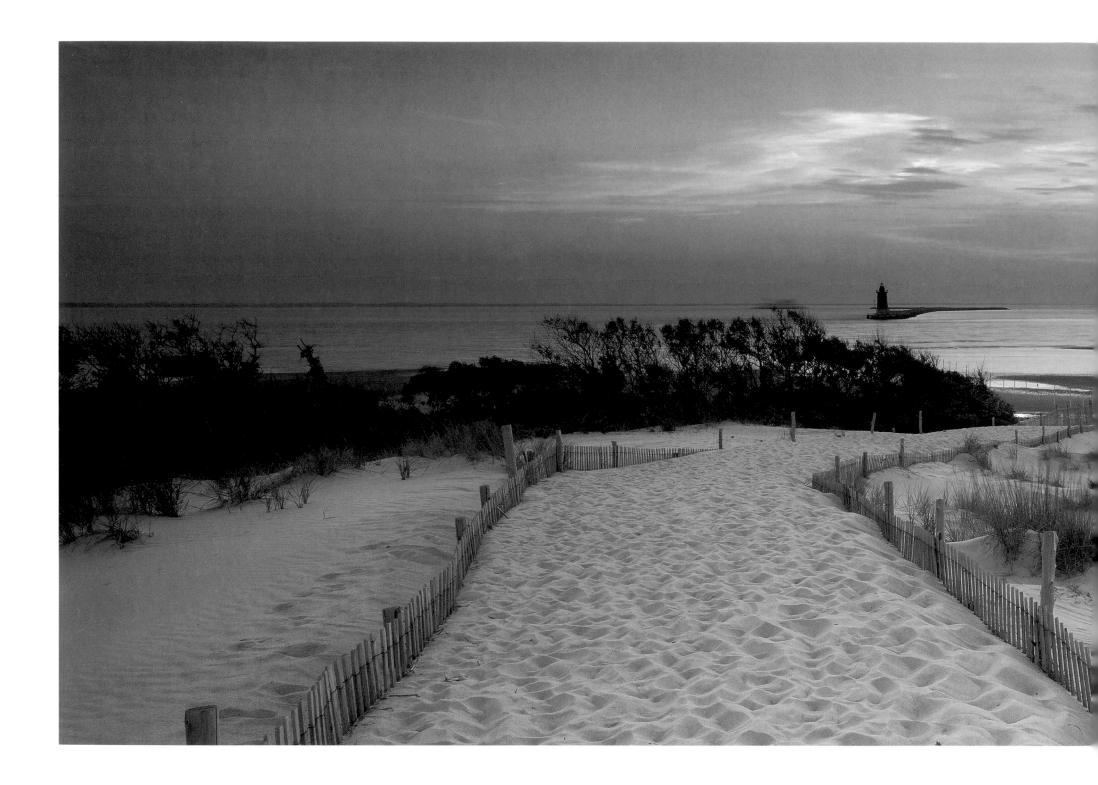

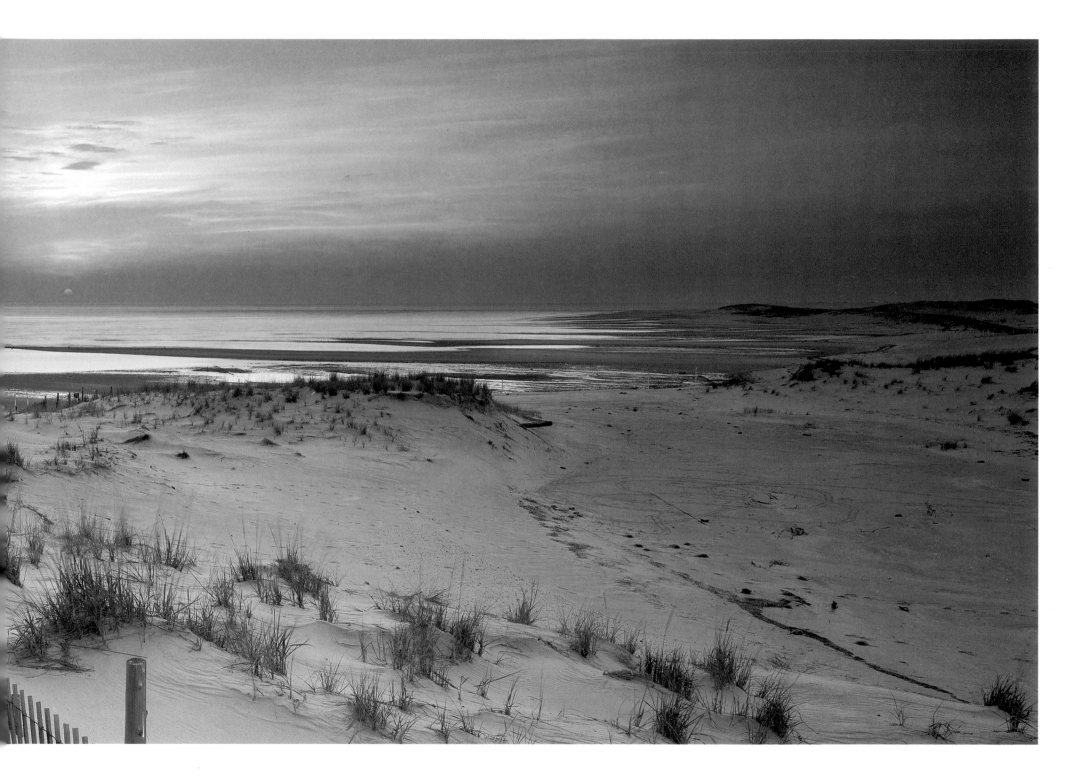

The path of humility is the path to glory. ROBERT H. SCHULLER **47**

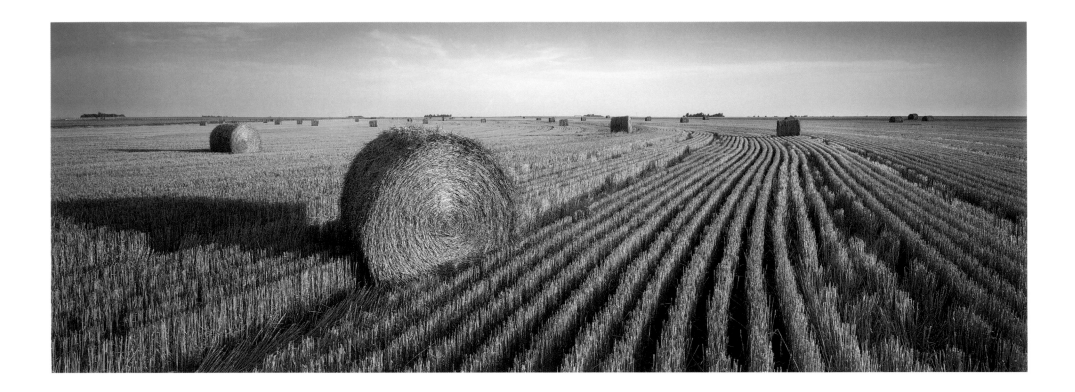

Let us not grow weary while doing good,
for in due season we shall reap if we do not lose heart.

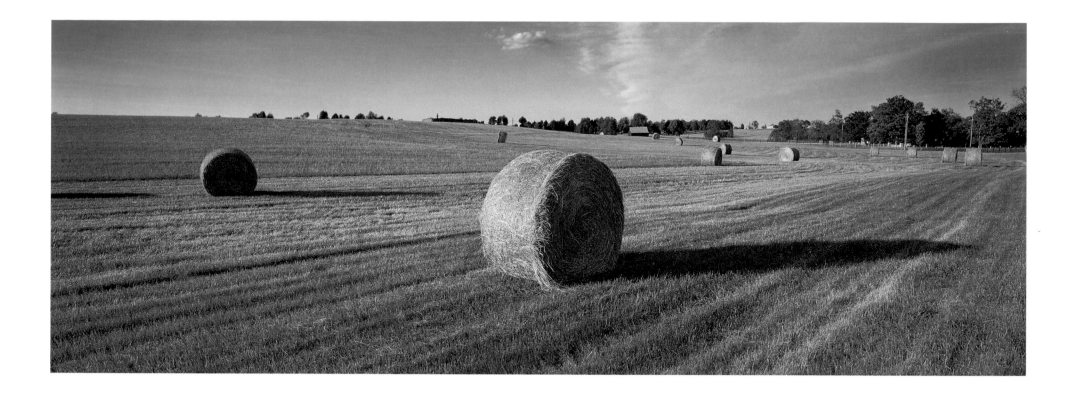

Now the fruit of righteousness is sown in peace
by those who make peace.

JAMES 3:18

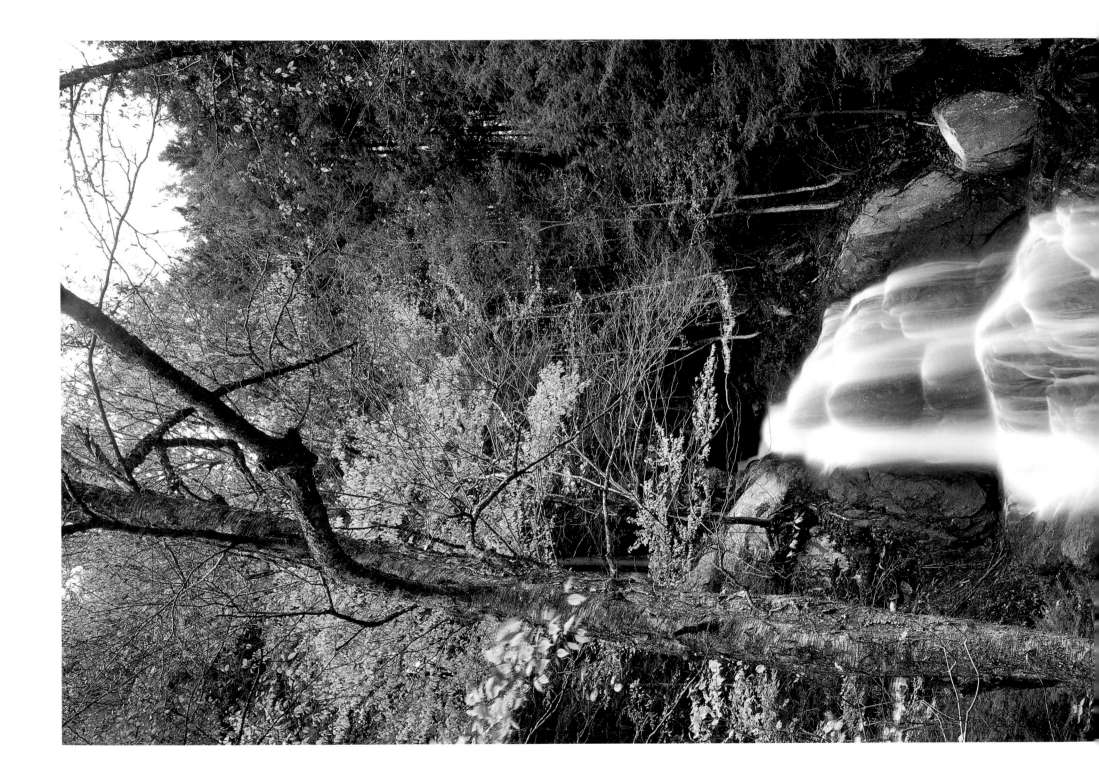

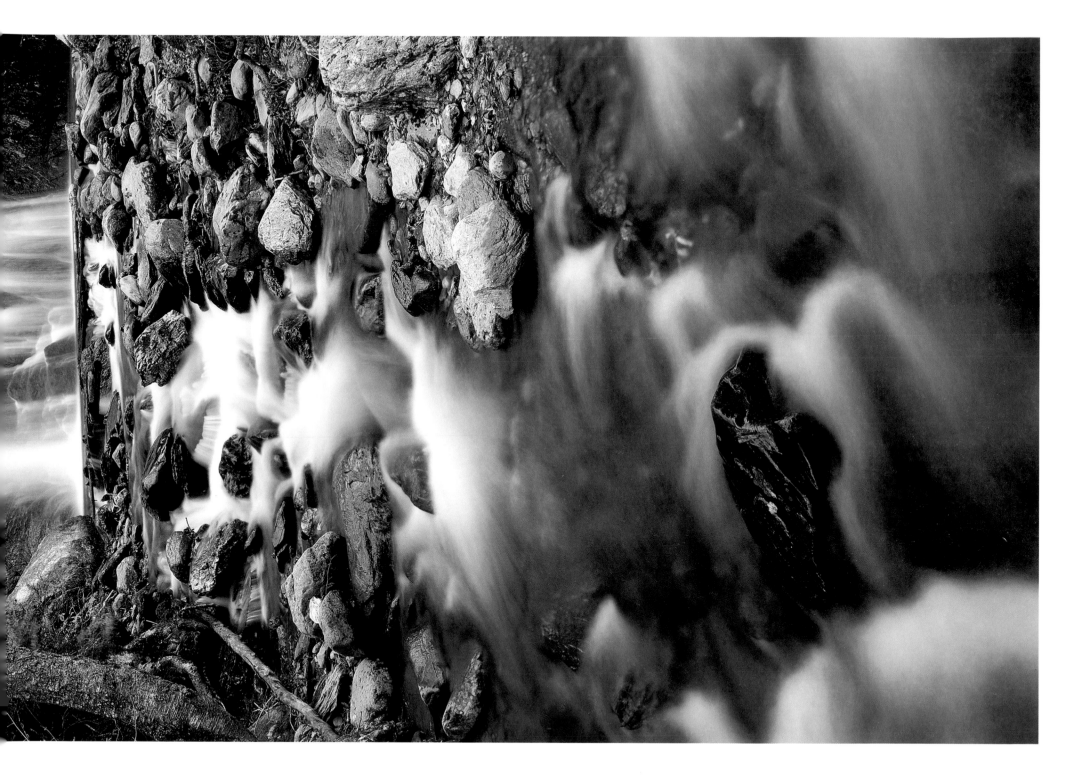

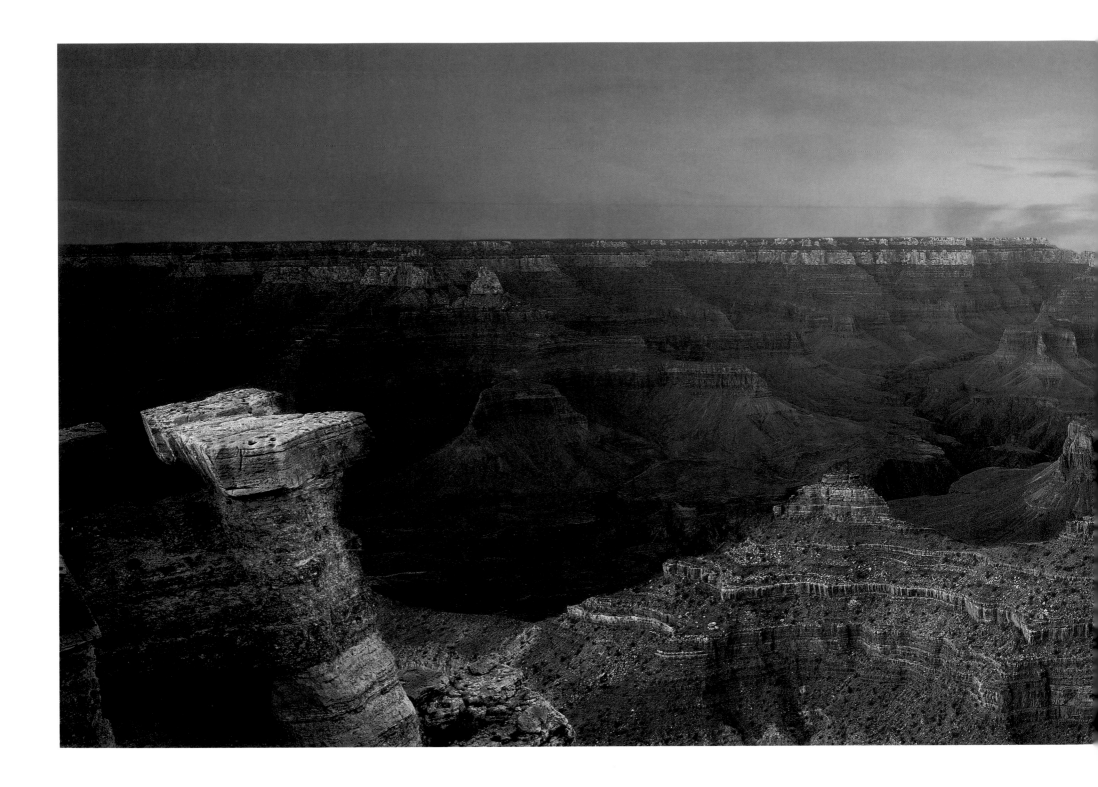

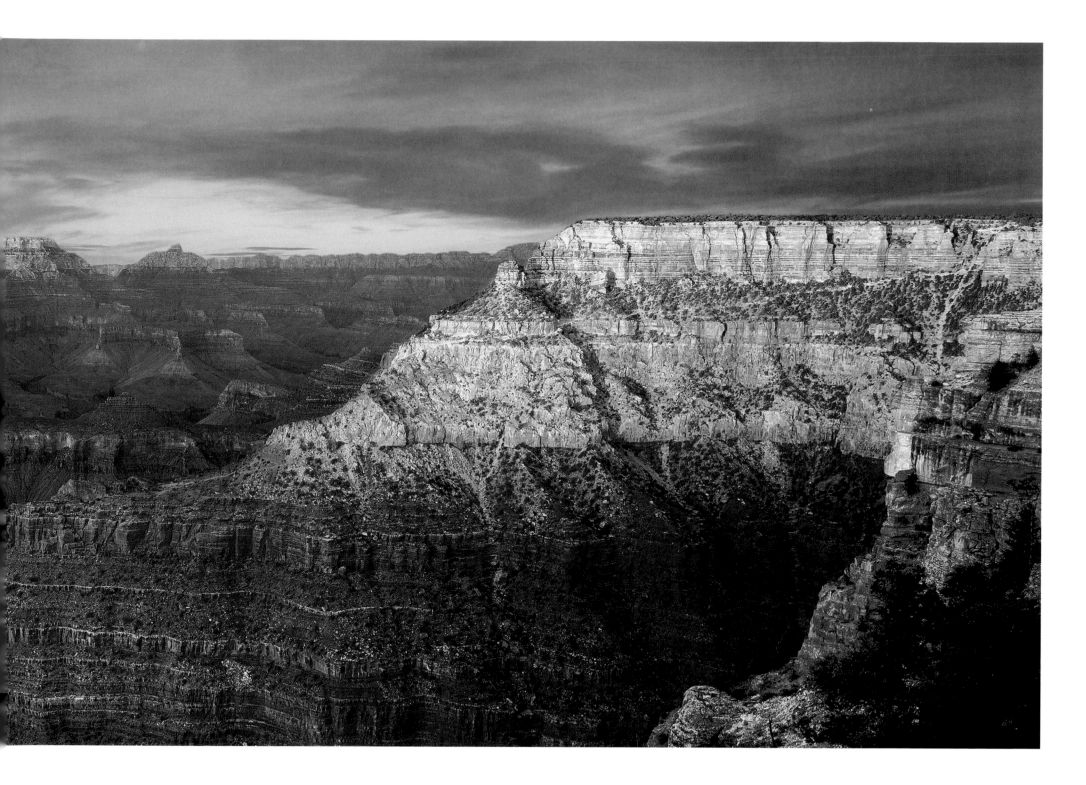

A big achievement is made up of little steps. ROBERT H. SCHULLER **53**

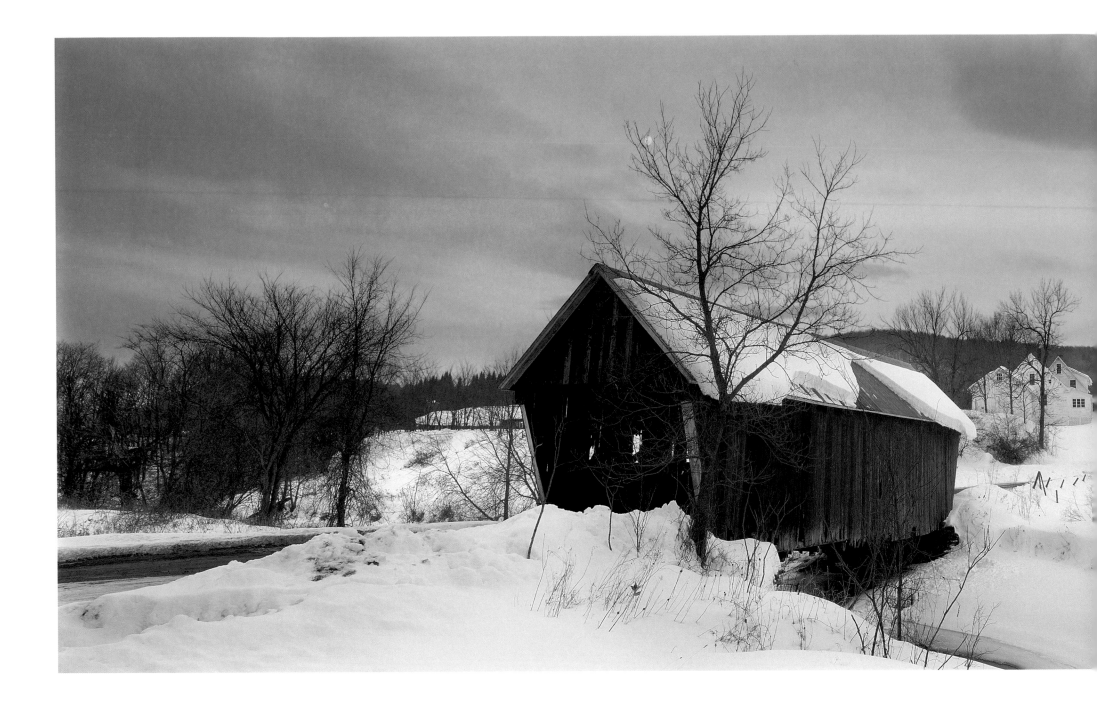

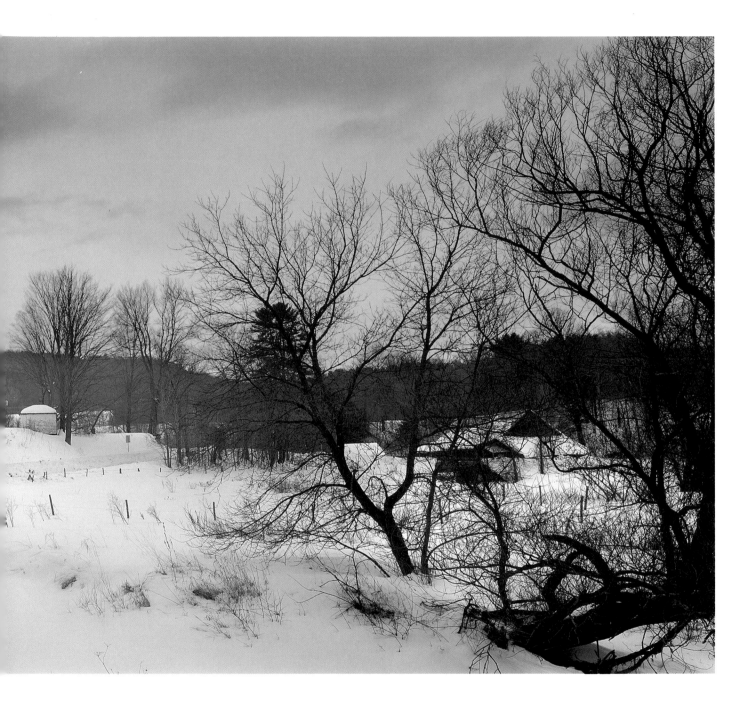

"For as the heavens are higher than the earth,
So are My ways higher than your ways,
And My thoughts than your thoughts.
For as the rain comes down, and the snow from heaven,
And do not return there,
But water the earth,
And make it bring forth and bud,
That it may give seed to the sower
And bread to the eater,
So shall My word be that goes forth from My mouth;
It shall not return to Me void,
But it shall accomplish what I please,
And it shall prosper in the thing for which I sent it."

ISAIAH 55:9-11

Let the heavens rejoice, and let the earth be glad;
Let the sea roar, and all its fullness;
Let the field be joyful, and all that is in it.
Then all the trees of the woods
will rejoice before the LORD.

PSALM 96:11-12

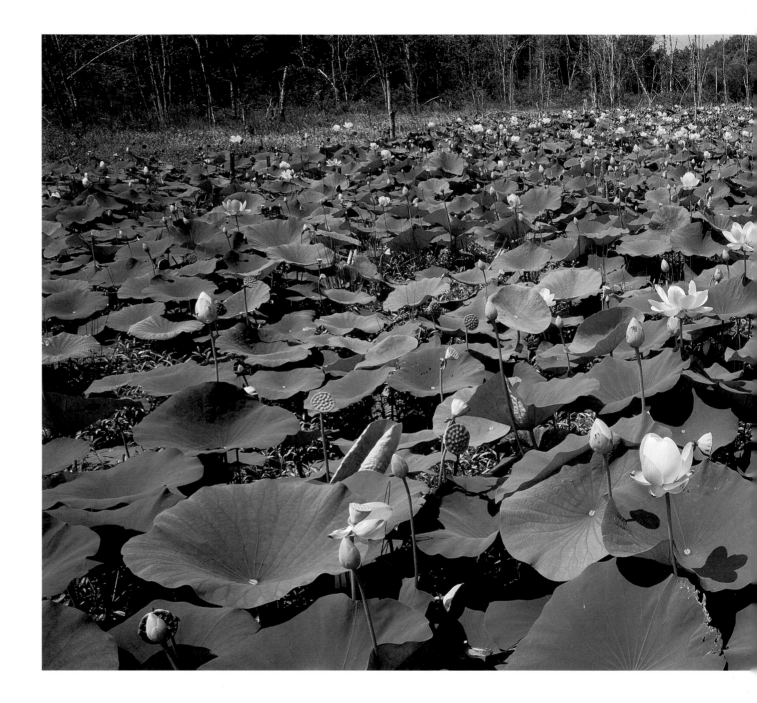

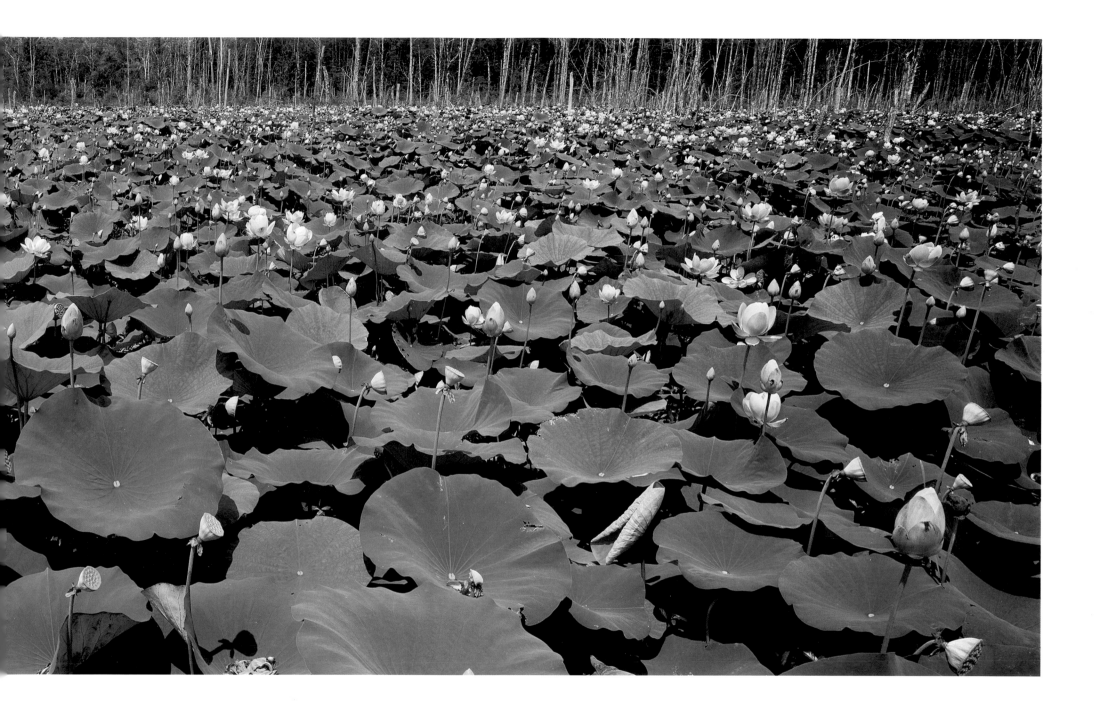

There is no life without growth.

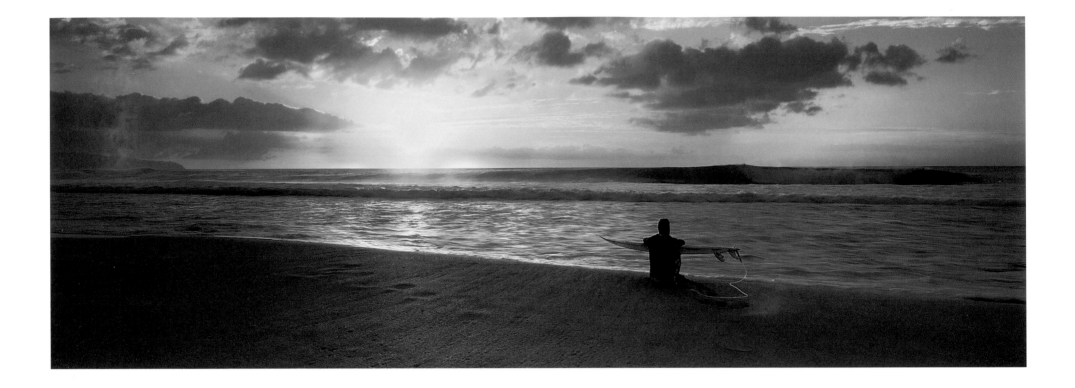

It's not about us

The day before my departure for Hawaii, my assistant rang to say he had broken his hand and could not make the journey. I considered waiting for him to recover, but I had photo deadlines for my first American book and time was running out. So I decided to go alone.

As soon as I arrived in Hawaii, I dropped in to see some old friends who live right on the beach. True friendship is wonderful. Though we had been apart for years, our relationship picked up again as though there had merely been a pause in the conversation. We talked for hours. As time rolled on, however, I sensed some tension in their home. The conversation was pleasant, but something was inconsistent in the words being spoken. I felt something was weighing heavily on my friends' hearts, but I didn't know what.

Late that afternoon I began to feel guilty about not taking any photos. I took a walk and set up my camera on the golden sand hoping for a photo opportunity. As the sun began to descend into the ocean a surfer walked into my shot and sat down. He was checking the surf but I thought all he was doing was ruining the sand in my shot and I hoped he would leave soon. Finally it dawned on me that perhaps his presence was a gift rather than a problem and so I clicked the shutter. The poor guy had probably been kept there longer than need be while I got the message because as soon as I had taken the shot he hit the waves with gusto. I stayed on, enjoying the beauty of creation and hoping for what I thought might be better shots. As I recalled the day's conversations and pondered what had gone unspoken, a clarity emerged and God showed me the nature of my friends' problem.

Back at the house I shared with them what had been revealed to me on the beach. Their initial reaction was surprise, but then the dam of pent up emotions cracked and tears began to flow. From that moment on we shared heart to heart for many days. So much for the book deadline – quality time with my friends was far more important right then. During breaks in our conversations I would wander out to take a few photos. As I waited for photo opportunities, the endless horizon reminded me of God's awesome power and I asked Him for wisdom to impart to my friends. After a few days of sharing together, my friends began to see what happens when we hand our problems and concerns over to God. At first it was hard for them to relinquish control, but as God ministered to them His peace began to fill their hearts and they felt His miraculous love and healing power at work in their lives.

My assistant's hand is long since healed and he now realizes his absence was an opportunity for God to demonstrate His great love and mercy. To add to the blessing, God gave me more shots than I needed because I was where He wanted me to be.

God is real. He may not do things in our lives the way we expect (but then, why should He?) If we are in Christ we can simply trust He will work out all things together for our good. After all, it's not about us. It's about God's purposes in our lives. And that often means He will use us to bless others. If we stand firm in Him, He will take us on the adventure of our lives.

And we know that all things work together for good
to those who love God,
to those who are the called according to His purpose.

ROMANS 8:28

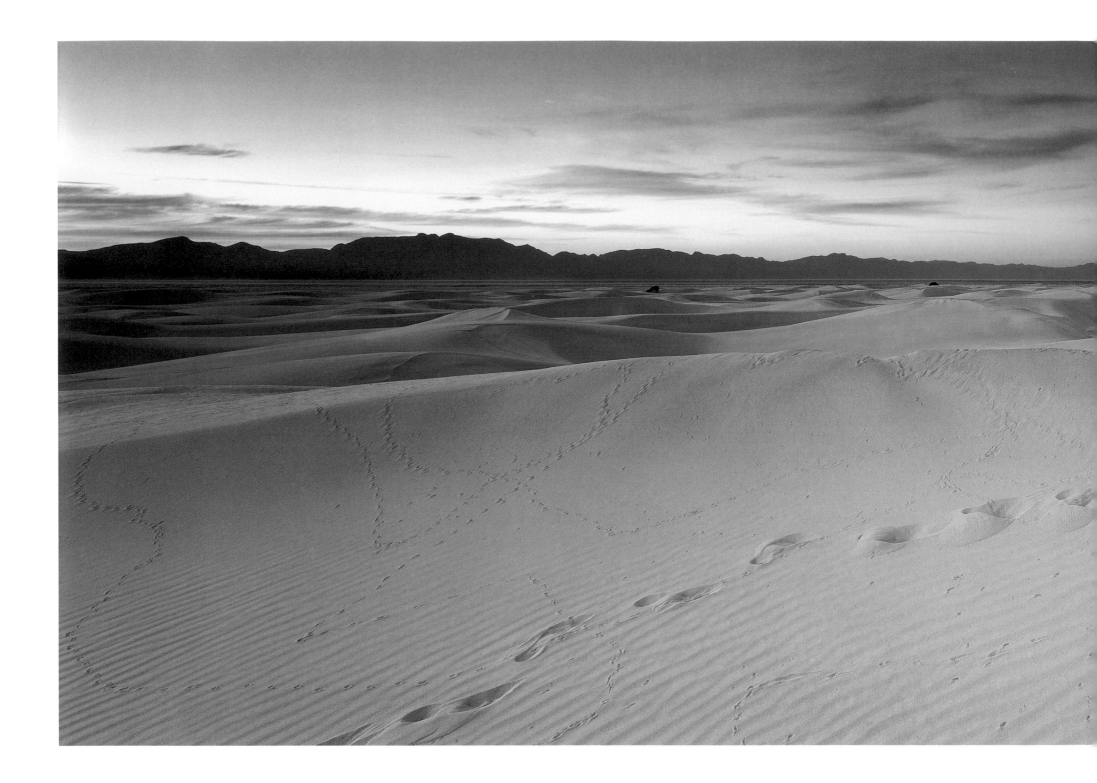

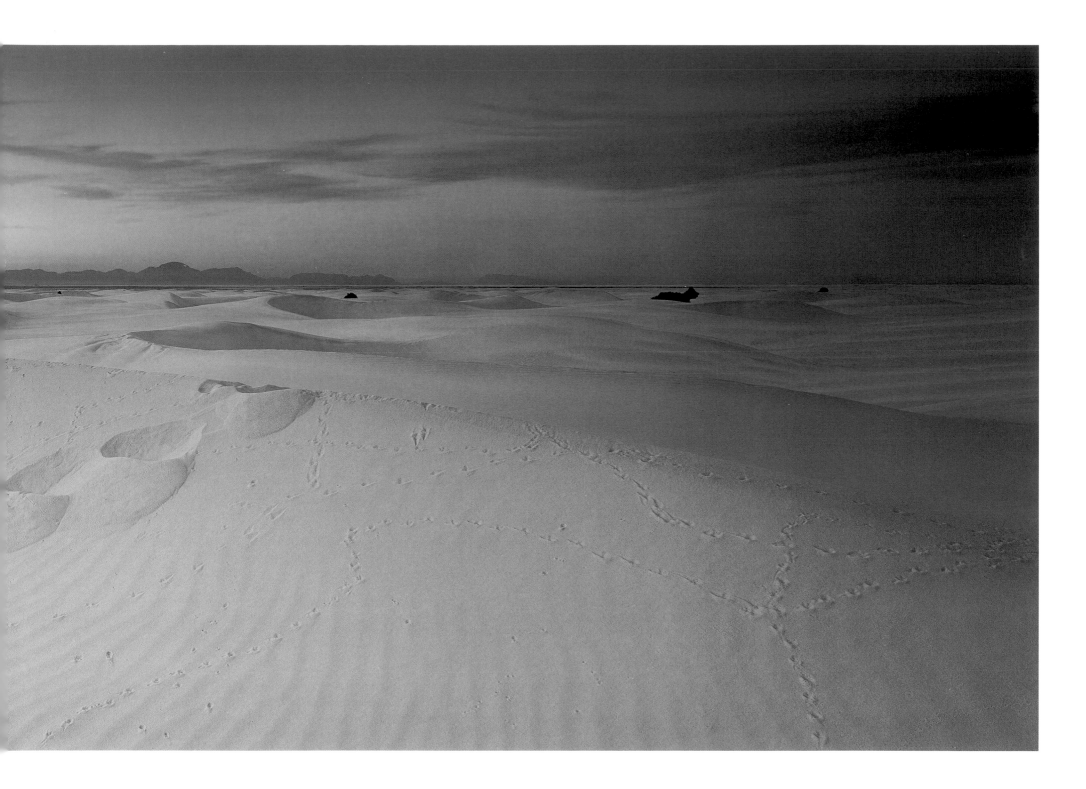

Dare to go where no one else has gone.

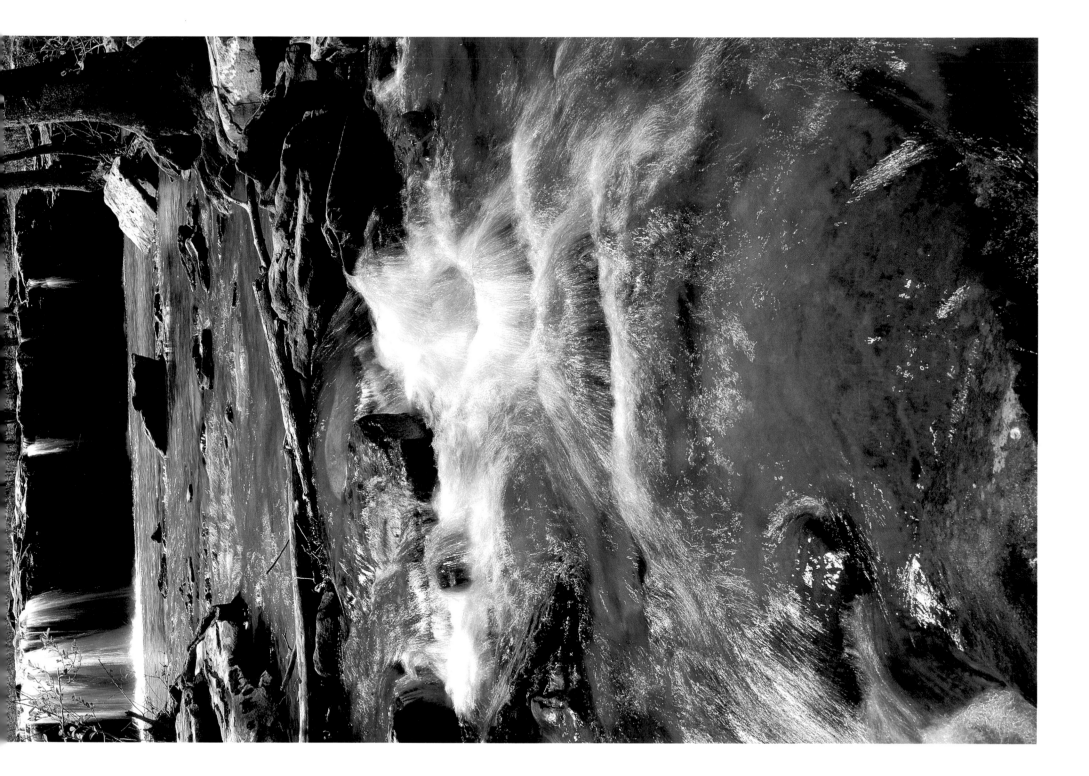

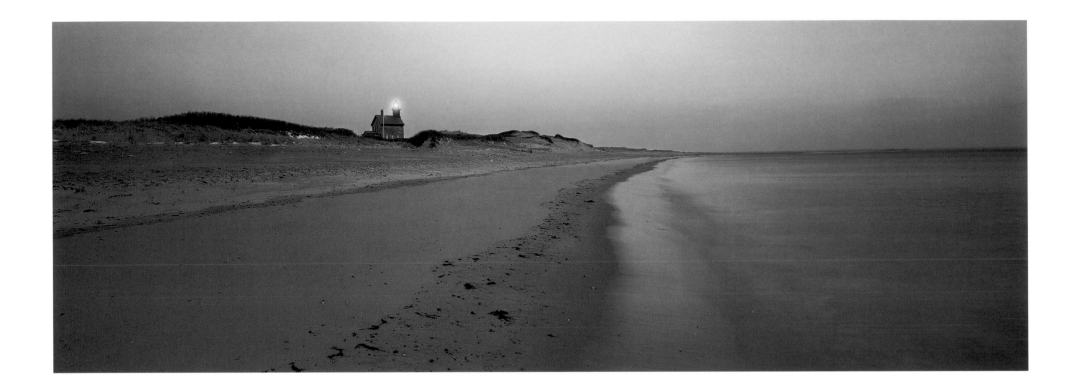

The LORD is my light and my salvation;
Whom shall I fear?
The LORD is the strength of my life;
Of whom shall I be afraid?

PSALM 27:1

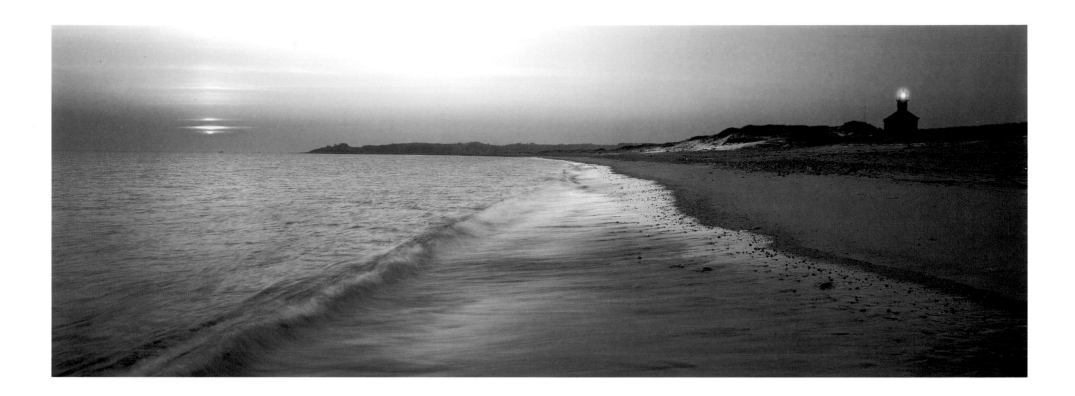

Oh, satisfy us early with Your mercy,
That we may rejoice and be glad all our days!

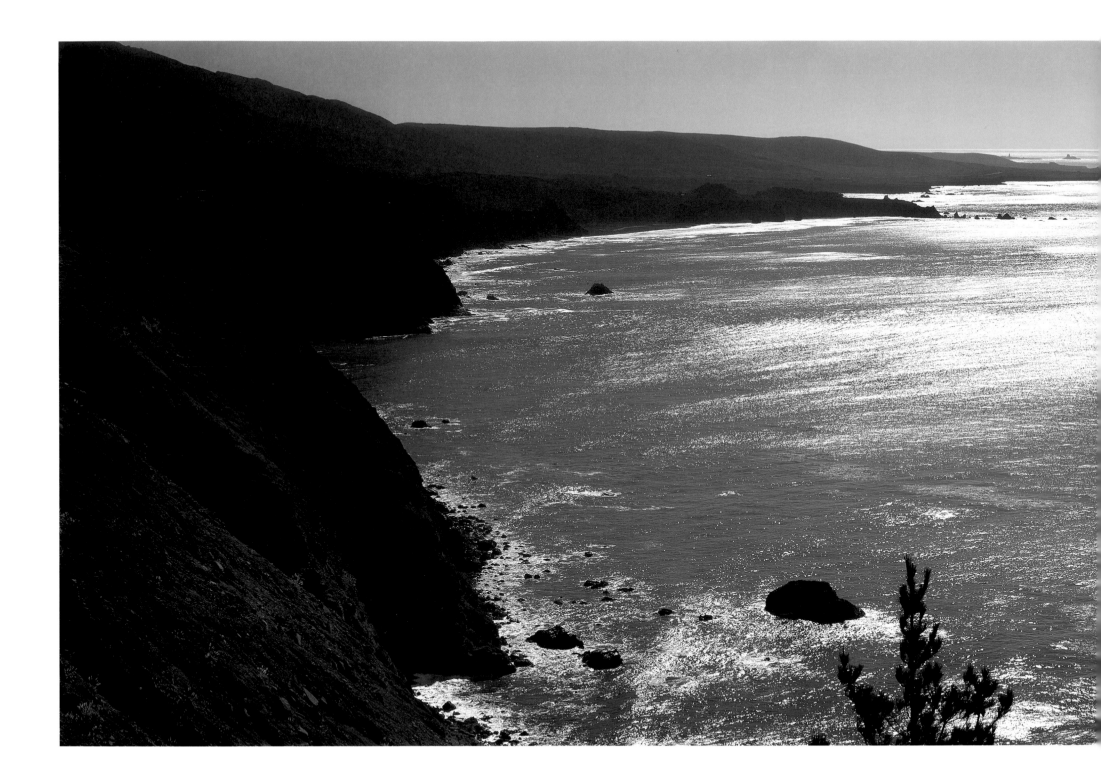

RAGGED POINT, BIG SUR COAST, CALIFORNIA

What the mind can believe you can achieve! ROBERT H. SCHULLER **67**

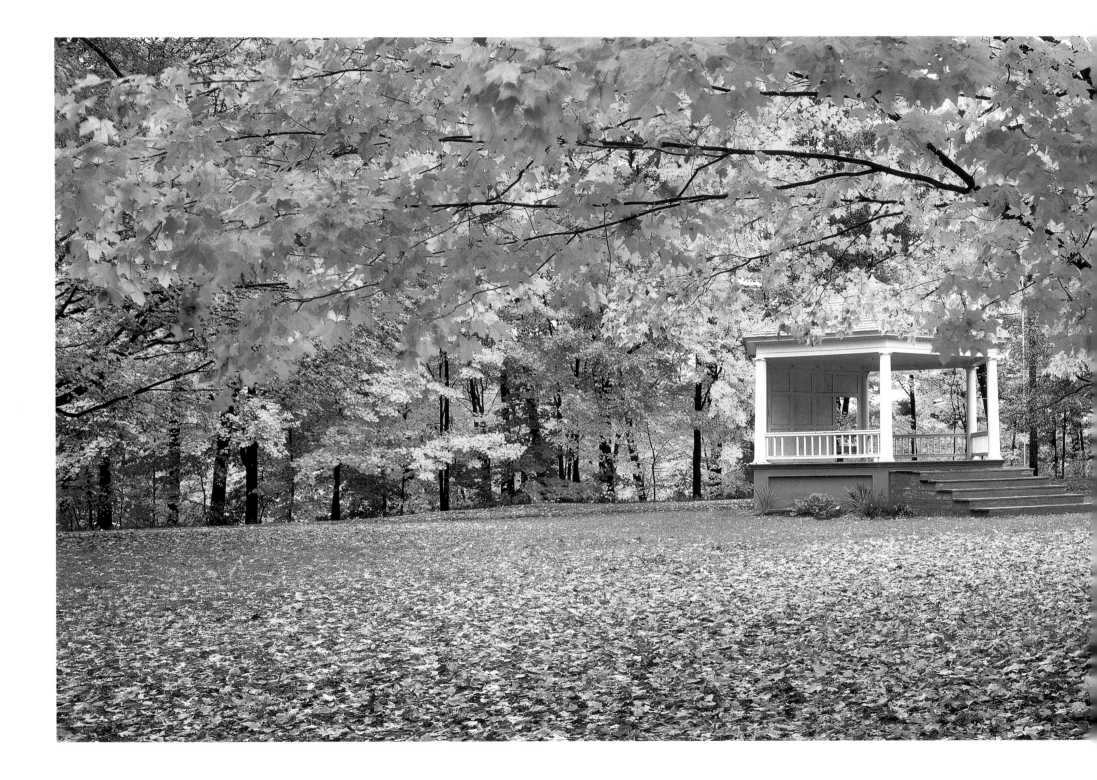

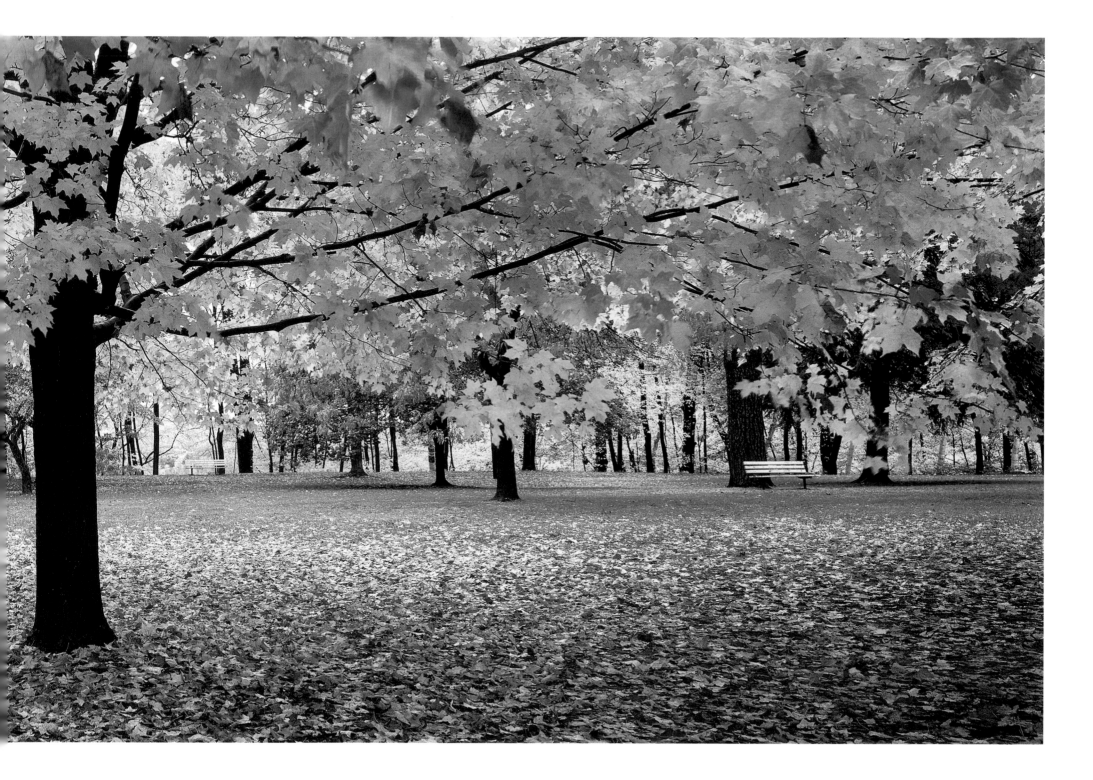

Keep making beautiful music – our world really needs it! ROBERT H. SCHULLER **69**

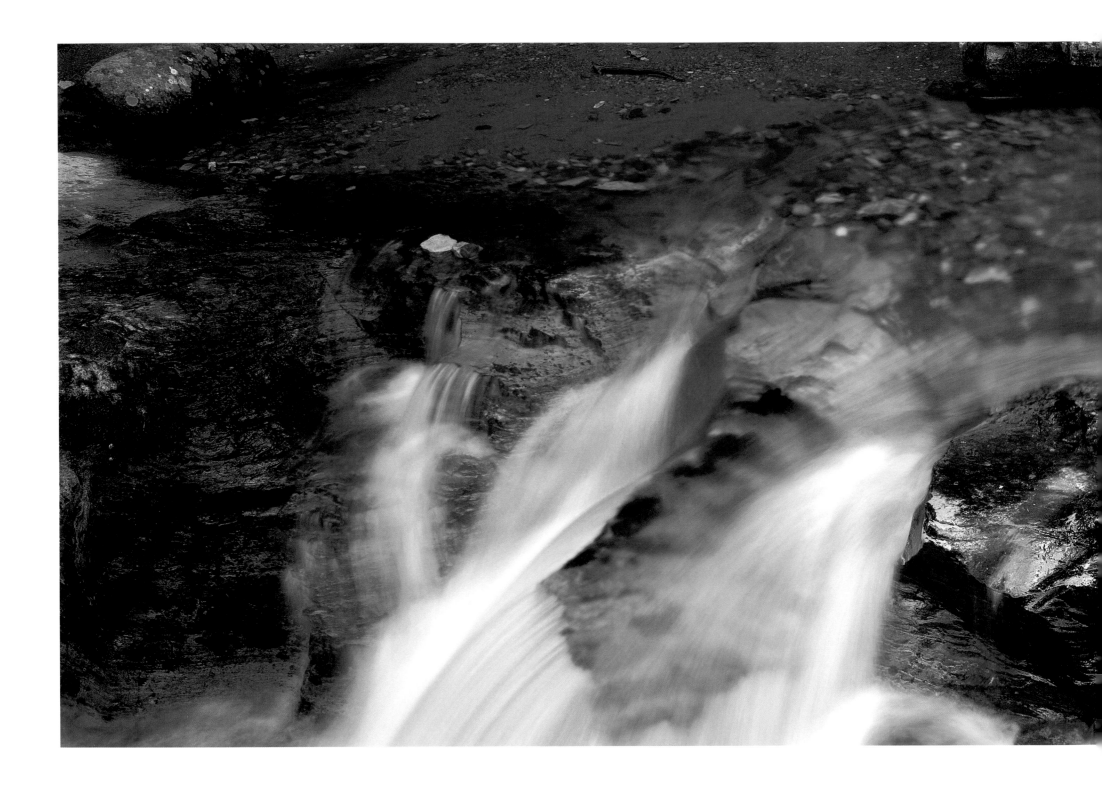

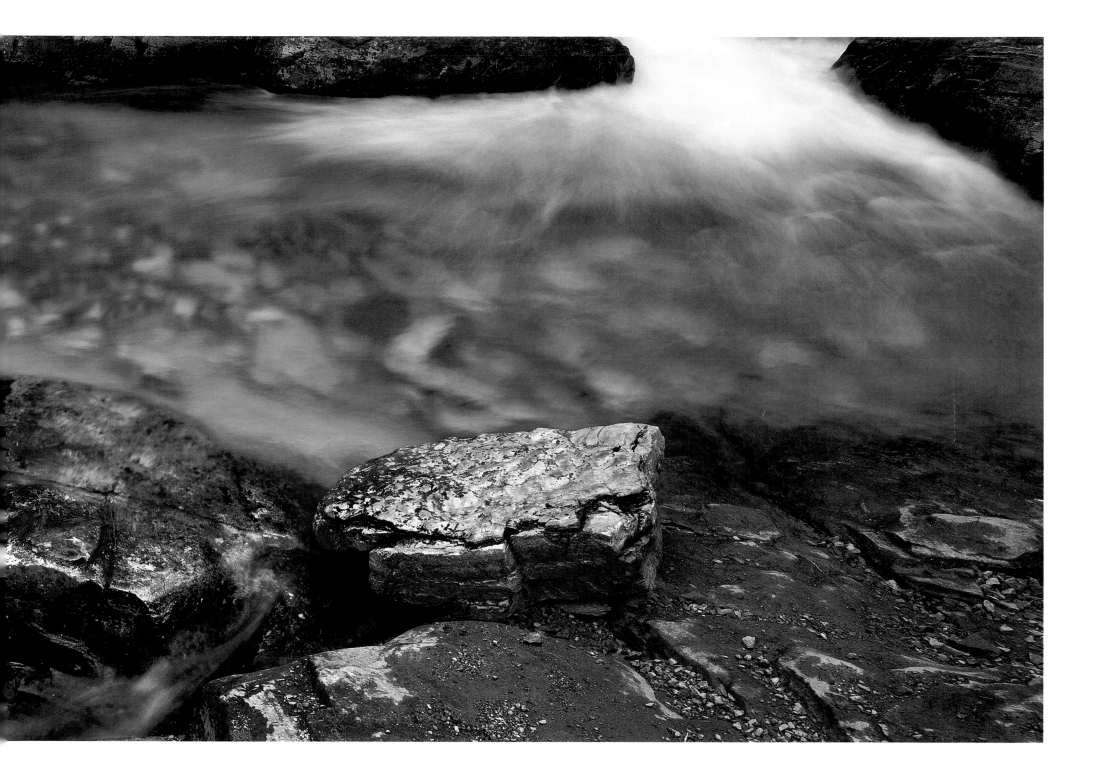

Let your hopes, not your hurts, shape your future. ROBERT H. SCHULLER **71**

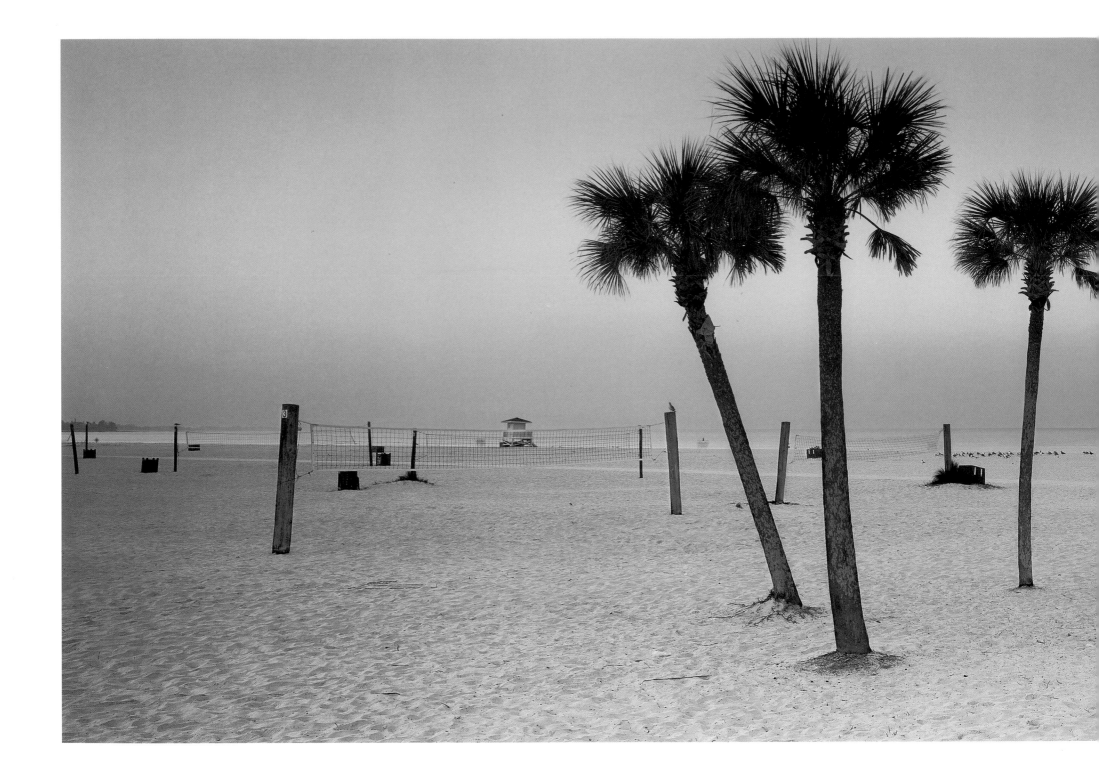

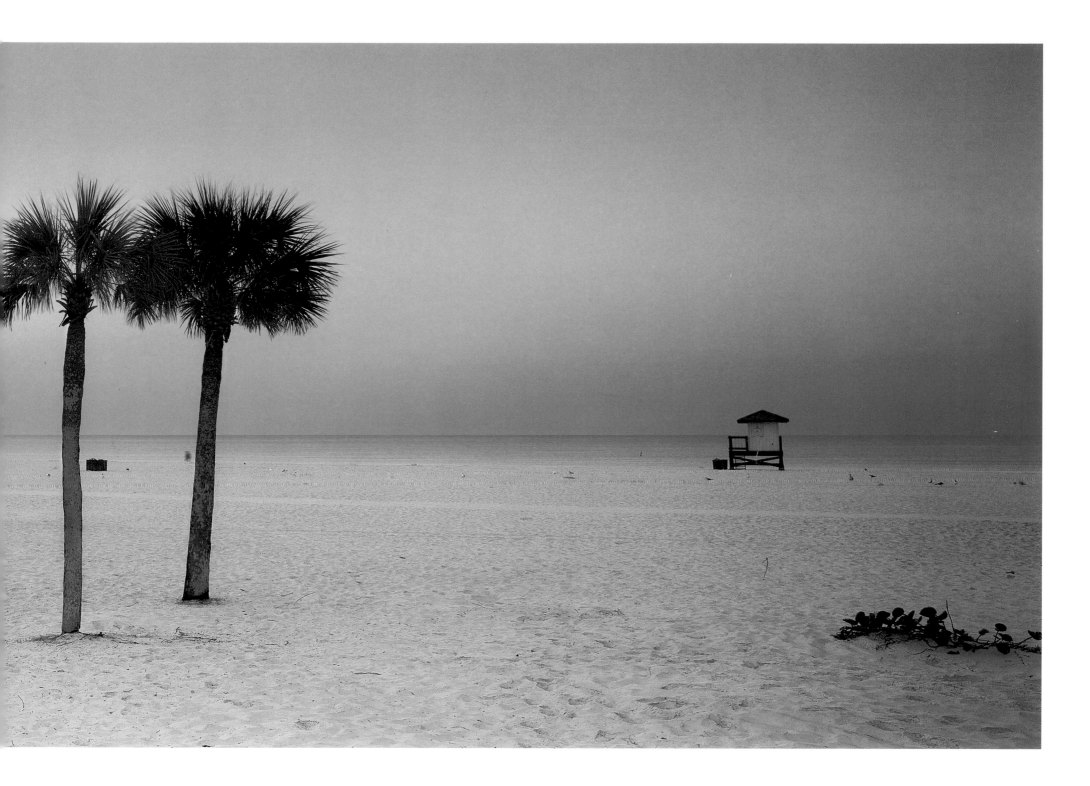

God doesn't say "No." He does say "Grow!"

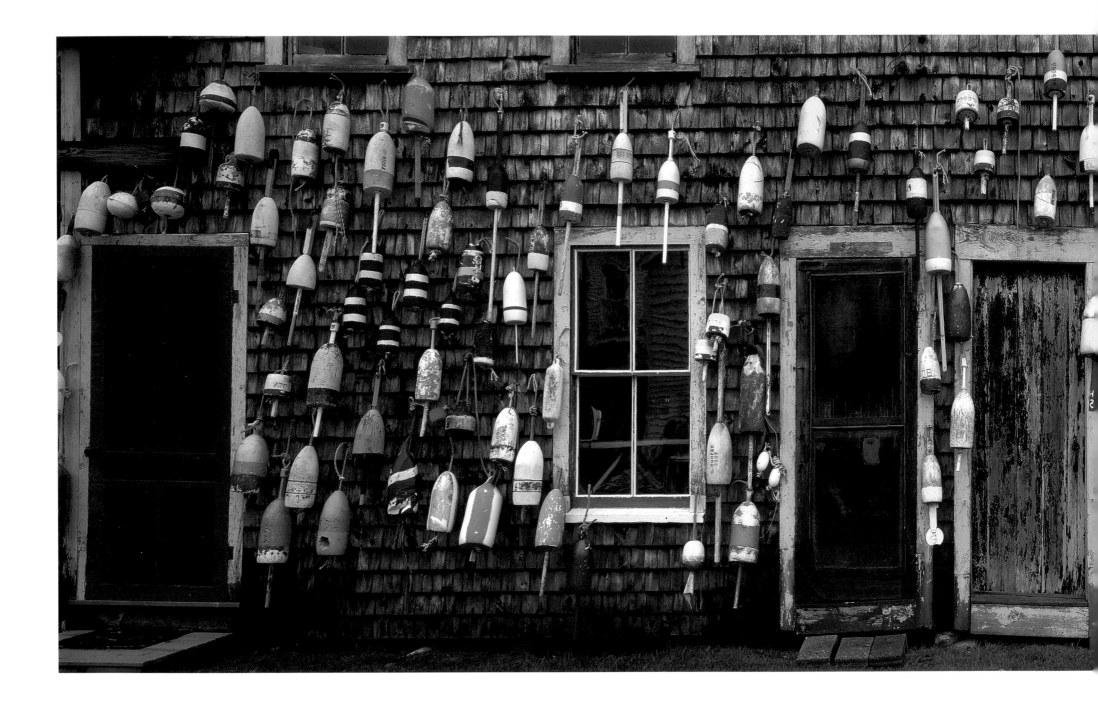

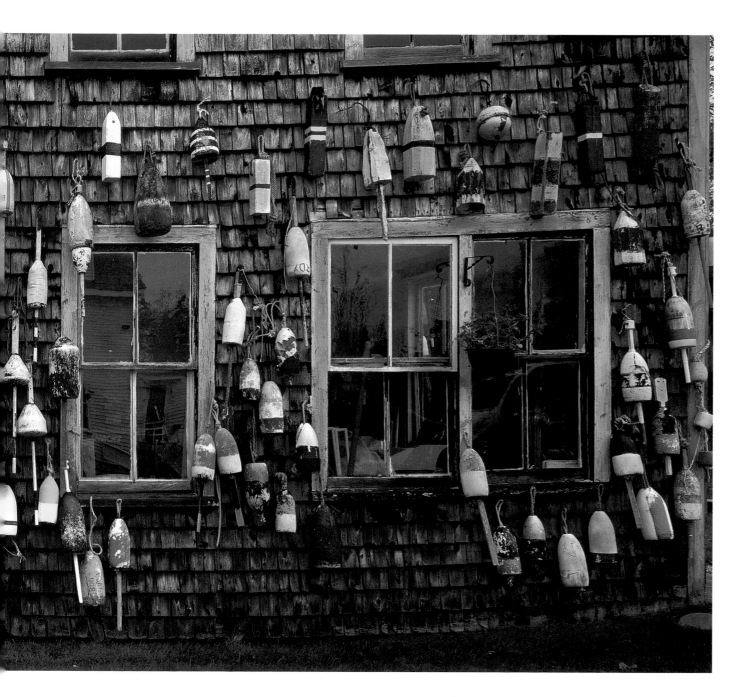

When I consider Your heavens, the work of Your fingers,
The moon and the stars, which You have ordained,
What is man that You are mindful of him,
And the son of man that You visit him?
For You have made him a little lower than the angels,
And You have crowned him with glory and honor.
You have made him to have dominion
over the works of Your hands;
You have put all things under his feet,
All sheep and oxen—
Even the beasts of the field,
The birds of the air,
And the fish of the sea
That pass through the paths of the seas.
O LORD, our Lord,
How excellent is Your name in all the earth!

PSALM 8:3-9

Those who go down to the sea in ships,
Who do business on great waters,
They see the works of the LORD,
And His wonders in the deep.
For He commands and raises the stormy wind,
Which lifts up the waves of the sea.
They mount up to the heavens,
They go down again to the depths;
Their soul melts because of trouble.
They reel to and fro, and stagger like a drunken man,
And are at their wits' end.
Then they cry out to the LORD in their trouble,
And He brings them out of their distresses.
He calms the storm,
So that its waves are still.
Then they are glad because they are quiet;
So He guides them to their desired haven.
Oh, that men would give thanks to the LORD for His goodness,
And for His wonderful works to the children of men!

PSALM 107:23-31

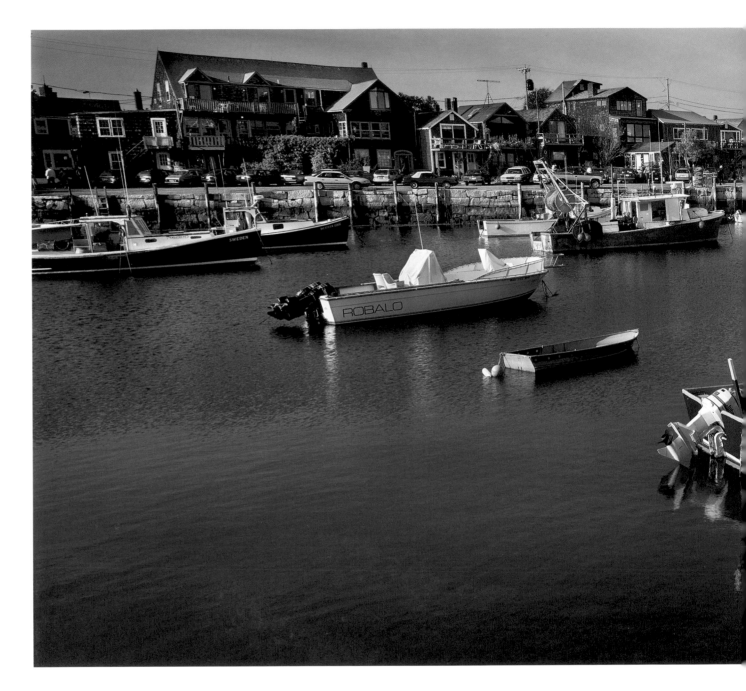

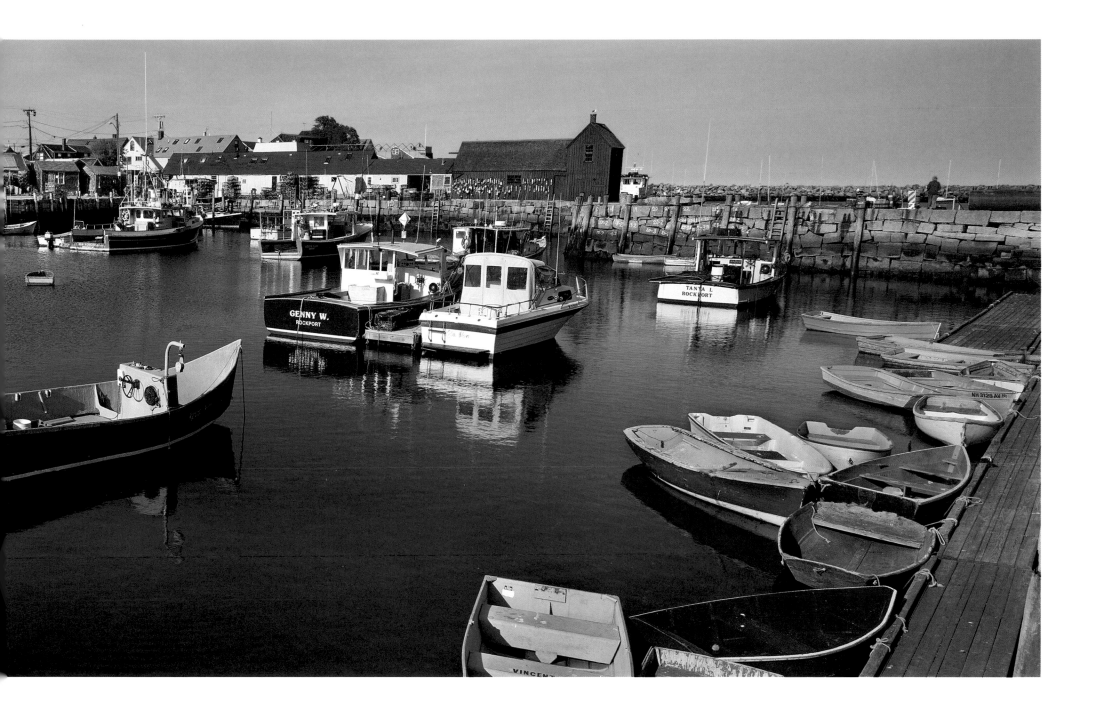

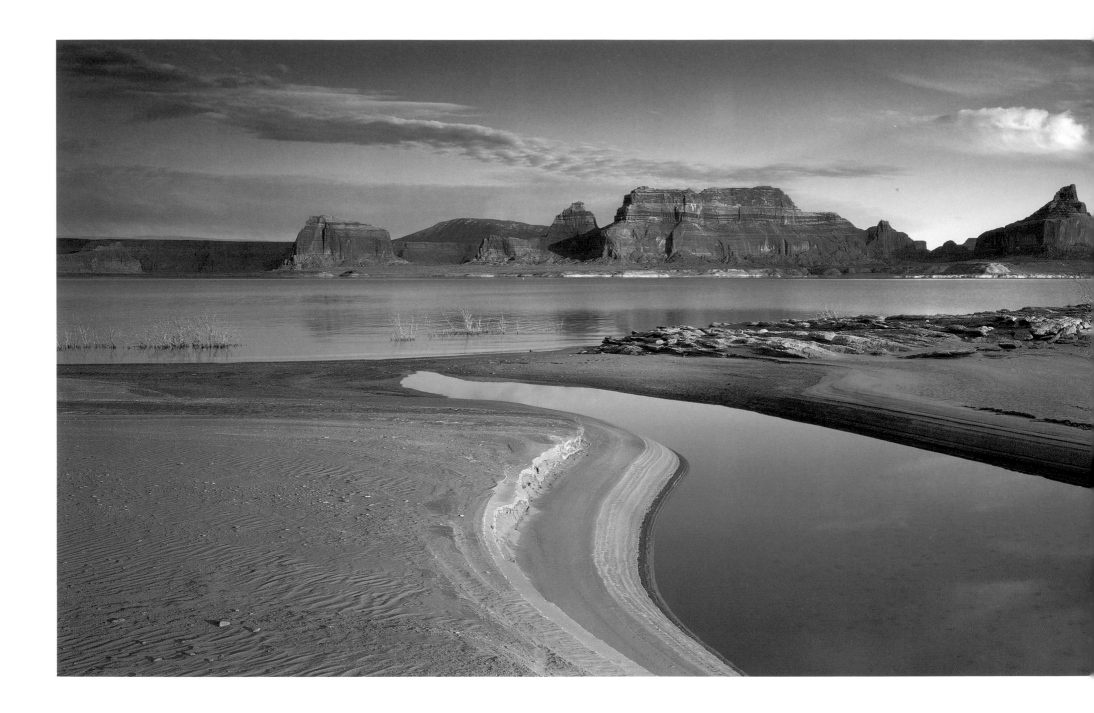

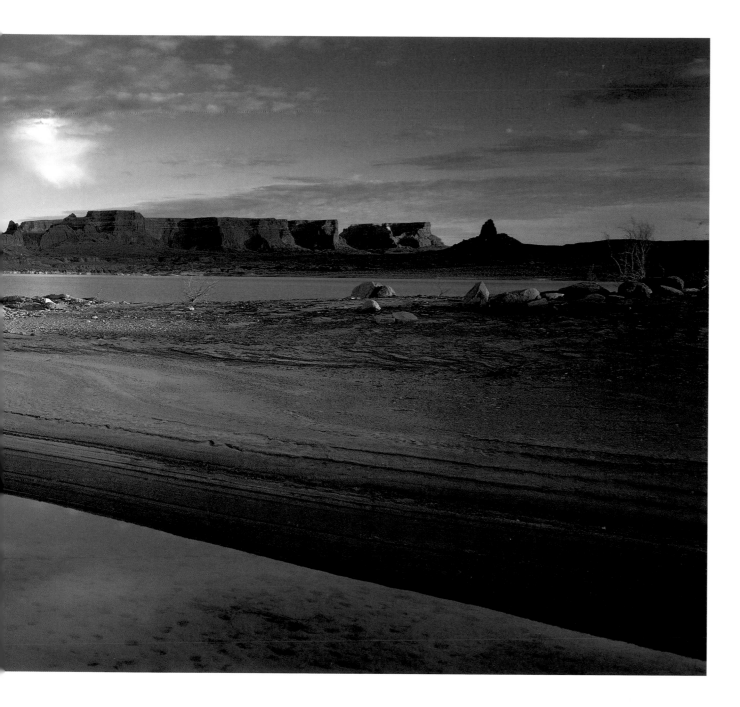

Behold, God is great, and we do not know Him;
Nor can the number of His years be discovered.
For He draws up drops of water,
Which distill as rain from the mist,
Which the clouds drop down
And pour abundantly on man.
Indeed, can anyone understand the spreading of clouds,
The thunder from His canopy?

JOB 36:26-29

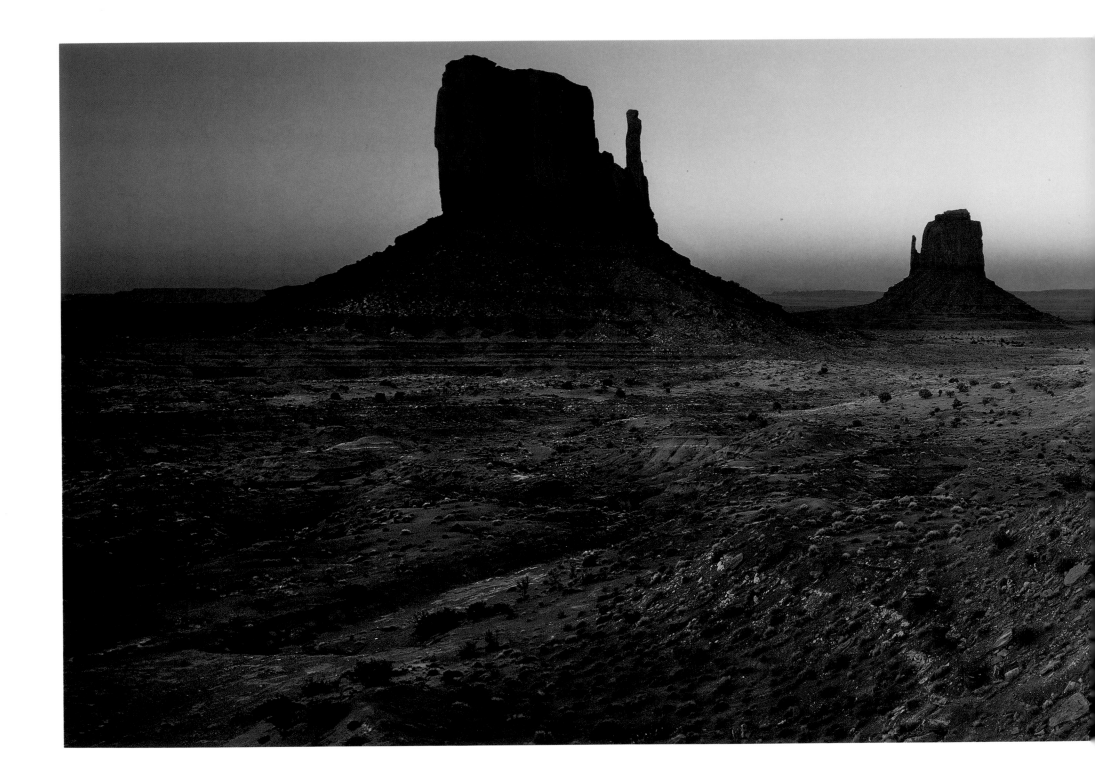

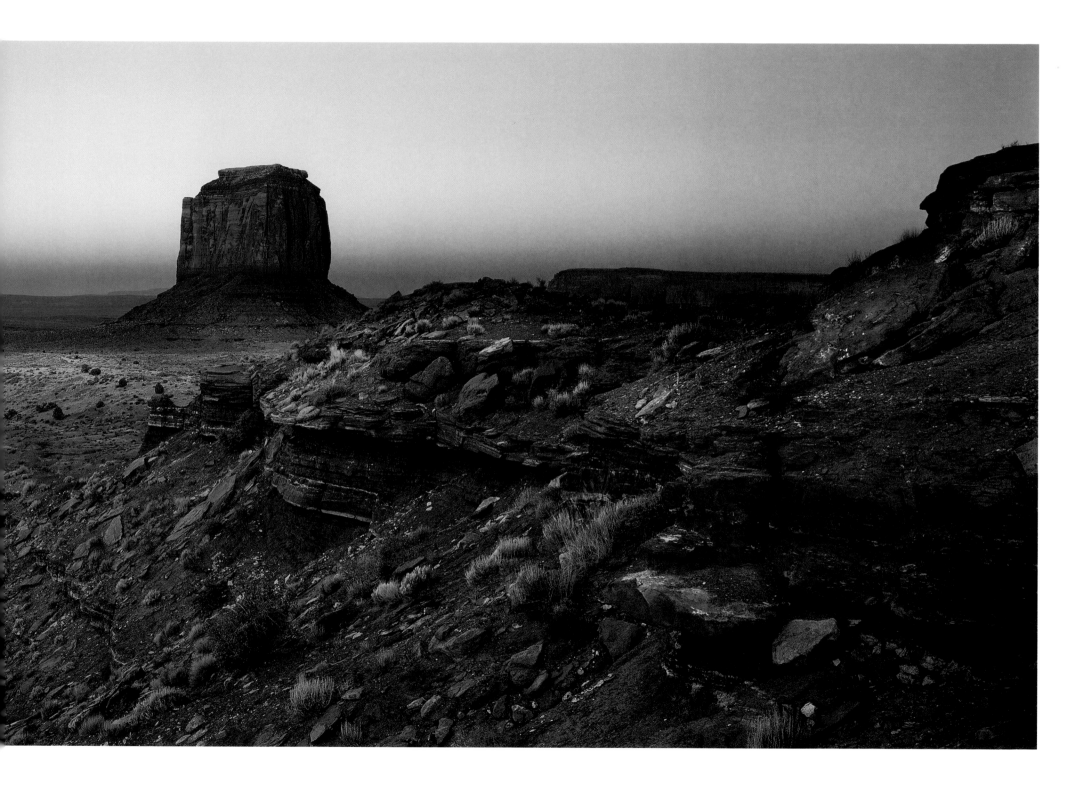

If God can inspire me to believe it, He can help me to achieve it.

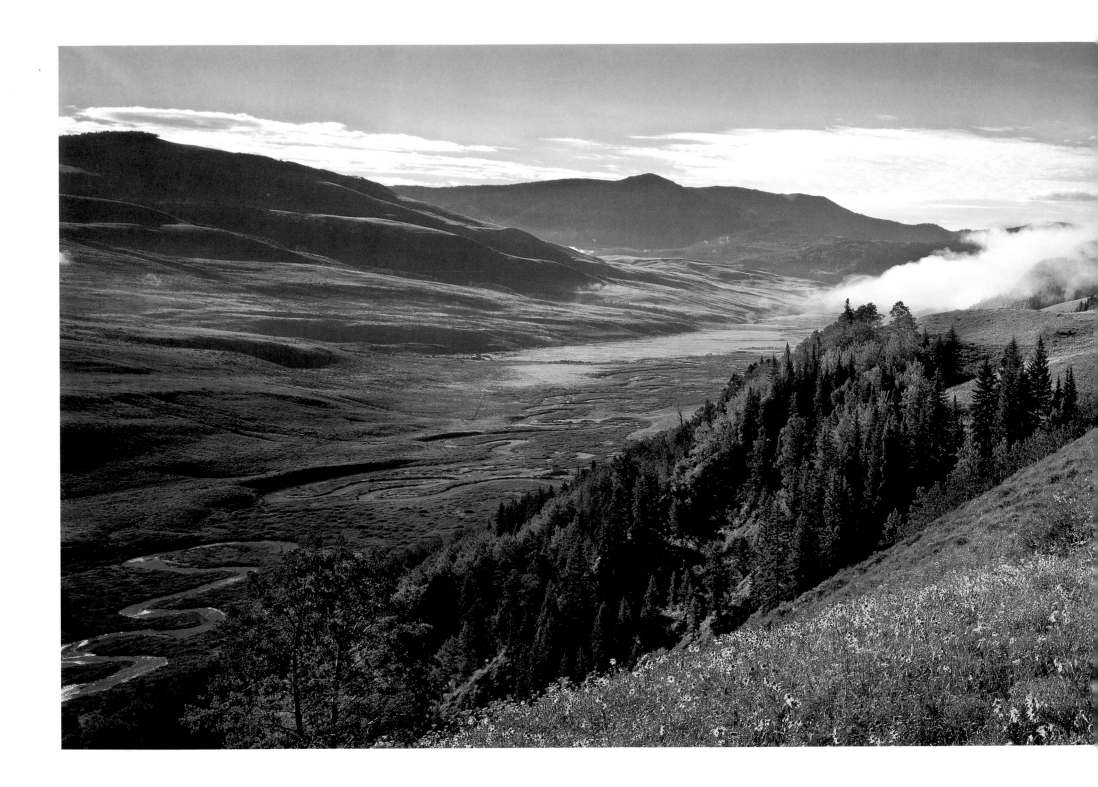

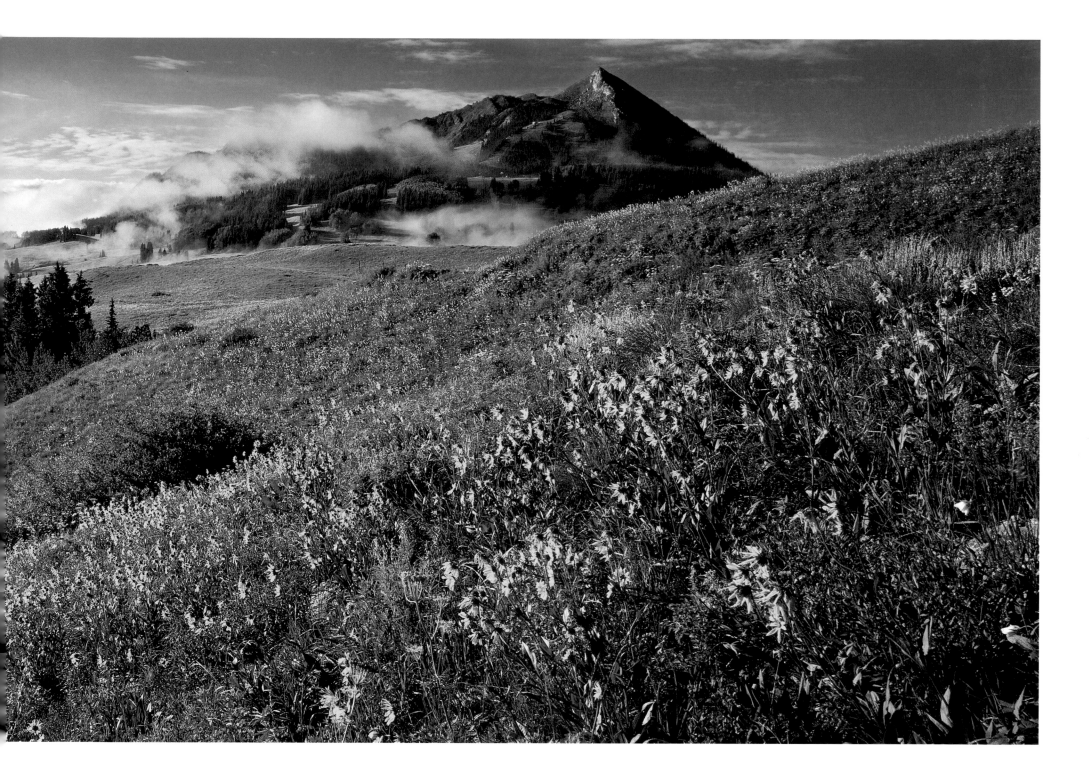

Climb the mountain and catch the new vision.

Send out Your light and Your truth!
Let them lead me;
Let them bring me to Your holy hill
And to Your tabernacle.

PSALM 43:3

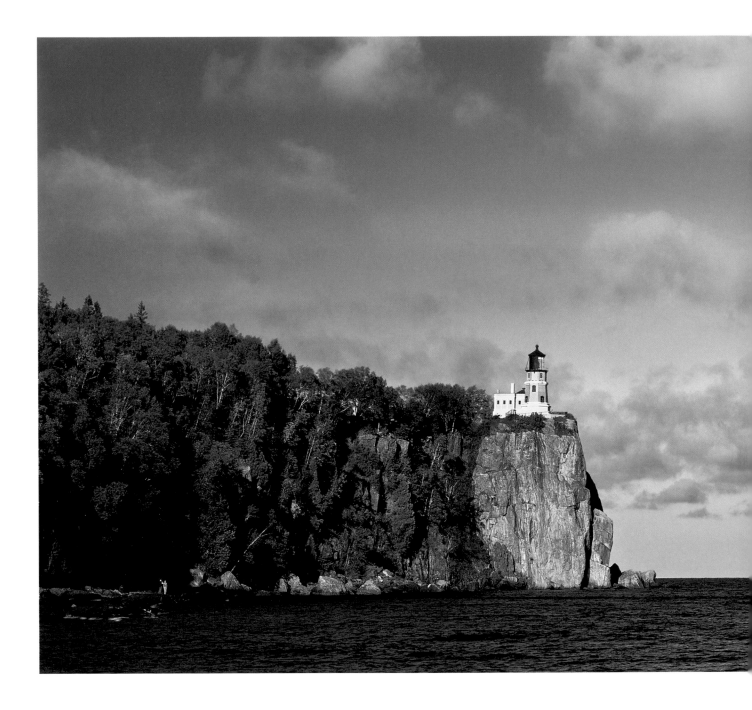

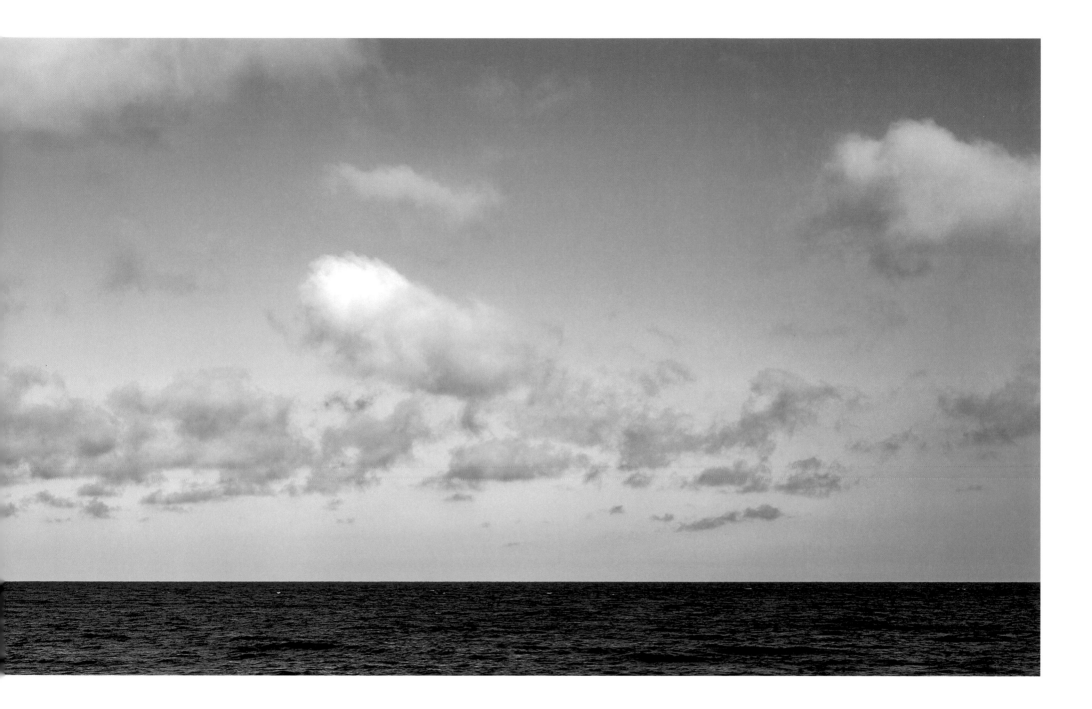

If you aim at nothing – you're sure to hit it!

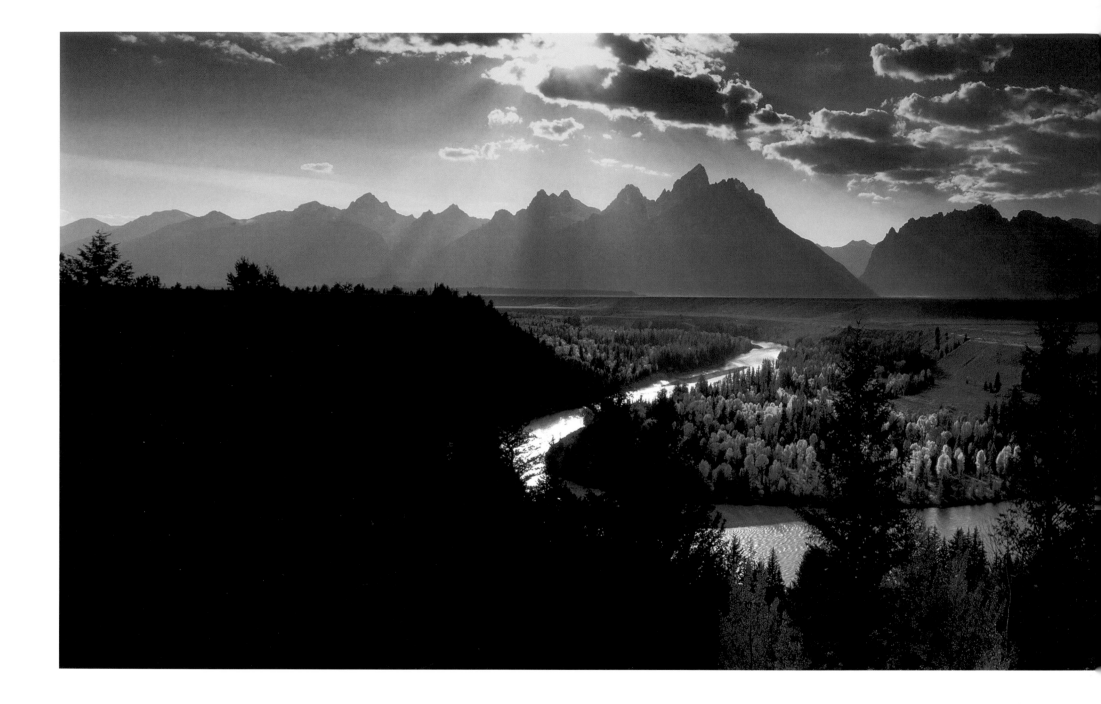

SNAKE RIVER, GRAND TETON NATIONAL PARK, WYOMING

Then Jesus cried out and said,
"He who believes in Me,
believes not in Me but in Him who sent Me.
And he who sees Me sees Him who sent Me.
I have come as a light into the world,
that whoever believes in Me
should not abide in darkness.

JOHN 12:44-46

For I know the thoughts that I think toward you,
says the LORD,
thoughts of peace and not of evil,
to give you a future and a hope.
JEREMIAH 29:11

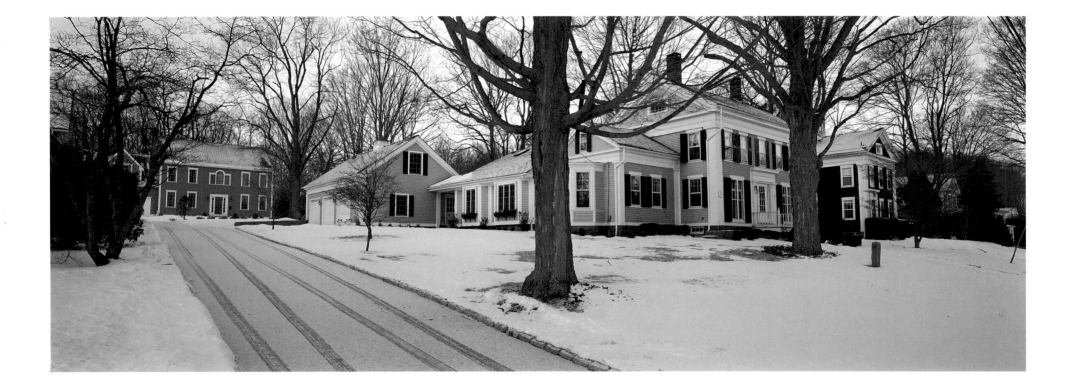

Through wisdom a house is built,
And by understanding it is established;
By knowledge the rooms are filled
With all precious and pleasant riches.

PROVERBS 24:3-4

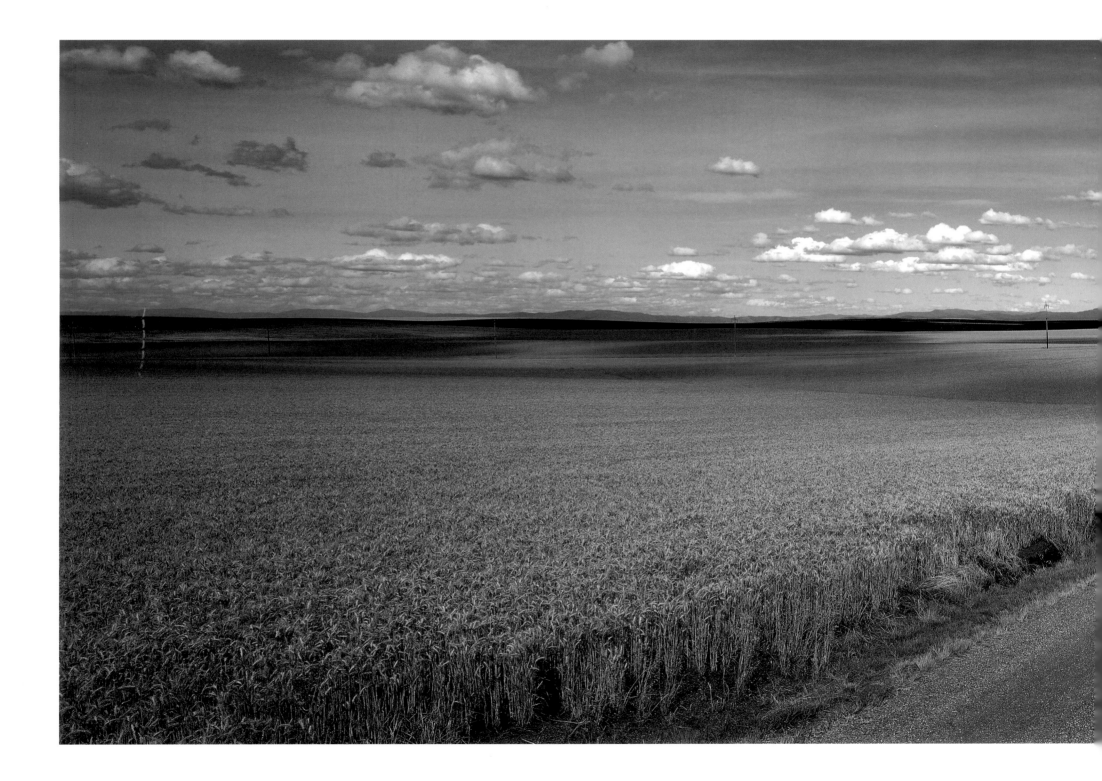

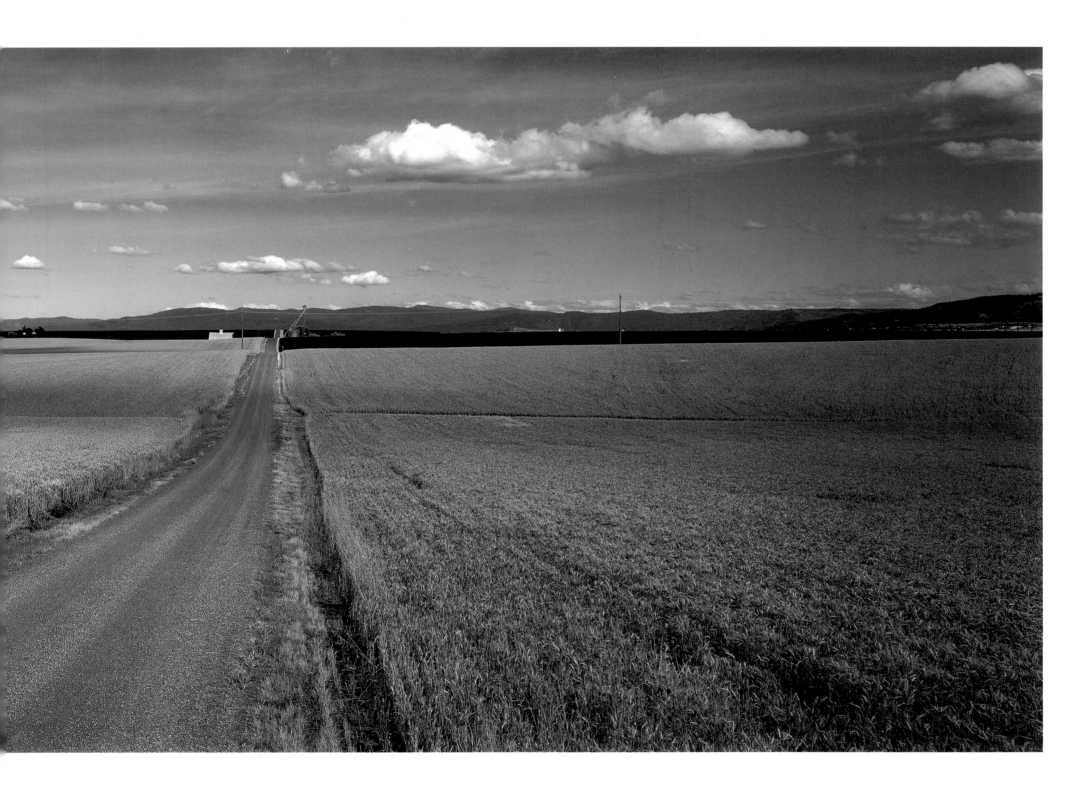

Success is a journey . . . not a destination. ROBERT H. SCHULLER **93**

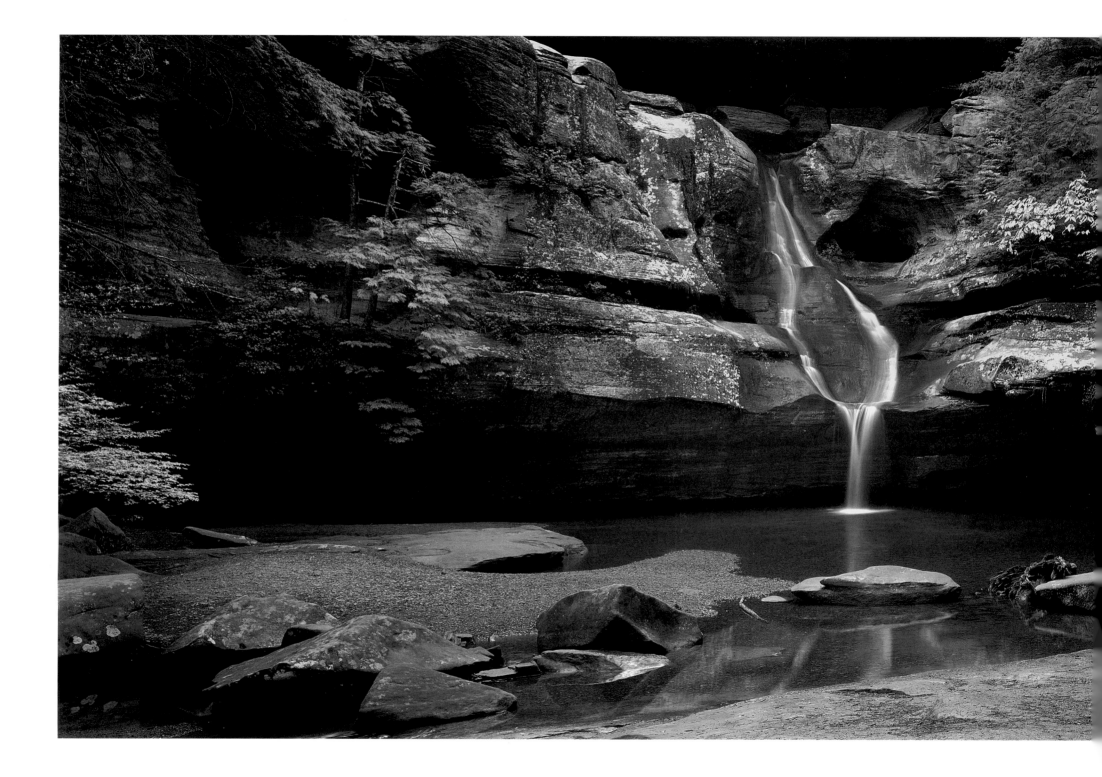

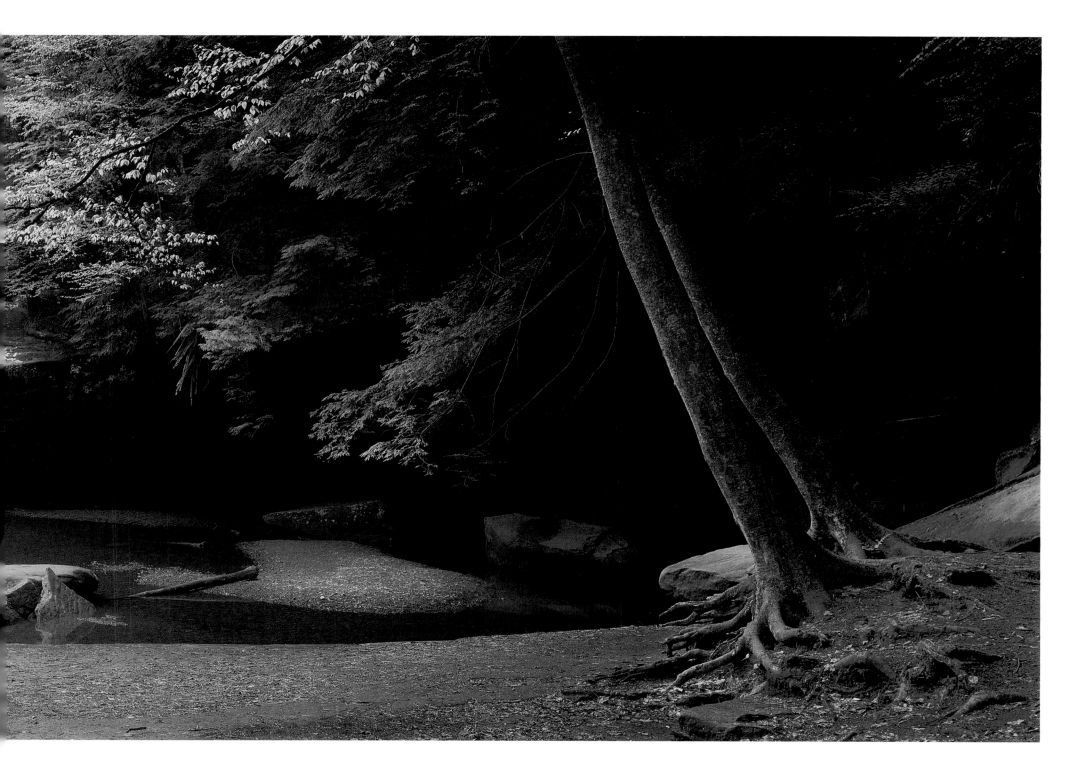

Once you've committed to a goal, the power will begin to flow into your life. ROBERT H. SCHULLER

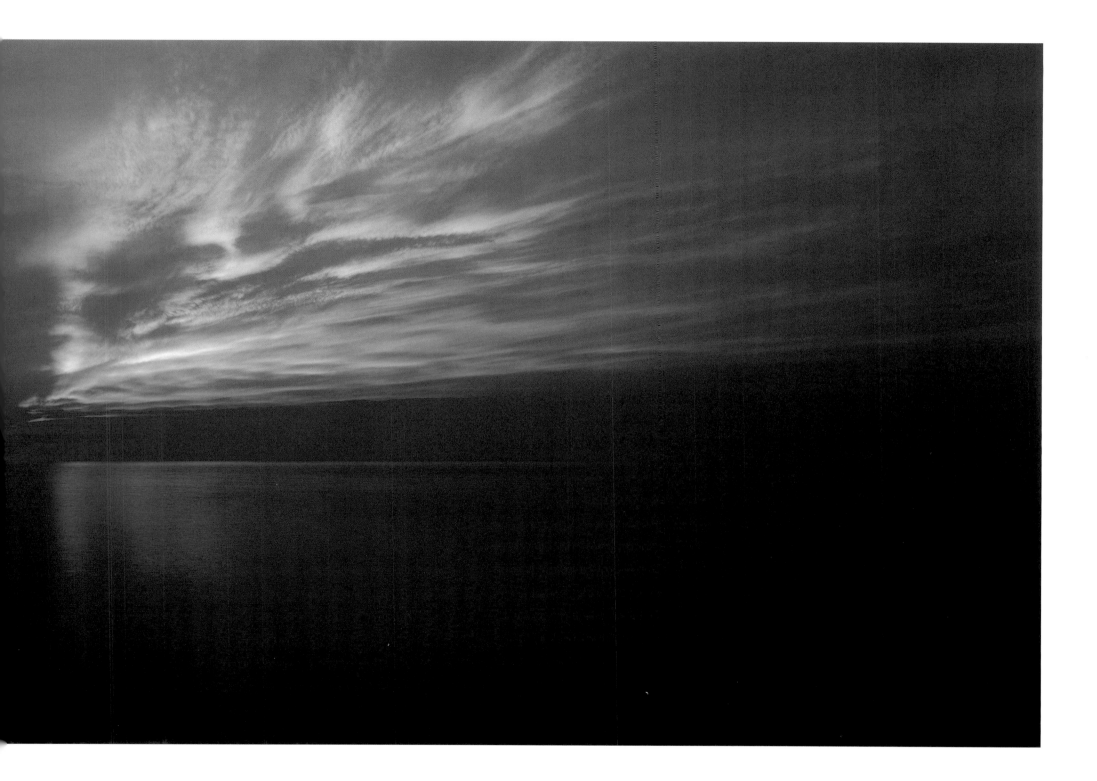

People who walk the walk of faith always expect a breakthrough. ROBERT H. SCHULLER **97**

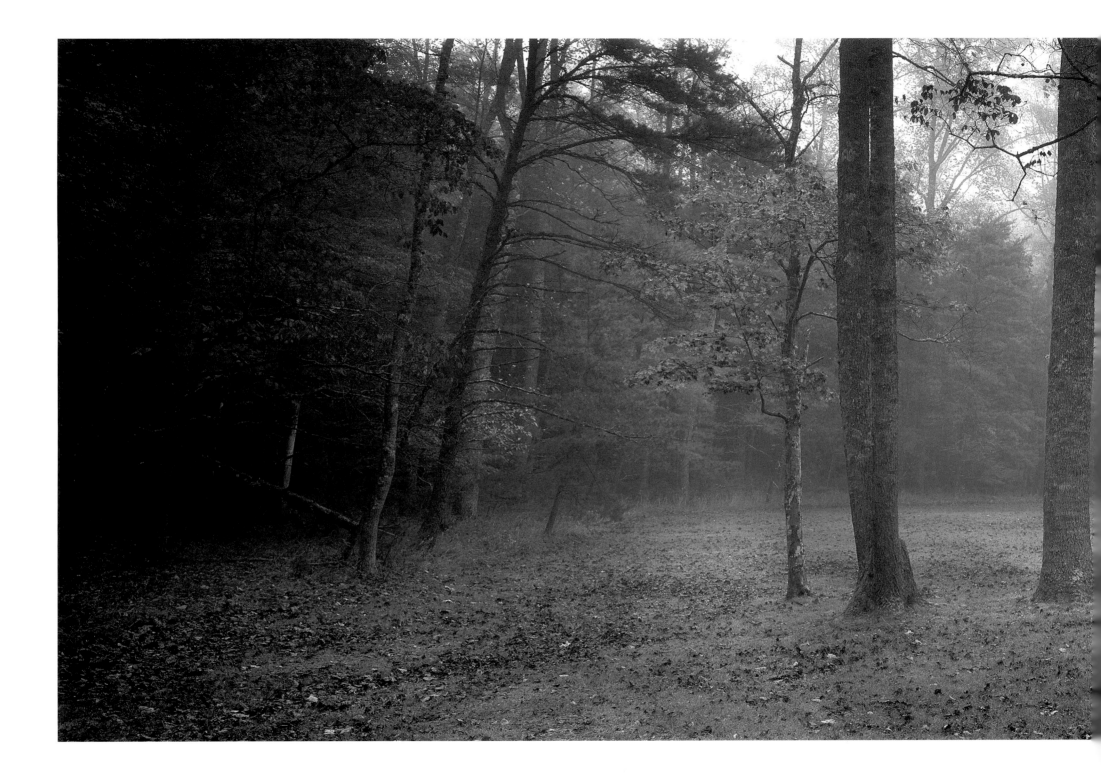

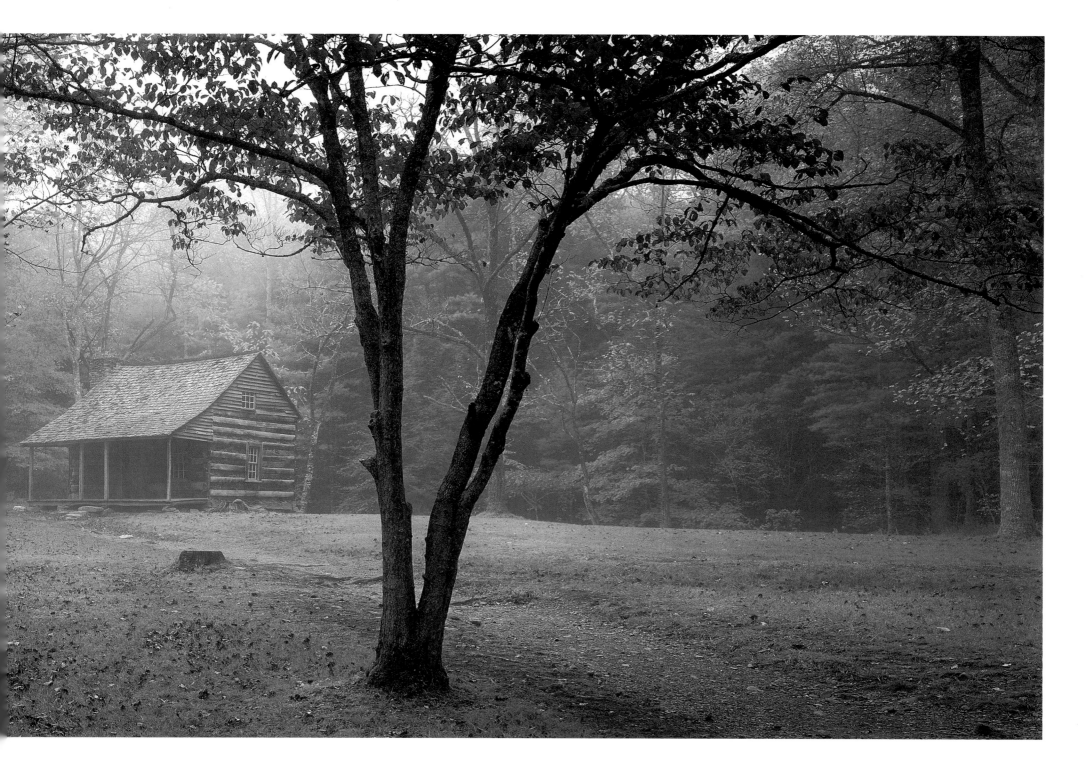

People who never take a chance never get ahead. ROBERT H. SCHULLER **99**

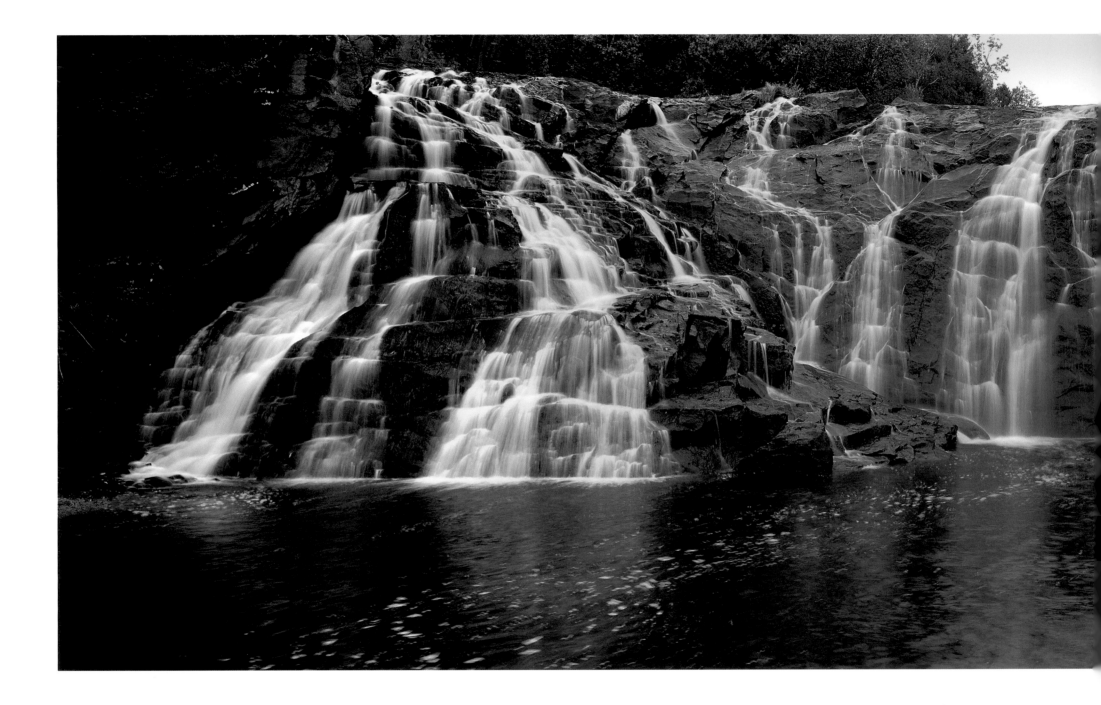

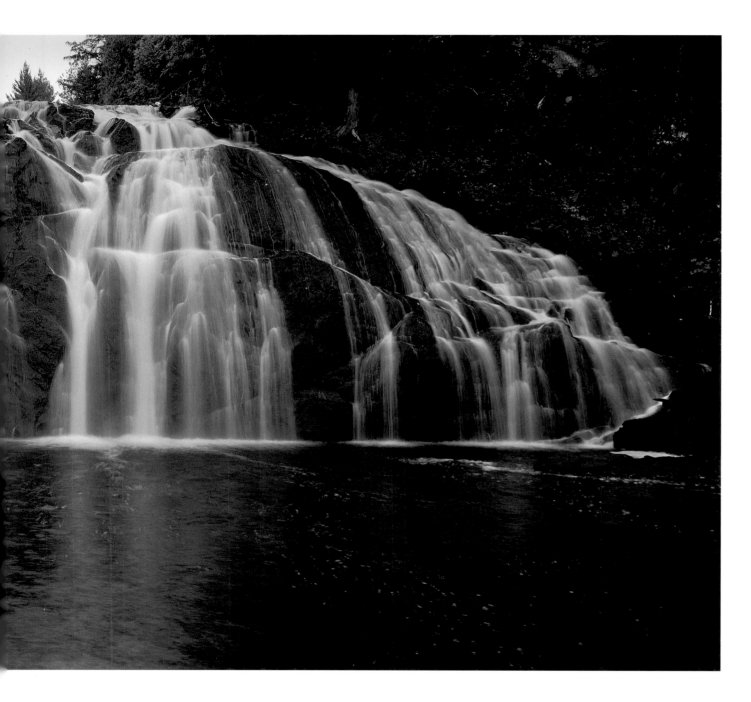

For I am persuaded that neither death nor life,
nor angels nor principalities nor powers,
nor things present nor things to come,
nor height nor depth, nor any other created thing,
shall be able to separate us
from the love of God which is in Christ Jesus our Lord.

ROMANS 8:38-39

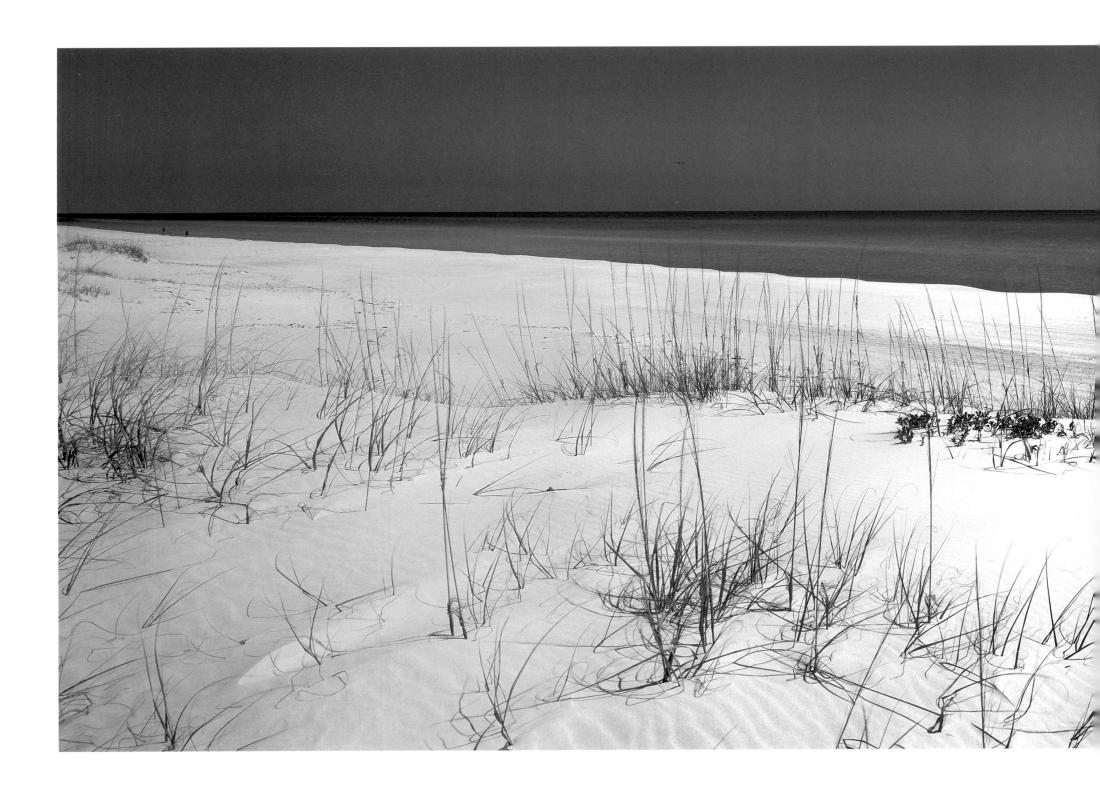

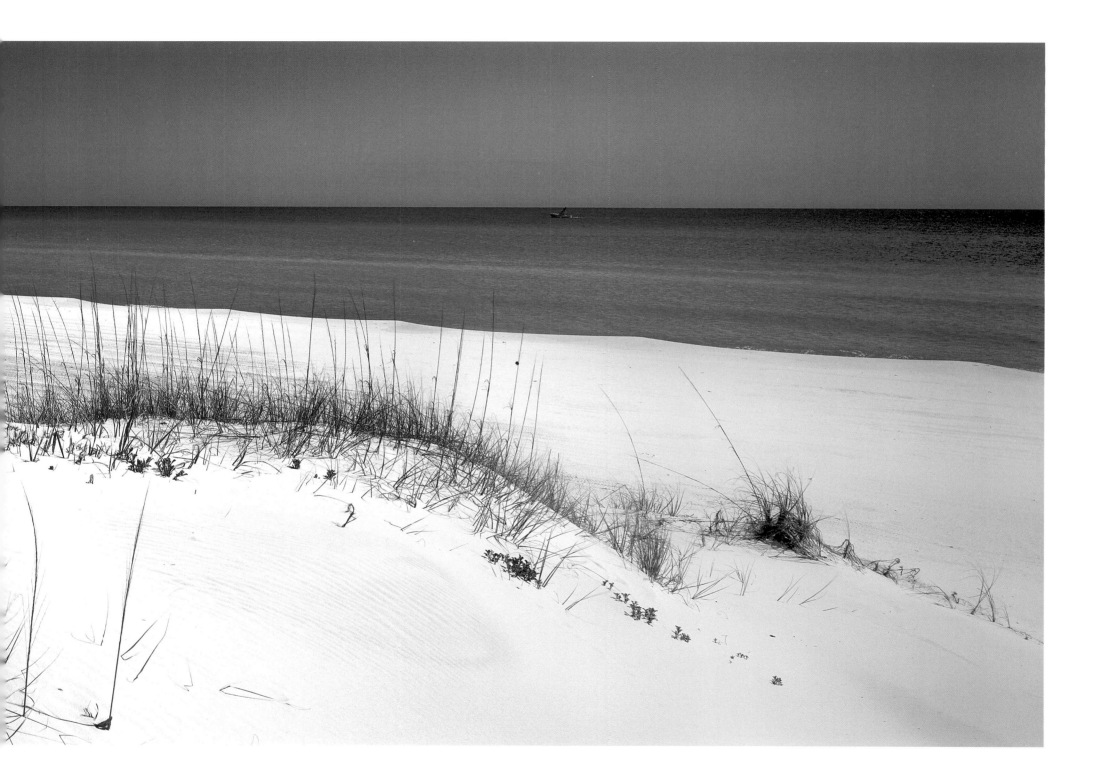

God matches the dreams to the dreamers. ROBERT H. SCHULLER **103**

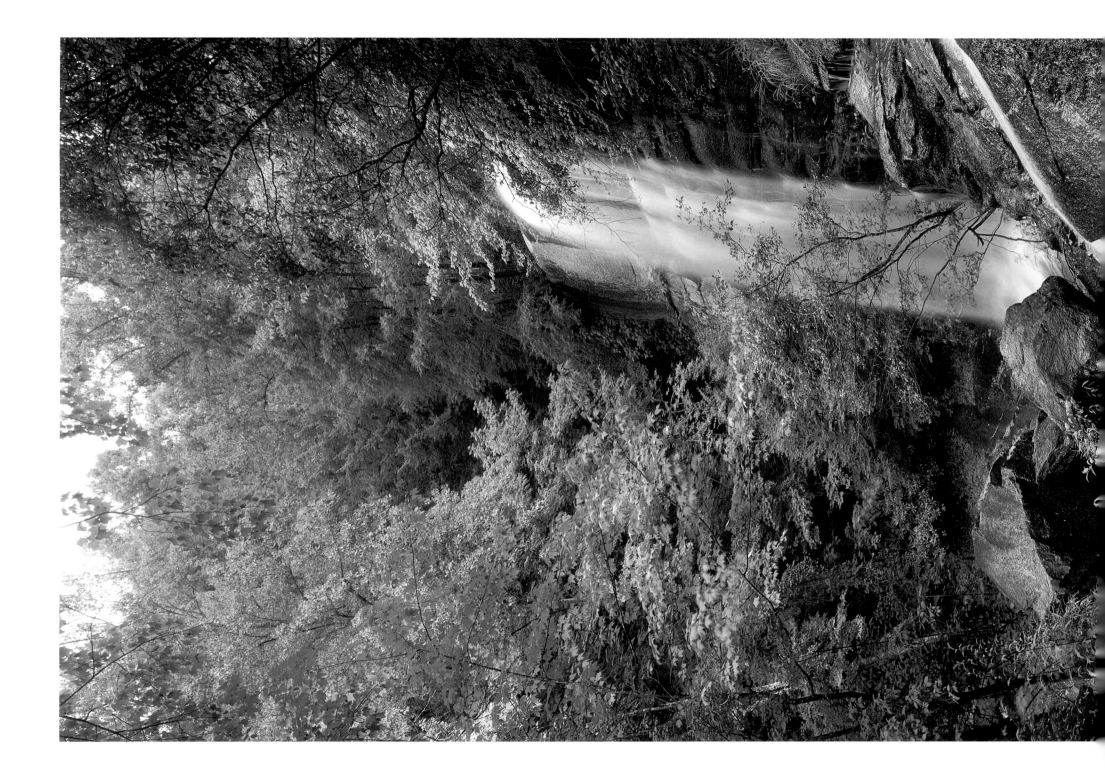

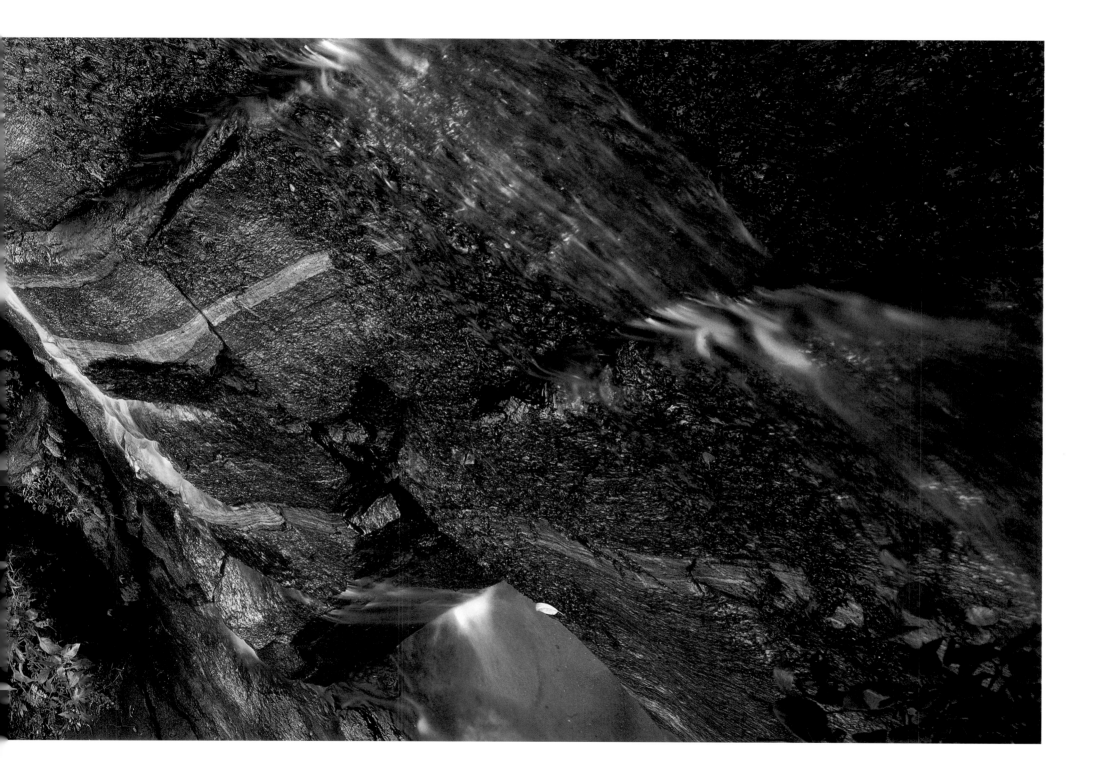

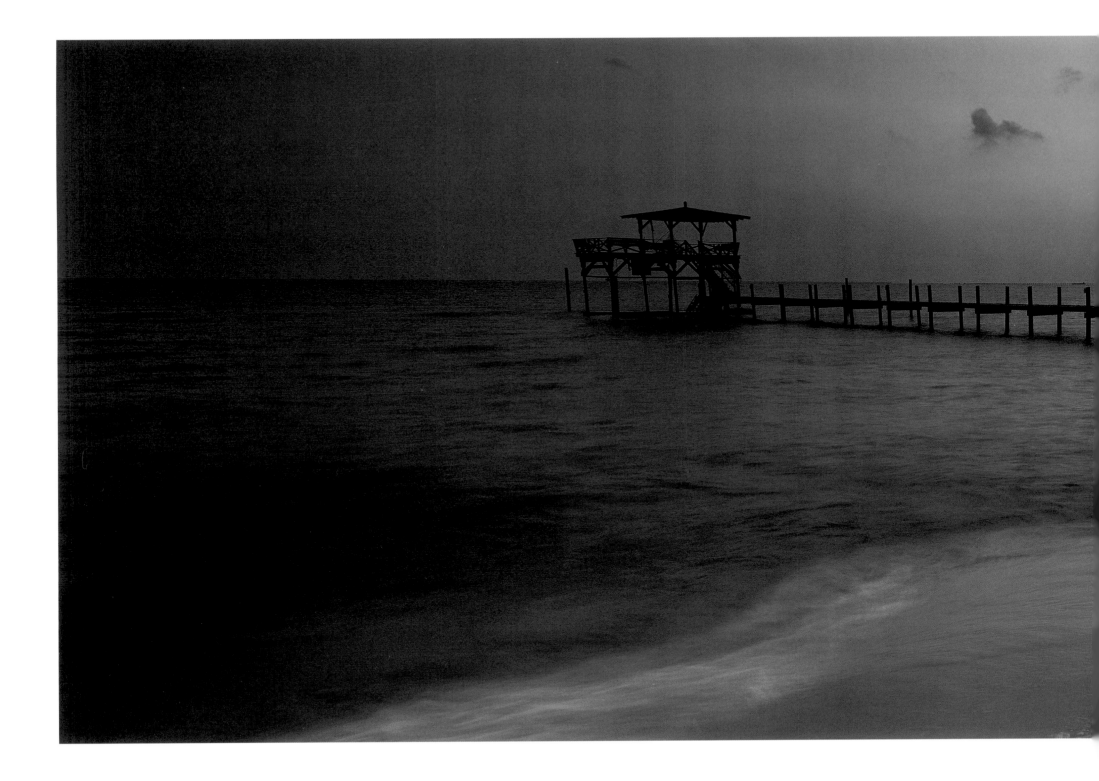

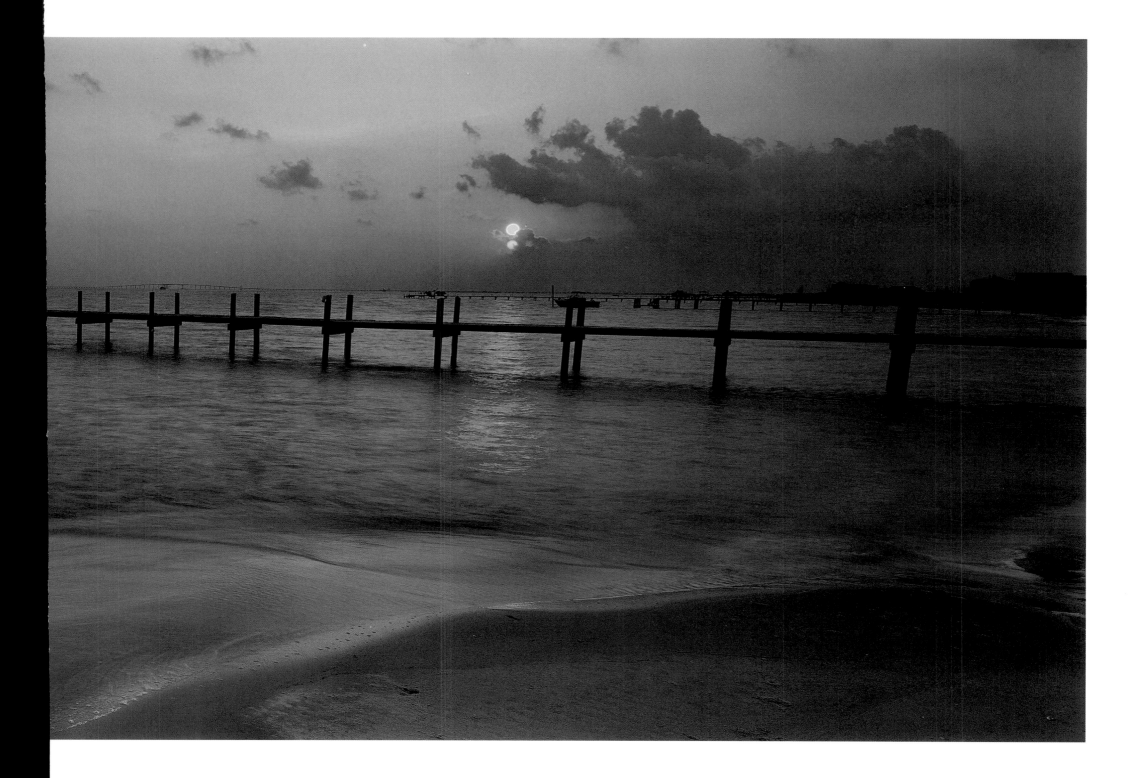

Look for the light behind every shadow. ROBERT H. SCHULLER **107**

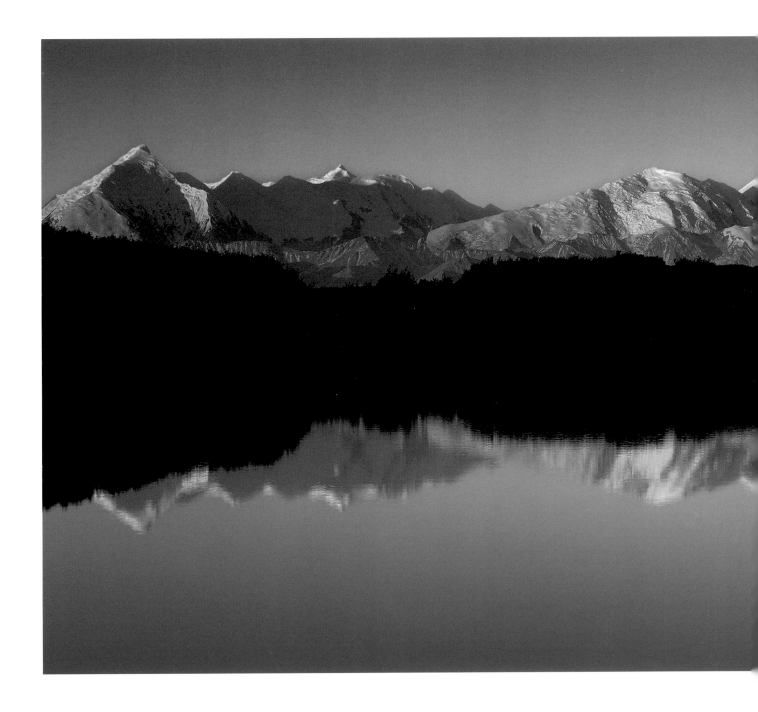

The works of the LORD are great,
Studied by all who have pleasure in them.
His work is honorable and glorious,
And His righteousness endures forever.
He has made His wonderful works to be remembered;
The LORD is gracious and full of compassion.
PSALM 111:2-4

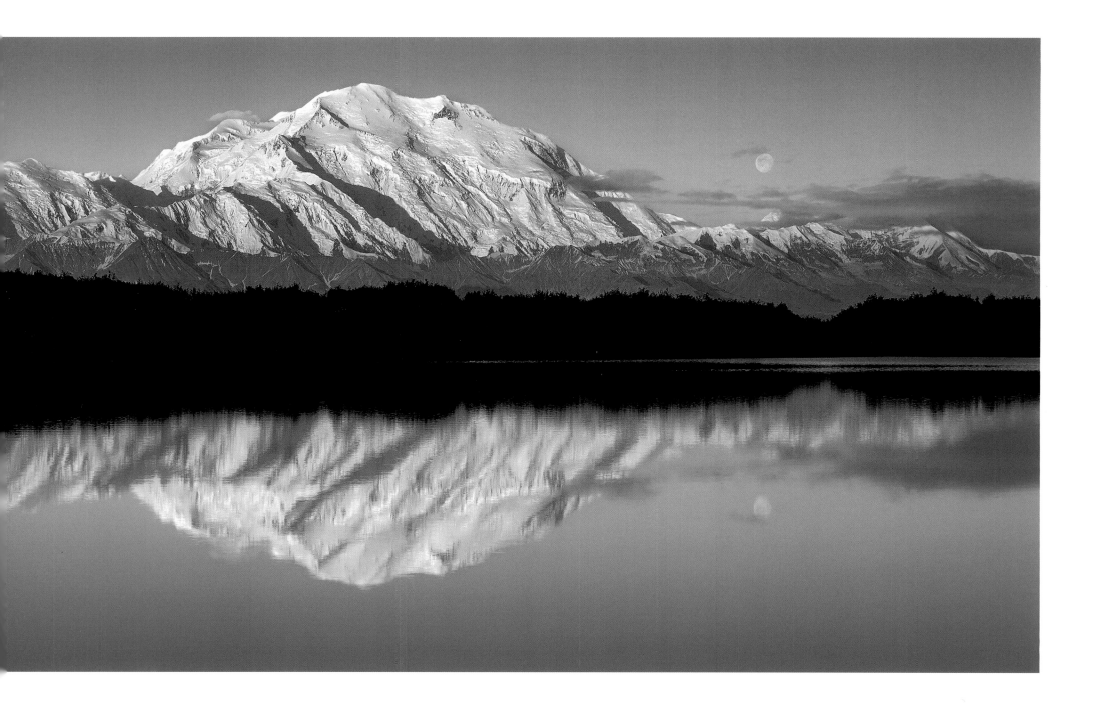

You can often measure a person by the size of their dream. ROBERT H. SCHULLER **109**

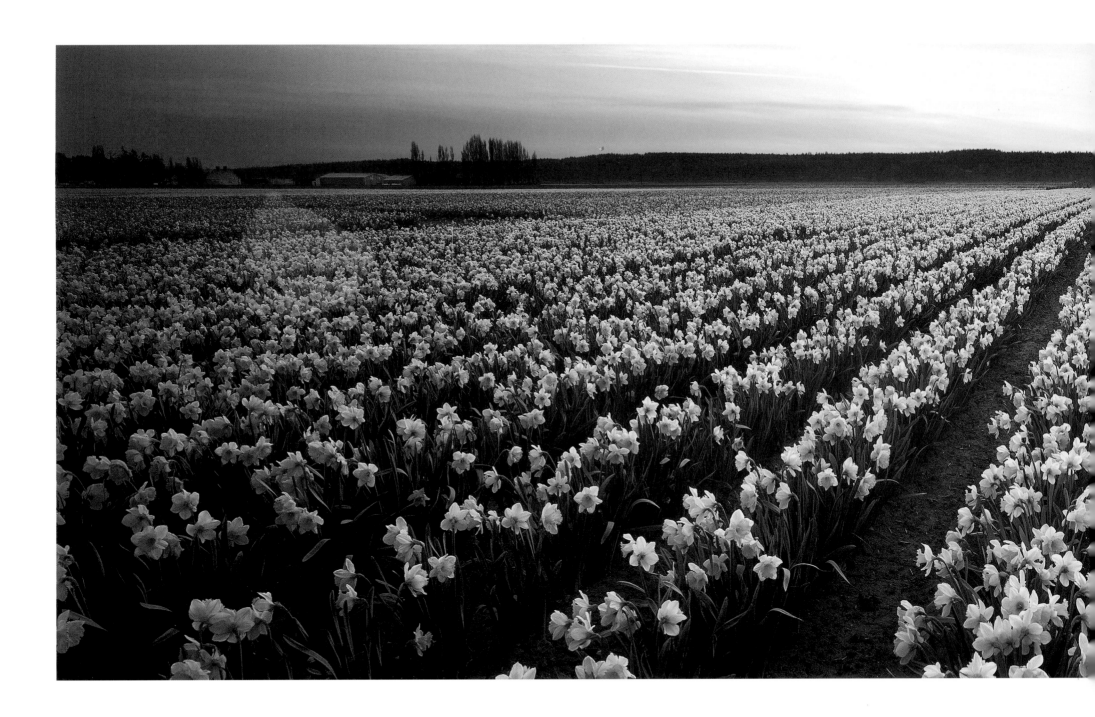

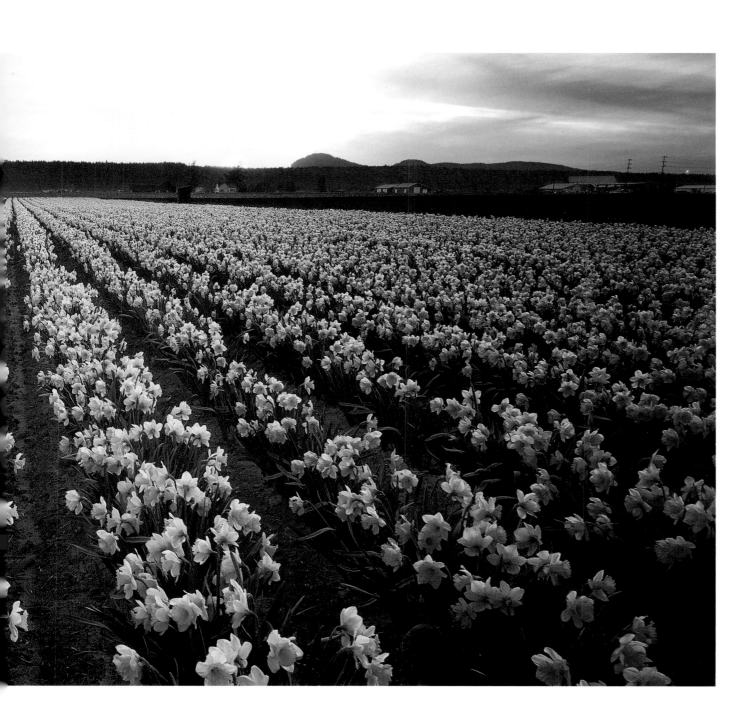

Now may the God of hope fill you
with all joy and peace in believing,
that you may abound in hope
by the power of the Holy Spirit.
ROMANS 15:13

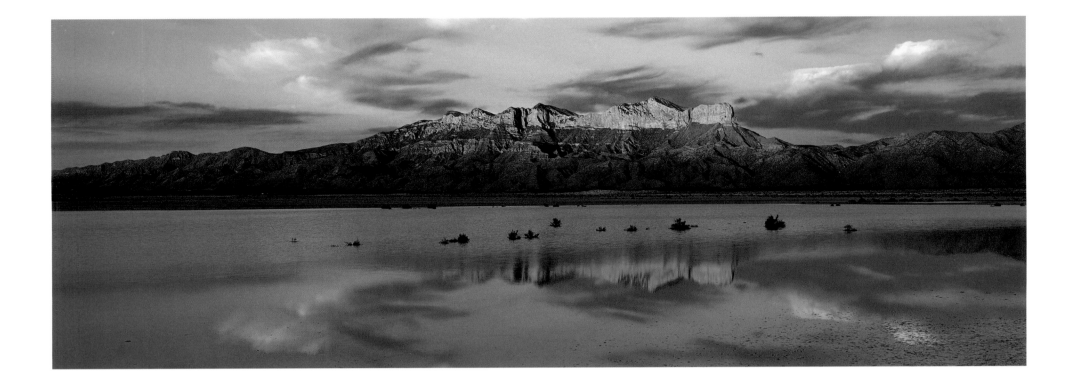

Out of Control

To be perfectly honest, sometimes when I'm looking for photos I don't have a clue where I'm going. Preparation helps prevent desperation to a certain extent, as I have learned from long experience. I do as much research as I can beforehand and try to have a plan. But quite often it's just not enough. Such was the case with this photo of Guadalupe Mountains.

When I arrived in Texas I was intending to head for Big Bend National Park, but for some reason I felt led to go in the opposite direction and take a look at the Guadalupe Mountains. As I drove into the area, I discovered the salt plains alongside the highway. Rain earlier in the week had filled them with water, which is apparently a rare event. I thought if only conditions were better there could be the makings of a good shot. But the light that day was bland, and to top things off it was blowing a gale. I drove all around the area looking for a better view of the mountains, but was drawn back to the muddy salt plains even though I knew a great photo would be impossible in such a wind. The weather forecast was for even stronger winds. Still I felt like I should wait and see what would happen.

The wind kept blowing but I decided to set up for the shot – just in case. To get into position I had to walk hundreds of yards through the muddy lake and whenever I stopped walking I would sink into the mud. I looked around for something to stand on and at the edge of the lake found a big old sign that I was able to use as a footing to stop me from sinking right down into the mire. As I waited there for hours, people driving past on the highway nearby honked their horns and waved. Floating there on a big tin sign in the middle of a muddy lake with the wind howling around me, I imagined they thought I was completely crazy. But through it all, I felt a peace that something good was going to happen.

With only half an hour of light left, still nothing had eventuated, but I waited and watched the clouds drifting in the sky above. The wind was still raging but it seemed to me that perhaps God was working on a cloud composition just for my photograph. Then just minutes before sunset, when the light was rich and golden, the clouds moved into perfect position. Suddenly the wind abated and the lake grew still just long enough for me to take this shot. Moments later the wind returned with a vengeance and the light was lost in the clouds.

I was in awe of my wonderful God who had created such a beautiful scene before me and given me this precious moment. All I had to do was click the shutter. It's okay for us to be out of control, as long as we give God the right to be in control! God is often working on bigger pictures than we can see and our role is simply to stand still and let Him work.

When we feel God has led us to a place, it's important that we don't leave without the blessing. Sometimes we can feel isolated and silly, slowly sinking in the mud of our own thoughts. But if we will be still and wait, God will bring together the right elements and we will receive the blessing He has for us.

For since the creation of the world
His invisible attributes are clearly seen,
being understood by the things that are made,
even His eternal power and Godhead,
so that they are without excuse.

ROMANS 1:20

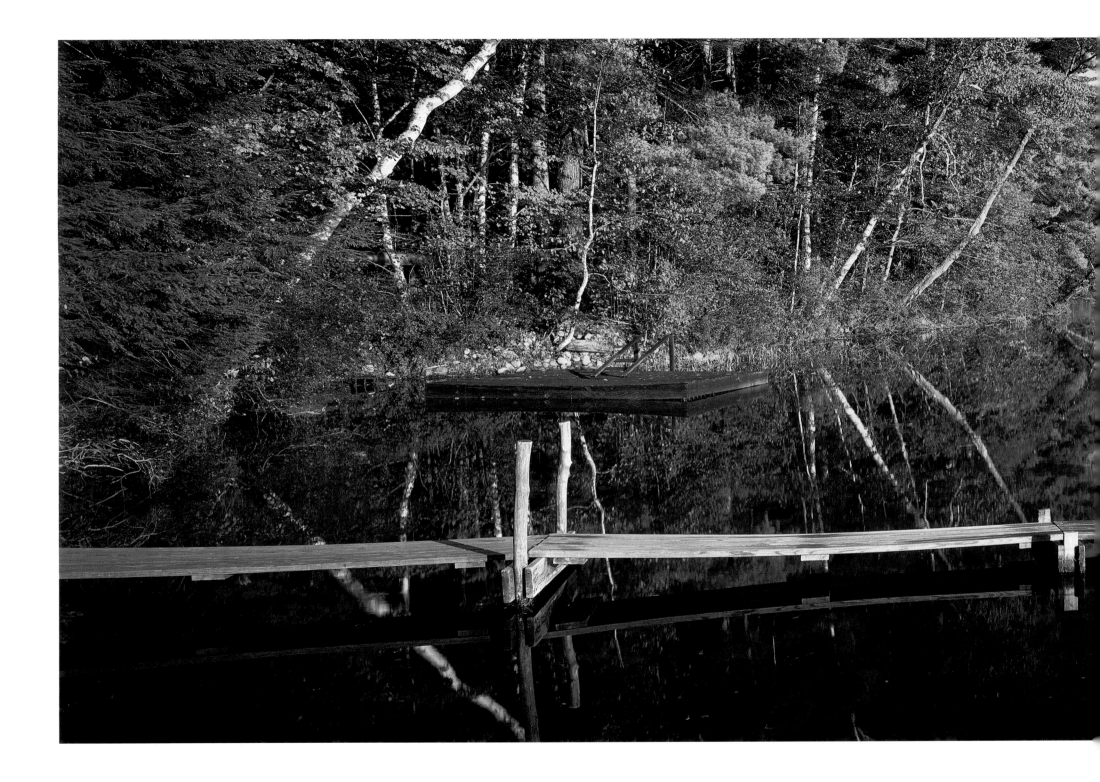

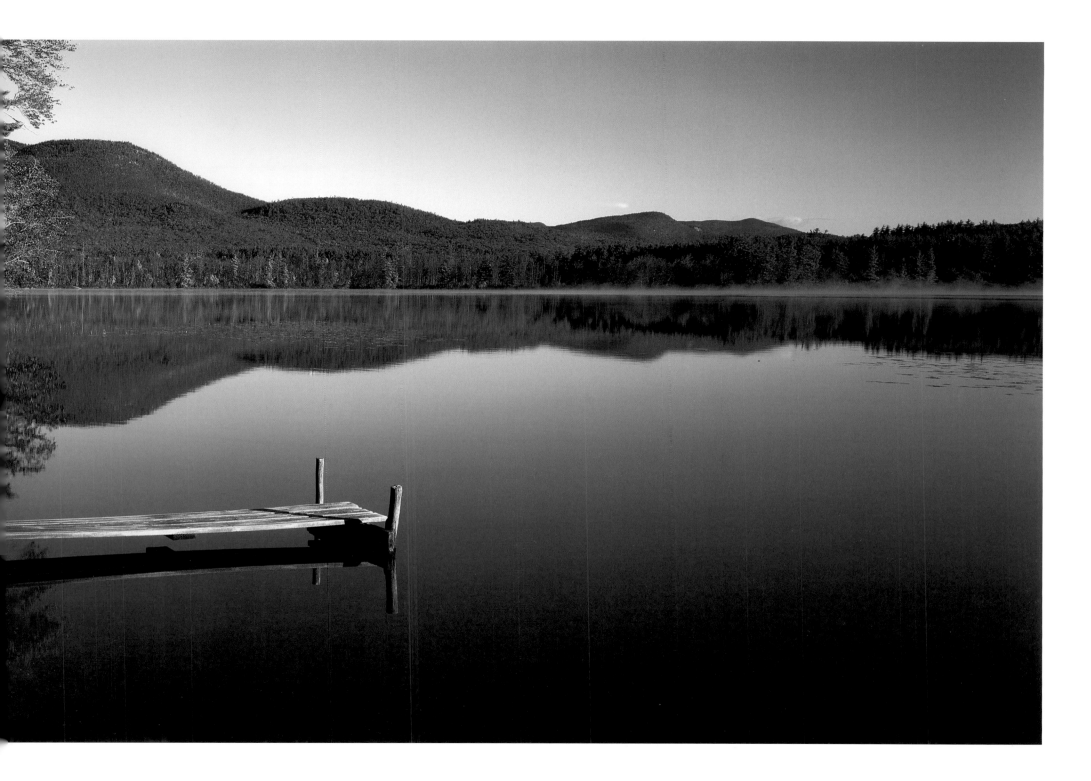

Blessed are those whose dreams are shaped by their hopes – not by their hurts. ROBERT H. SCHULLER **115**

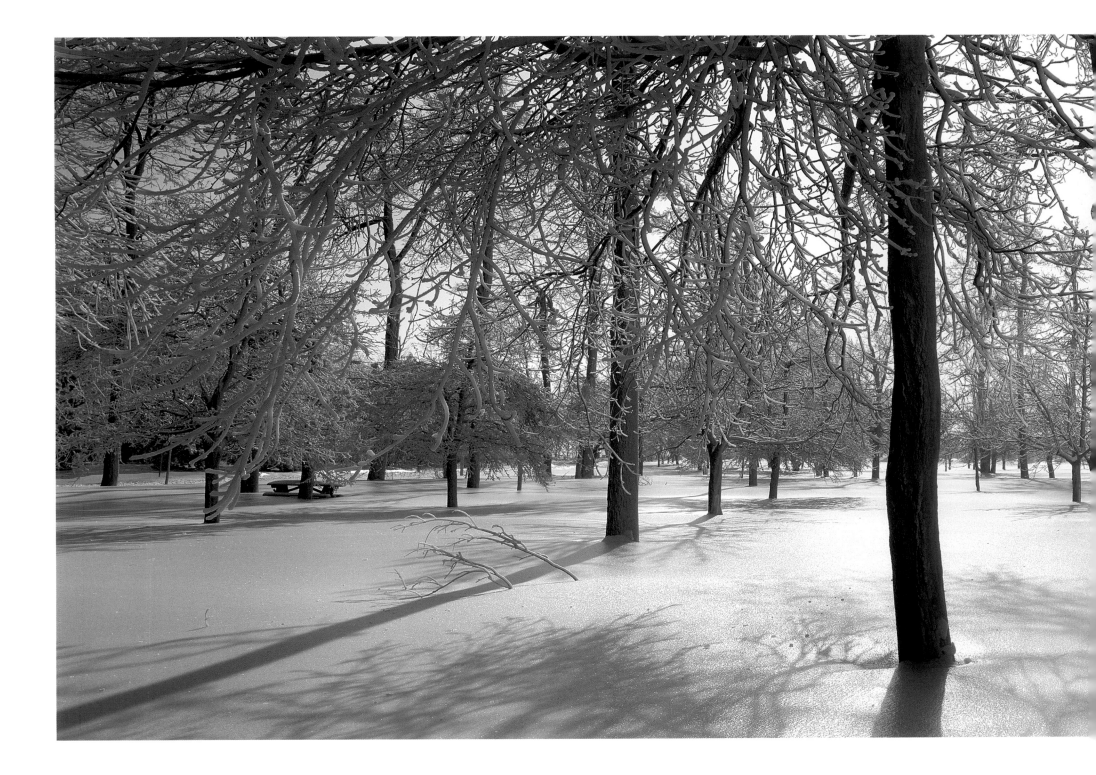

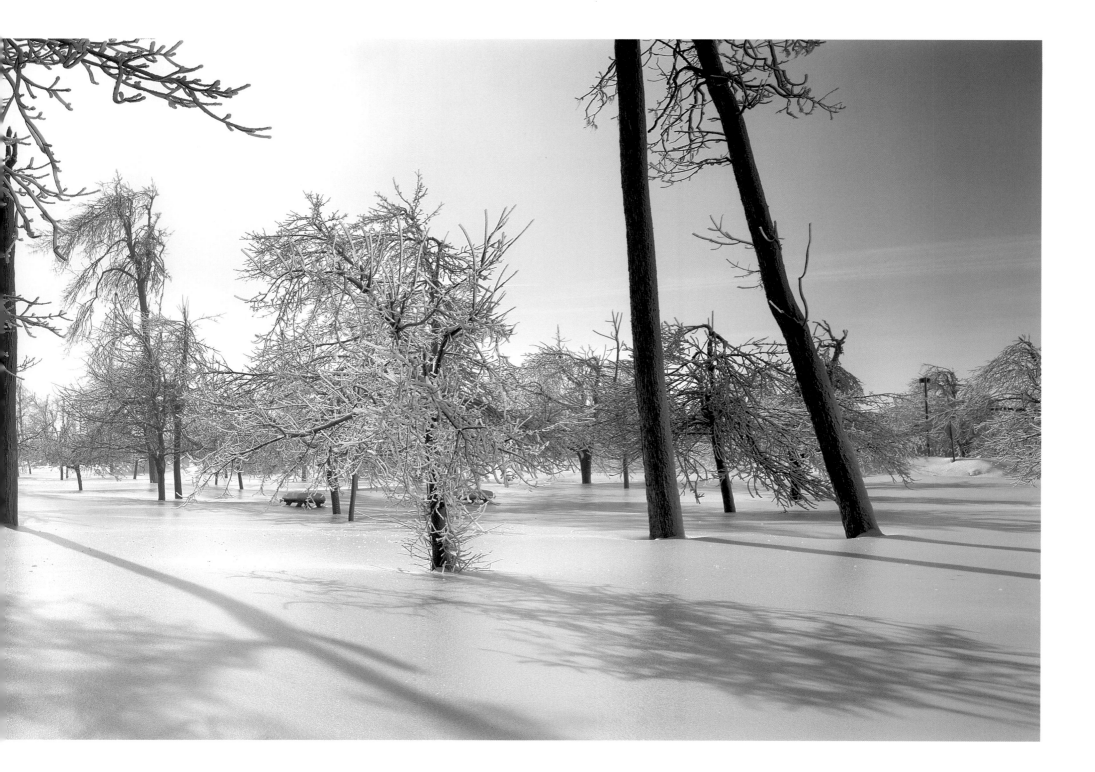

Resentments are snowdrifts and forgiveness is the snowplow.

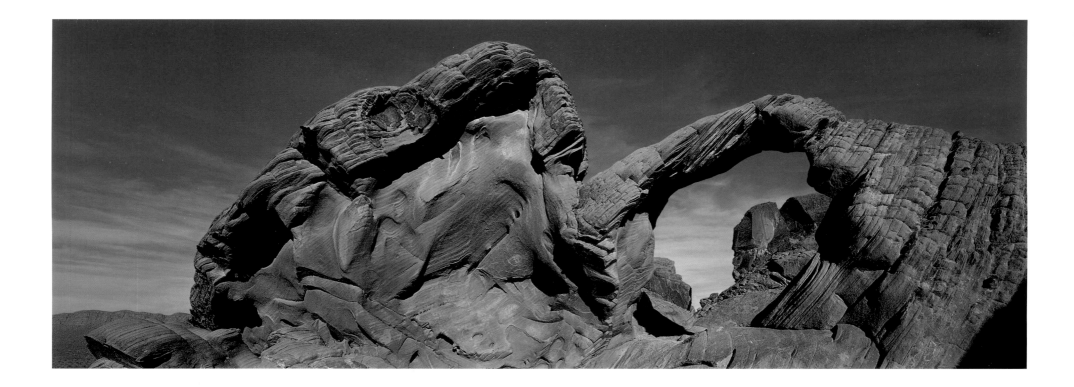

My brethren, count it all joy when you fall into various trials,
knowing that the testing of your faith produces patience.
But let patience have its perfect work,
that you may be perfect and complete, lacking nothing.

JAMES 1:2-4

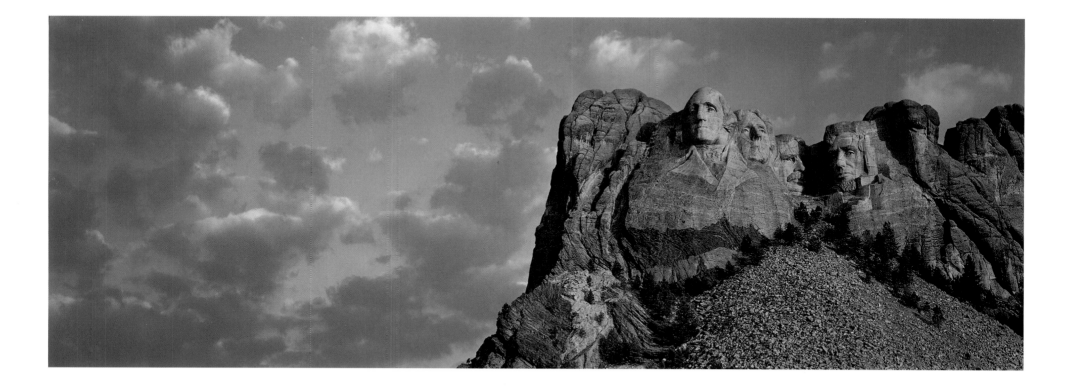

Let love be without hypocrisy.
Abhor what is evil. Cling to what is good.
Be kindly affectionate to one another with brotherly love,
in honor giving preference to one another;
not lagging in diligence, fervent in spirit, serving the Lord.

ROMANS 12:9-11

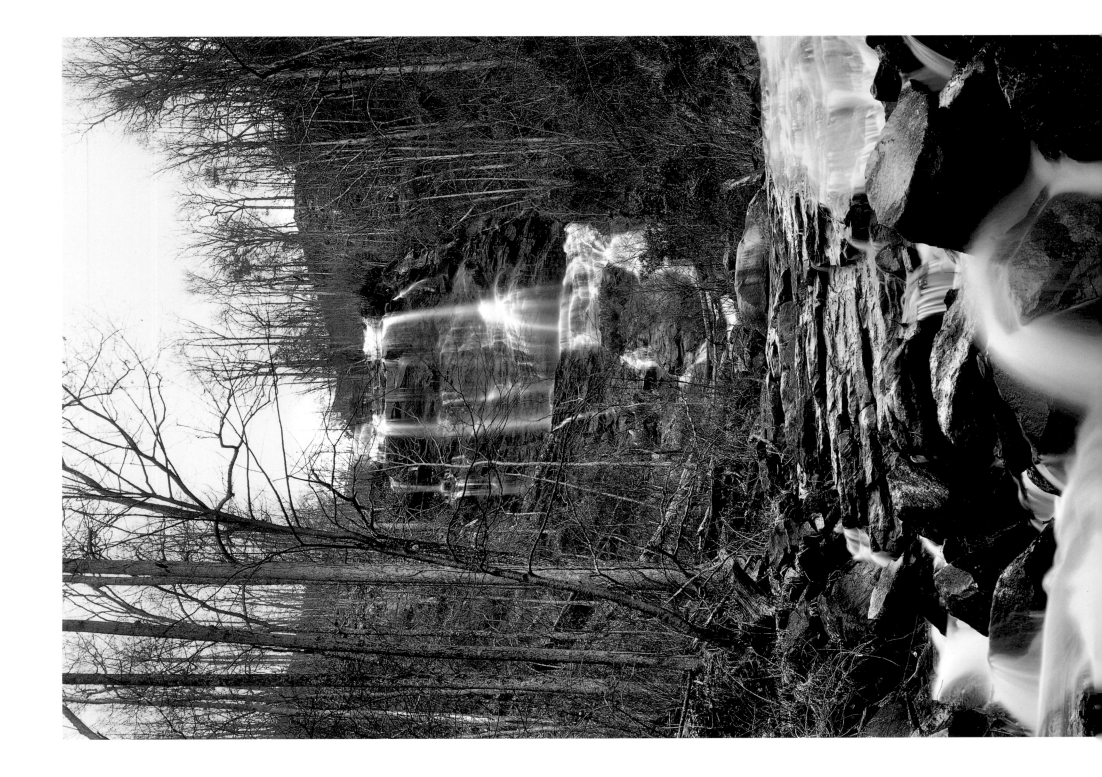

AMICALOLA FALLS, CHATTAHOOCHEE NATIONAL FOREST, GEORGIA

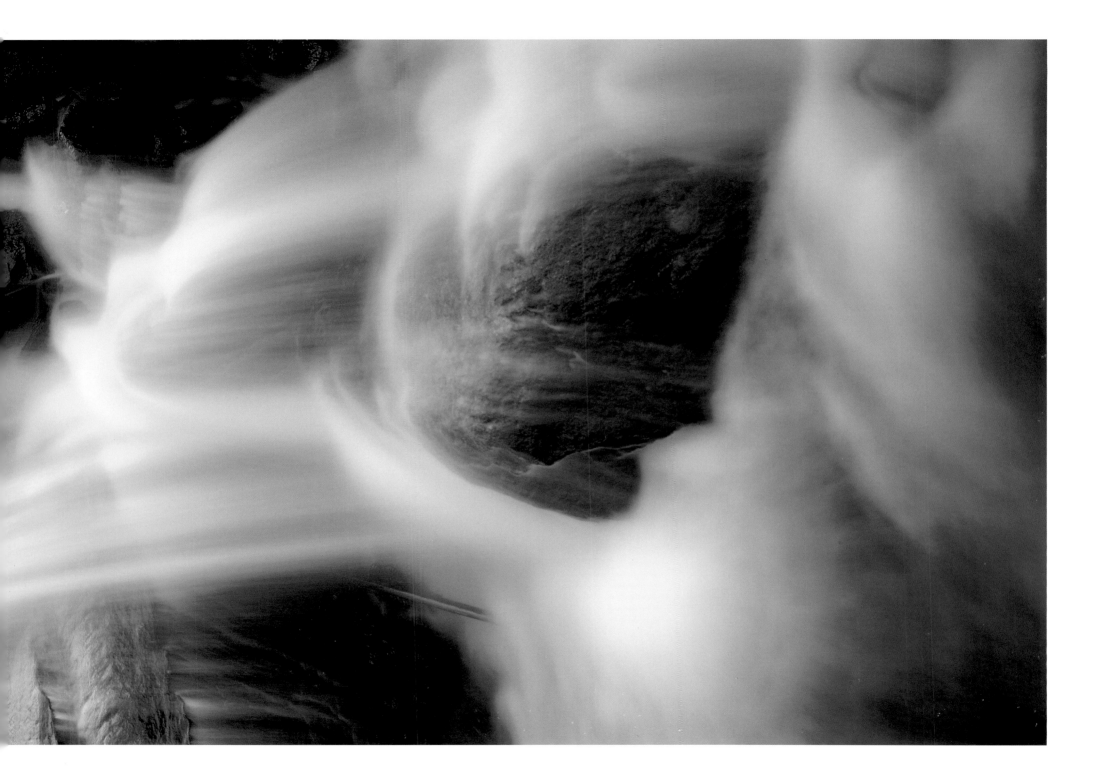

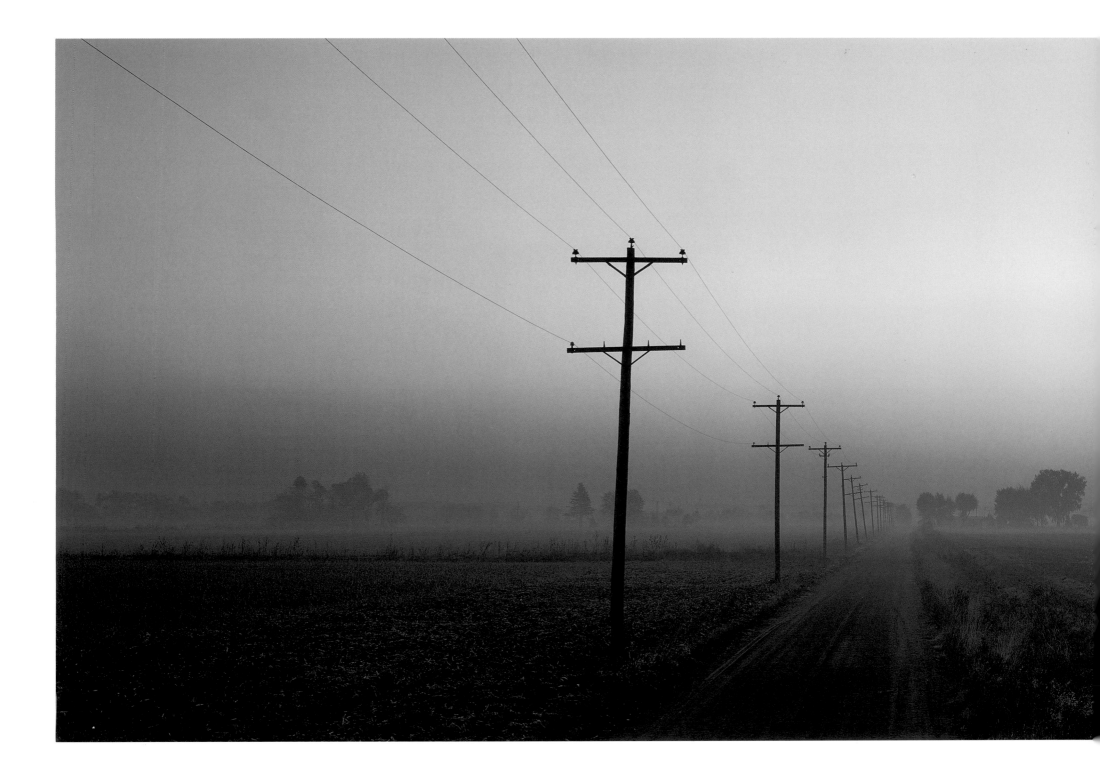

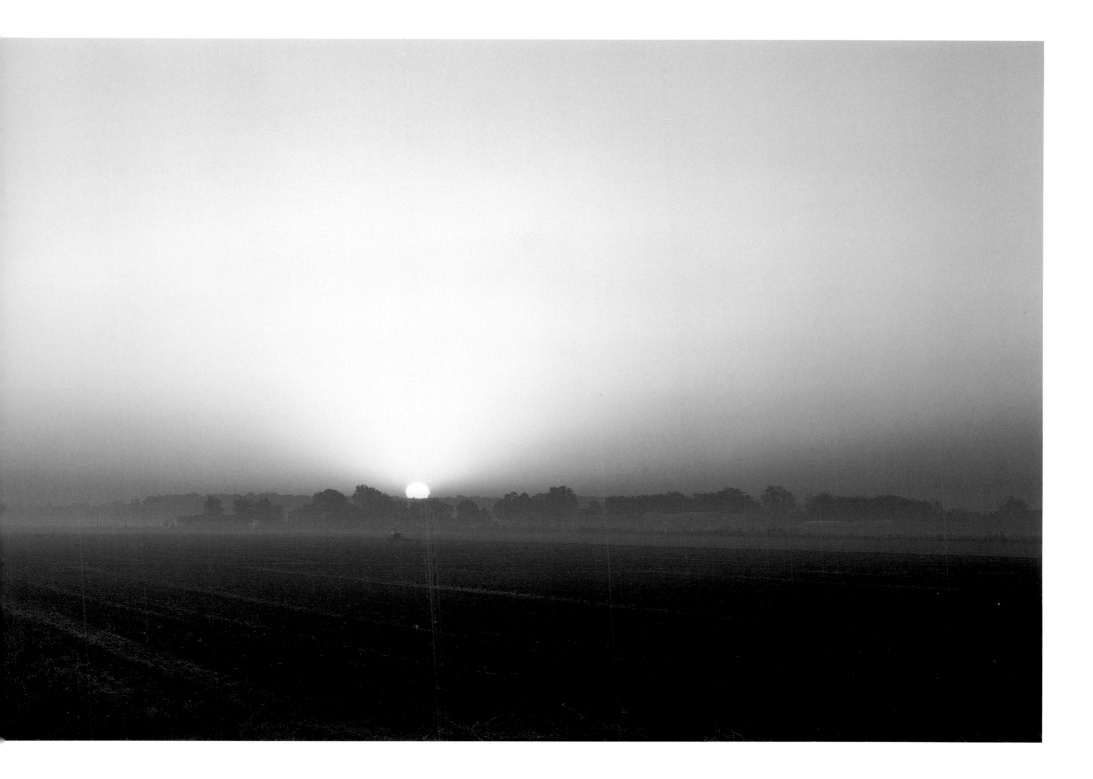

Winning starts with beginning! ROBERT H. SCHULLER **123**

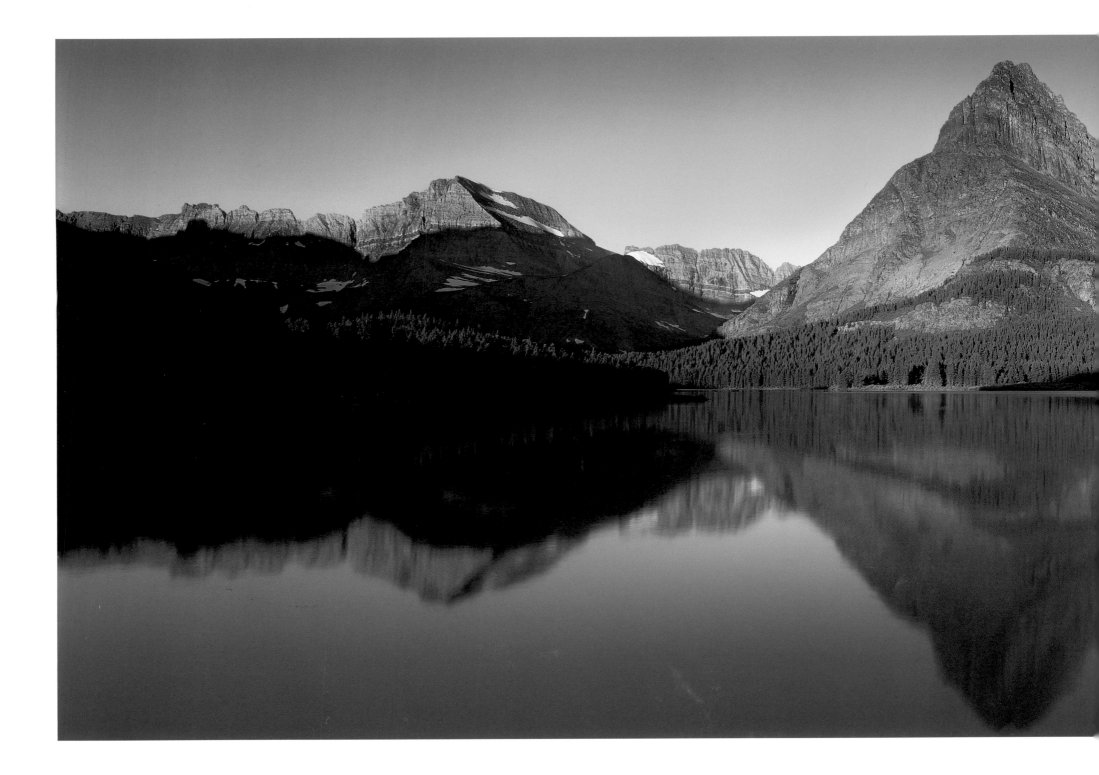

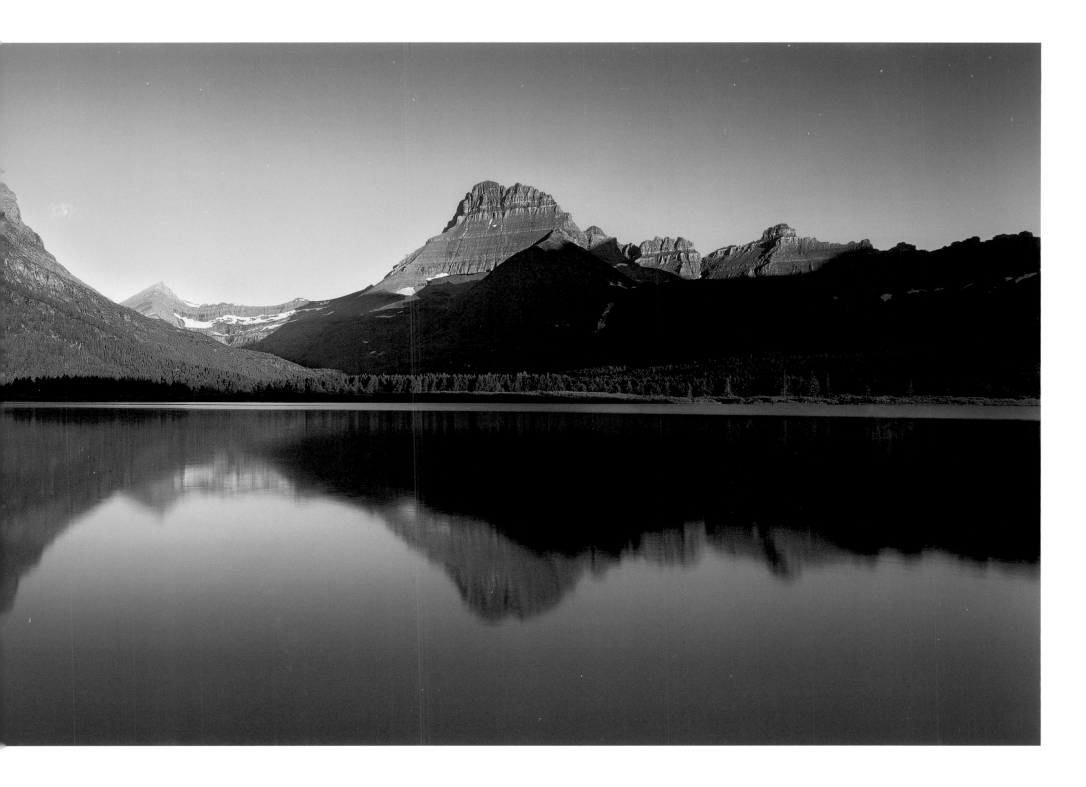

God gives endurance to match encounters.

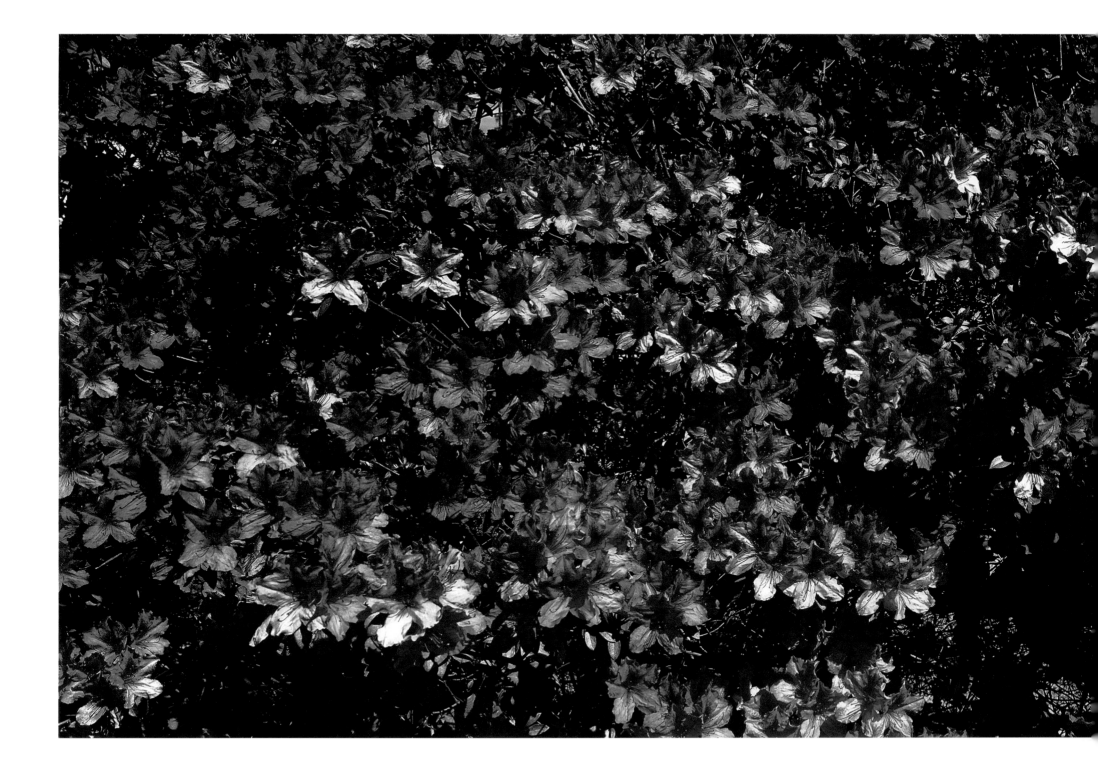

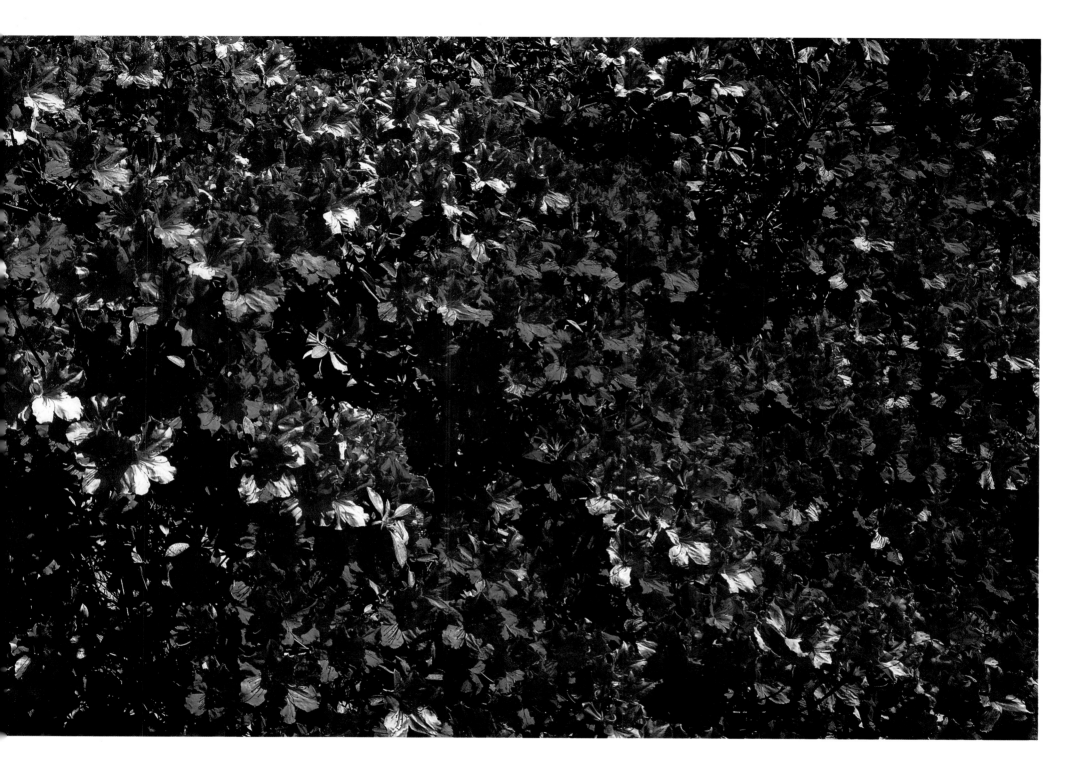

The only joy of living is the joy of giving. ROBERT H. SCHULLER **127**

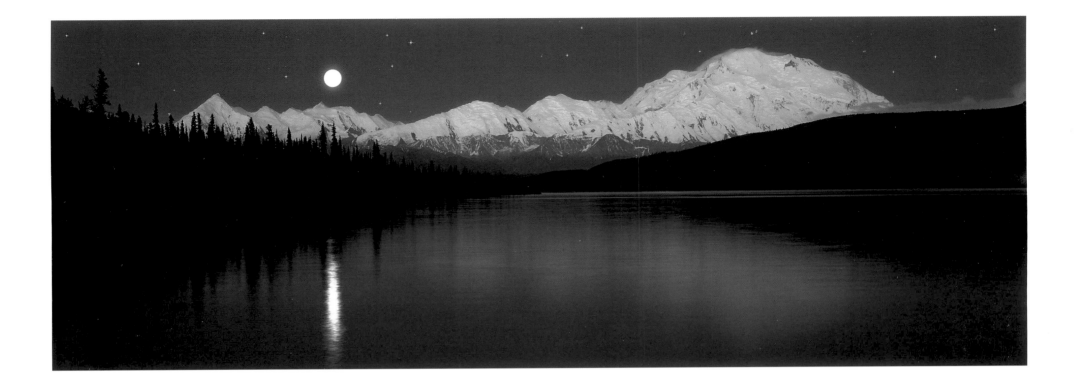

Reach for the Stars

No adventure begins until the adventurers leave the sanctuary of their own harbor. In doing so they open themselves up to great risk. Their quest may cost them everything they have. And yet, how greatly the world is enriched by those who dare to venture beyond the comfort of what is already known.

If Christopher Columbus had not ventured beyond the safety of his known world, America would not have been discovered. The common belief of his day was that the earth was flat – a careless mariner, it was thought, could sail right off its edge, to the destruction of both ship and crew. When Columbus made public his intention to prove the world was round, he was ridiculed by many whose beliefs were being challenged. But some, who also dared to dream, would no doubt have been excited that a man was willing to follow his heart. I marvel at the courage of Columbus in setting off into the unknown on his quest for knowledge – urged on by just a few dreamers and belittled by many who doubted his sanity. History eventually vindicated him, but he had to endure the hardship that often comes with being an innovator.

On February 1st 2003, families, friends and interested bystanders waited as the astronauts on board the space shuttle Columbia prepared to return to Earth from space. As excitement grew in anticipation of their imminent arrival, tragedy suddenly struck. The space shuttle broke up on re-entry into the Earth's atmosphere and all seven people on board were killed. As the tragic news shook the world it reminded us all of the great cost of pioneering new frontiers. Those men and women had assumed great risk in their service to humanity and had paid the ultimate price.

In an address to the American people, President George Bush stated, "In an age when space flight has come to seem almost routine, it is easy to overlook the dangers of travel by rocket, and the difficulties of navigating the fierce outer atmosphere of the Earth. These astronauts knew the dangers, and they faced them willingly, knowing they had a high and noble purpose in life. Because of their courage and daring and idealism, we will miss them all the more. All Americans today are thinking, as well, of the families of these men and women who have been given this sudden shock and grief. You are not alone. Our entire nation grieves with you. And those you loved will always have the respect and gratitude of this country. The cause in which they died will continue. Mankind is led into the darkness beyond our world by the inspiration of discovery and the longing to understand. Our journey into space will go on. In the skies today we saw destruction and tragedy. Yet farther than we can see there is comfort and hope. In the words of the prophet Isaiah, "Lift your eyes and look to the heavens. Who created all these? He who brings out the starry hosts one by one and calls them each by name. Because of His great power and mighty strength, not one of them is missing.'

The same Creator who names the stars knows all our hopes and dreams. Let us take our lead from those seven brave souls aboard the Columbia and dare to dream still. Let us take up our courage, breaking down the walls of our earthly limitations, that we too may reach for the stars.

Lift up your eyes on high,
And see who has created these things,
Who brings out their host by number;
He calls them all by name,
By the greatness of His might,
And the strength of His power;
Not one is missing.

ISAIAH 40:26

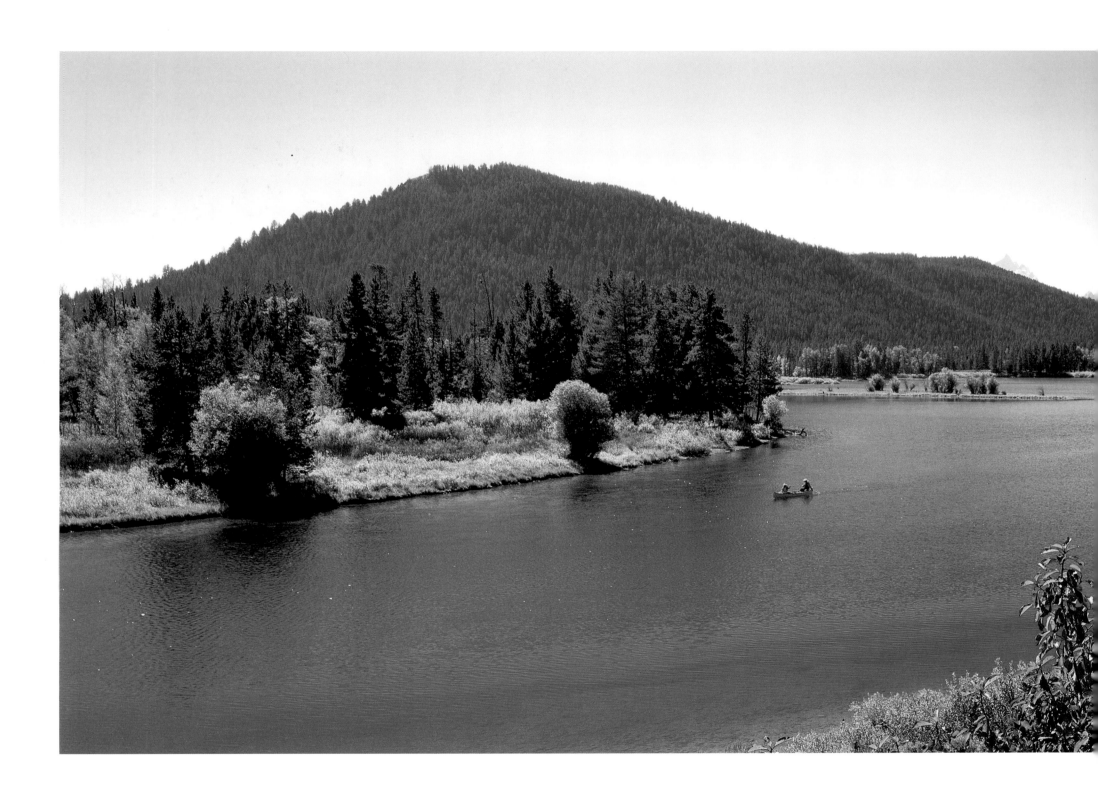

Let your worry drain out and let God's peace flow in. ROBERT H. SCHULLER **131**

Who is like You, O LORD, among the gods?
Who is like You, glorious in holiness,
Fearful in praises, doing wonders?
EXODUS 15:11

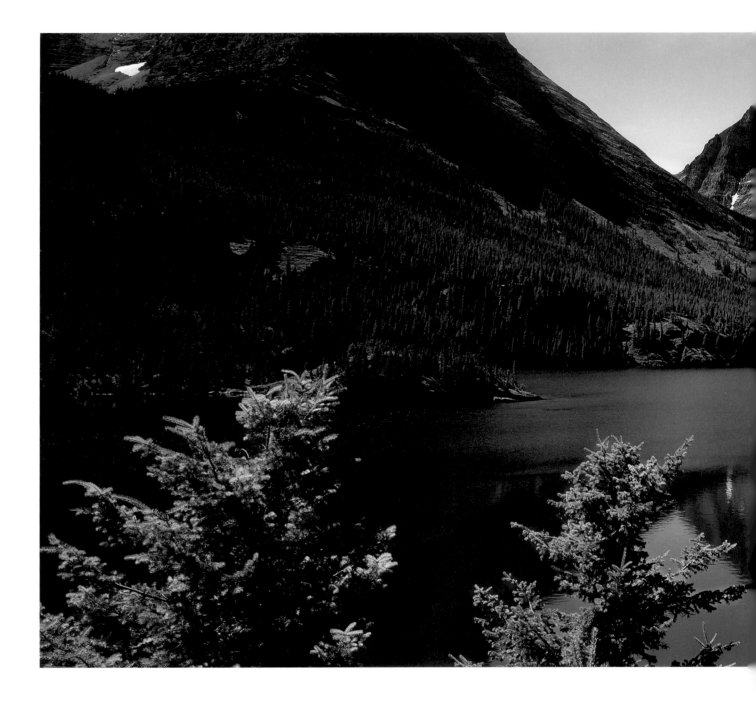

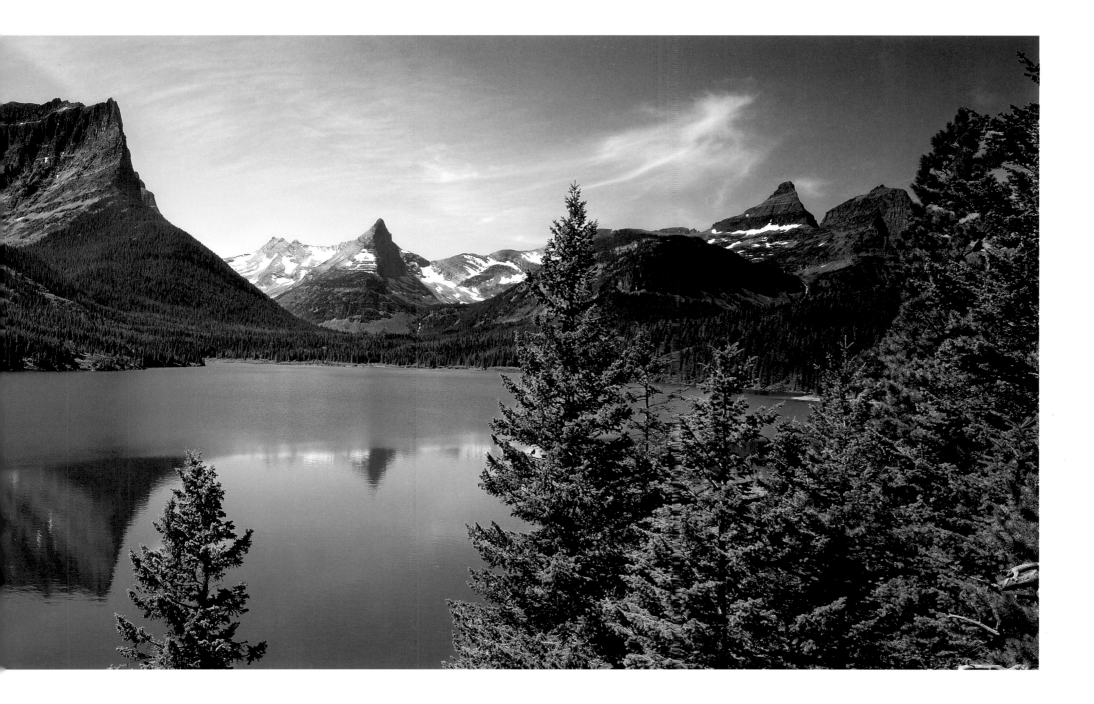

Look for the good, and you will find it. ROBERT H. SCHULLER **133**

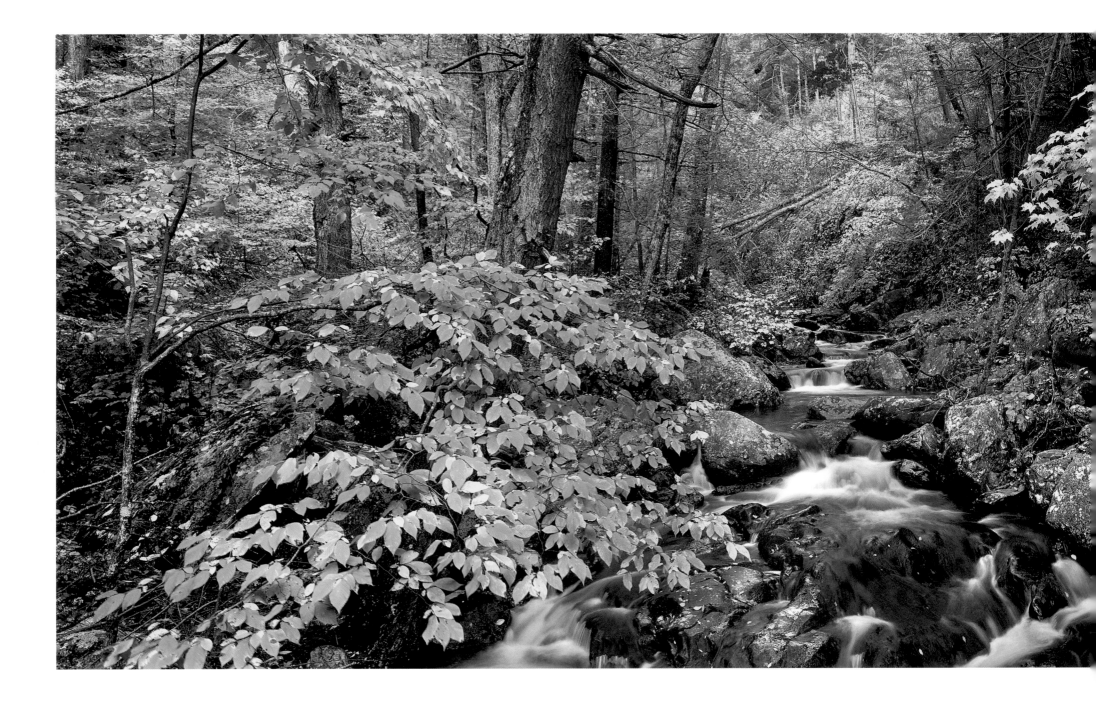

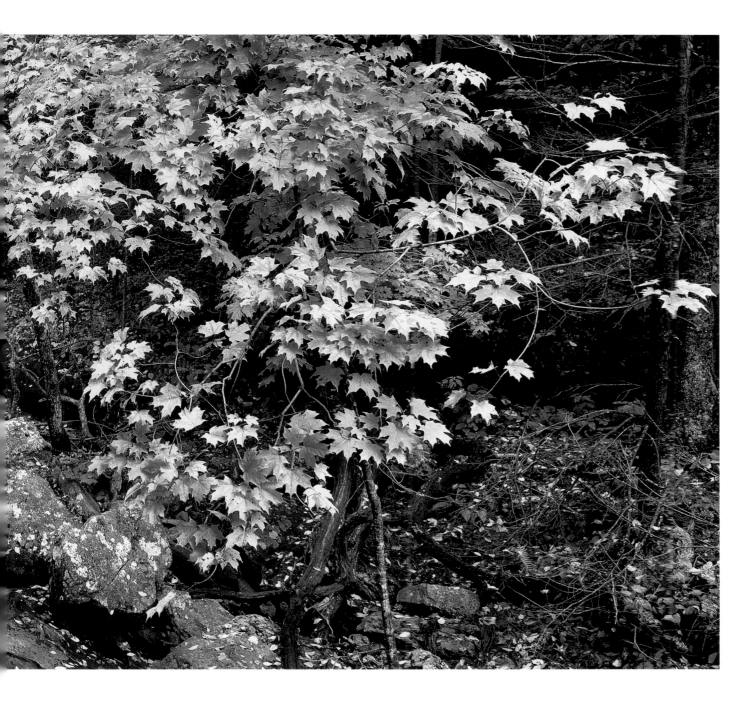

Repay no one evil for evil.
Have regard for good things in the sight of all men.
If it is possible, as much as depends on you,
live peaceably with all men.
Beloved, do not avenge yourselves,
but rather give place to wrath; for it is written,
"Vengeance is Mine, I will repay," says the Lord.
Therefore "If your enemy is hungry, feed him;
If he is thirsty, give him a drink;
For in so doing you will heap coals of fire on his head."
Do not be overcome by evil,
but overcome evil with good.

ROMANS 12:17-21

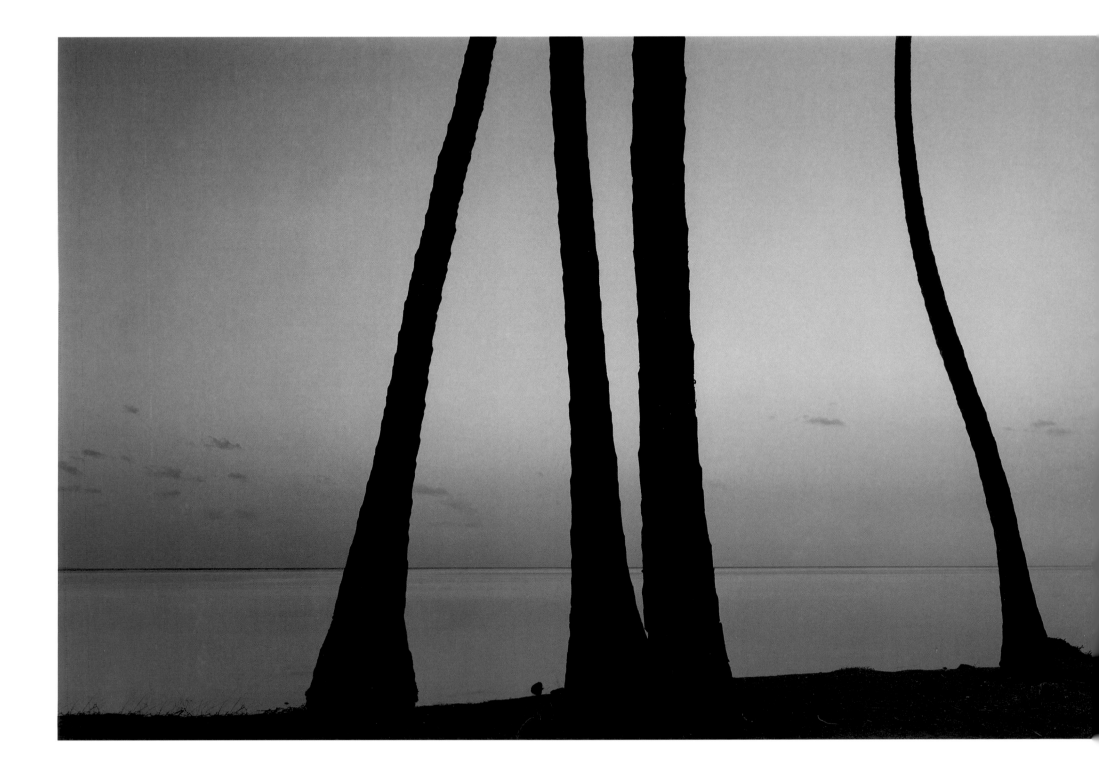

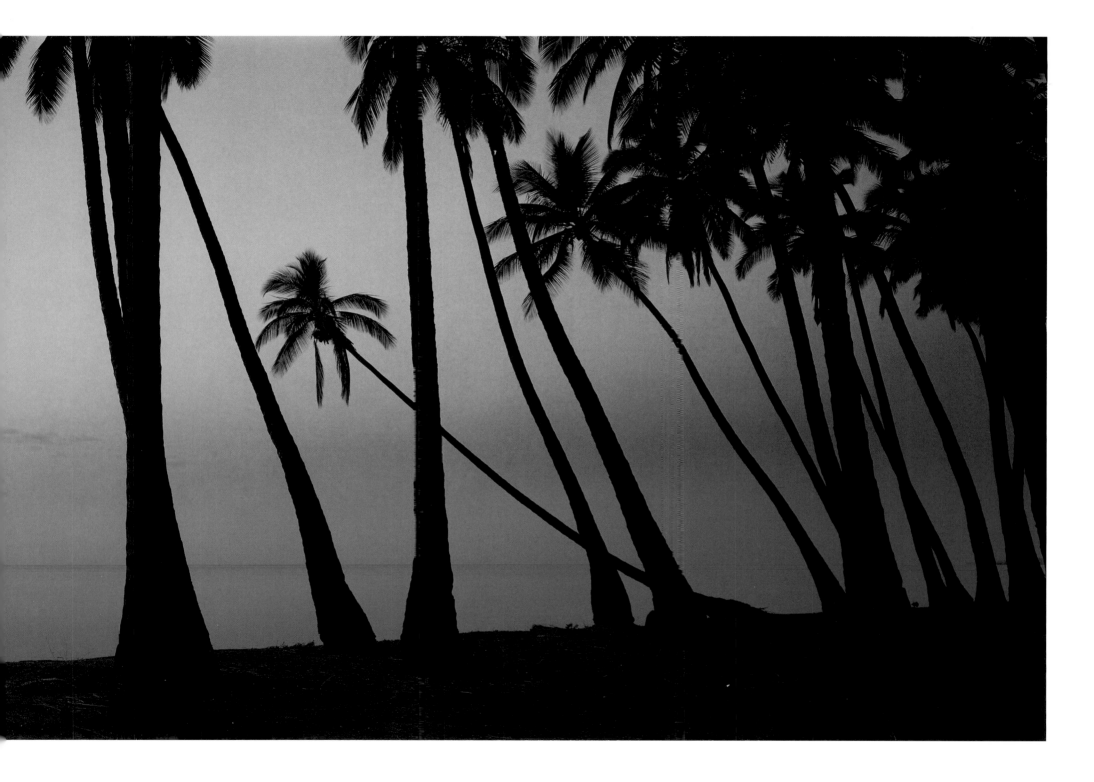

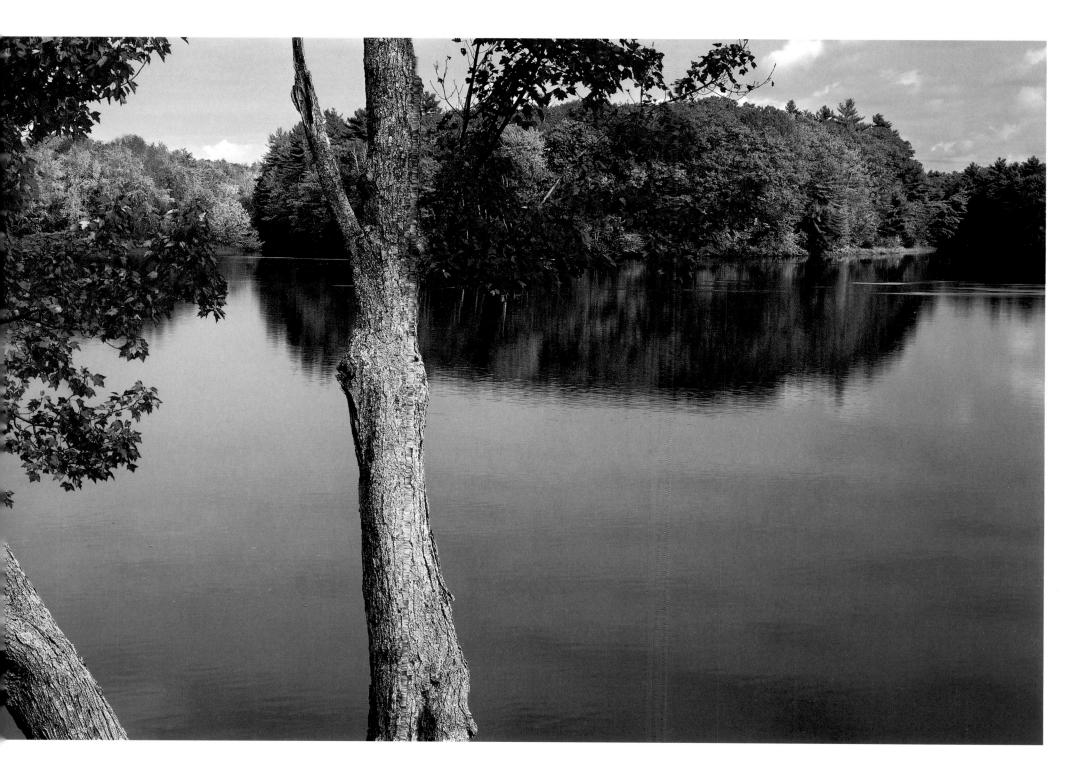

When you discover the beauty in yourself, you will begin to discover the beauty in others. ROBERT H. SCHULLER **139**

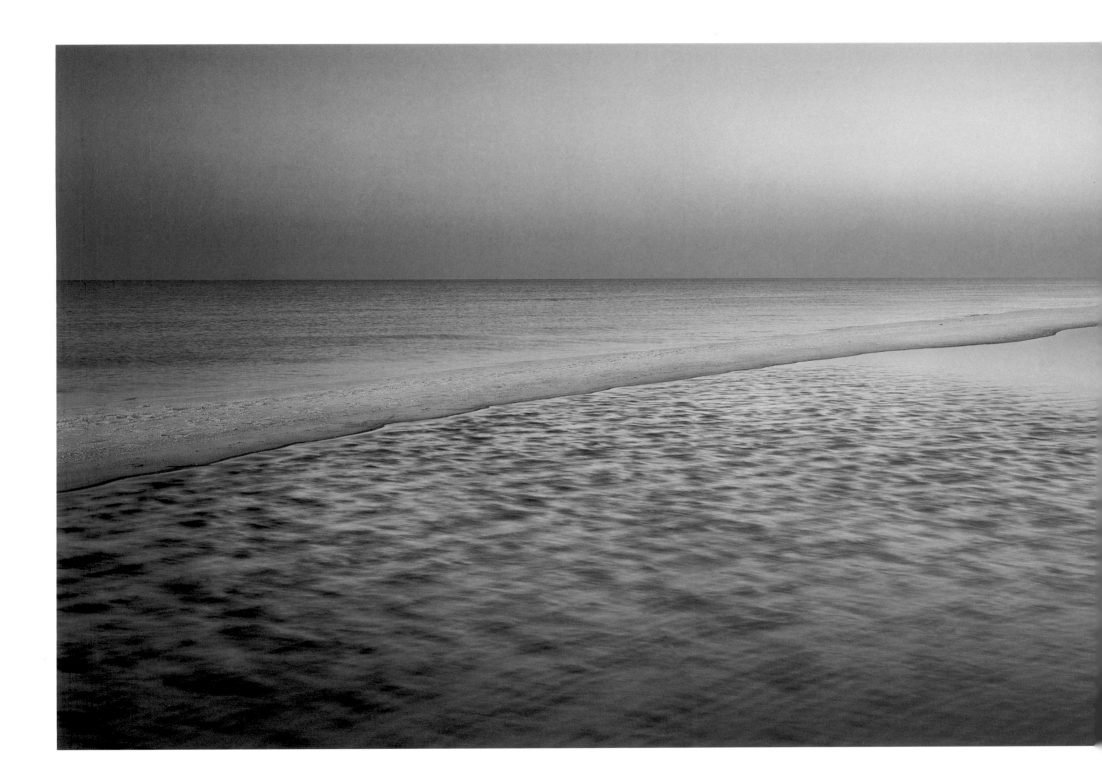

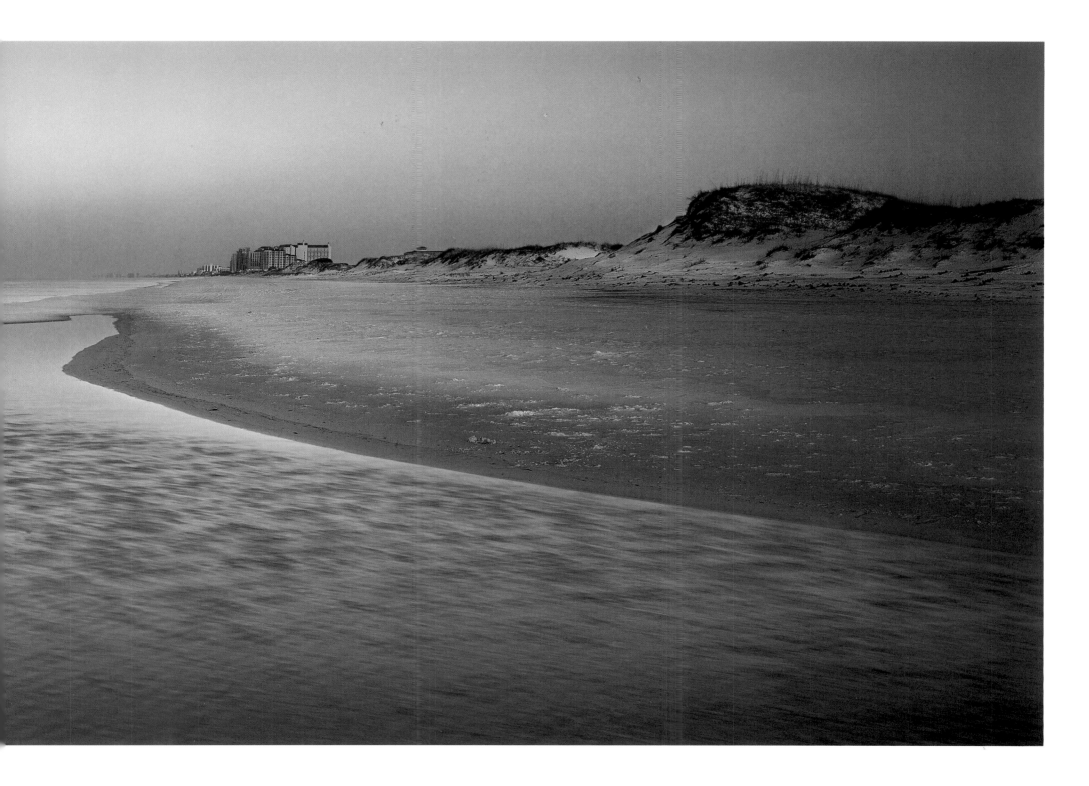

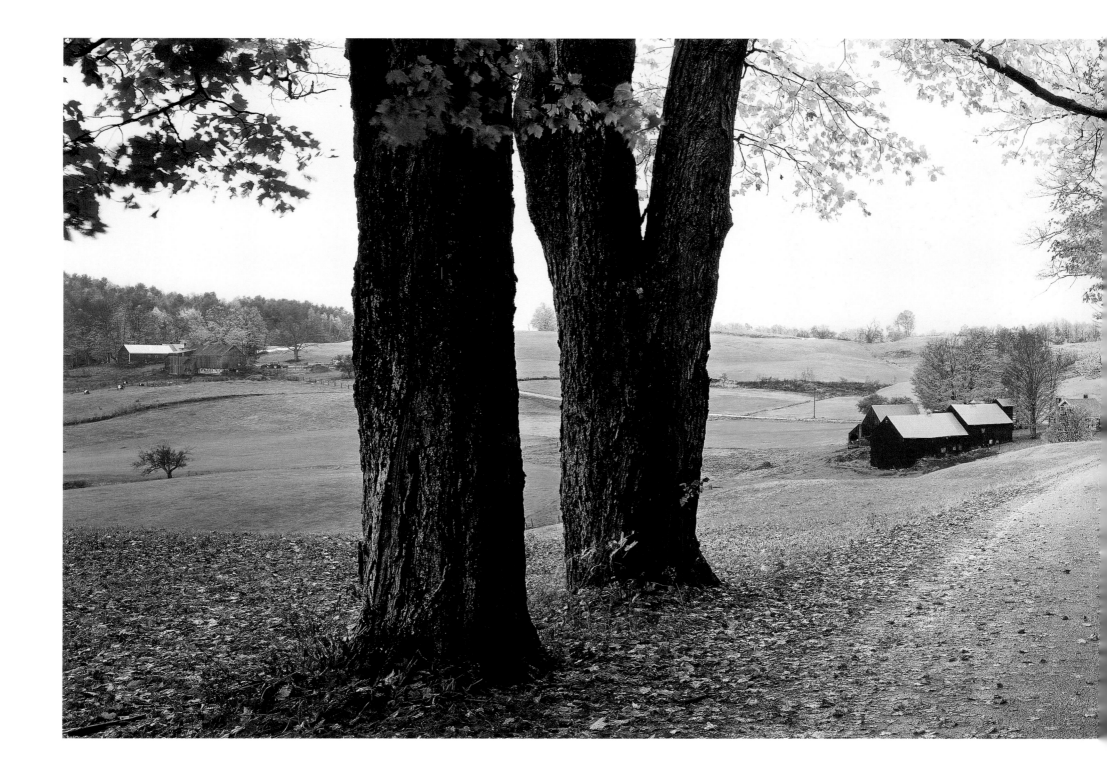

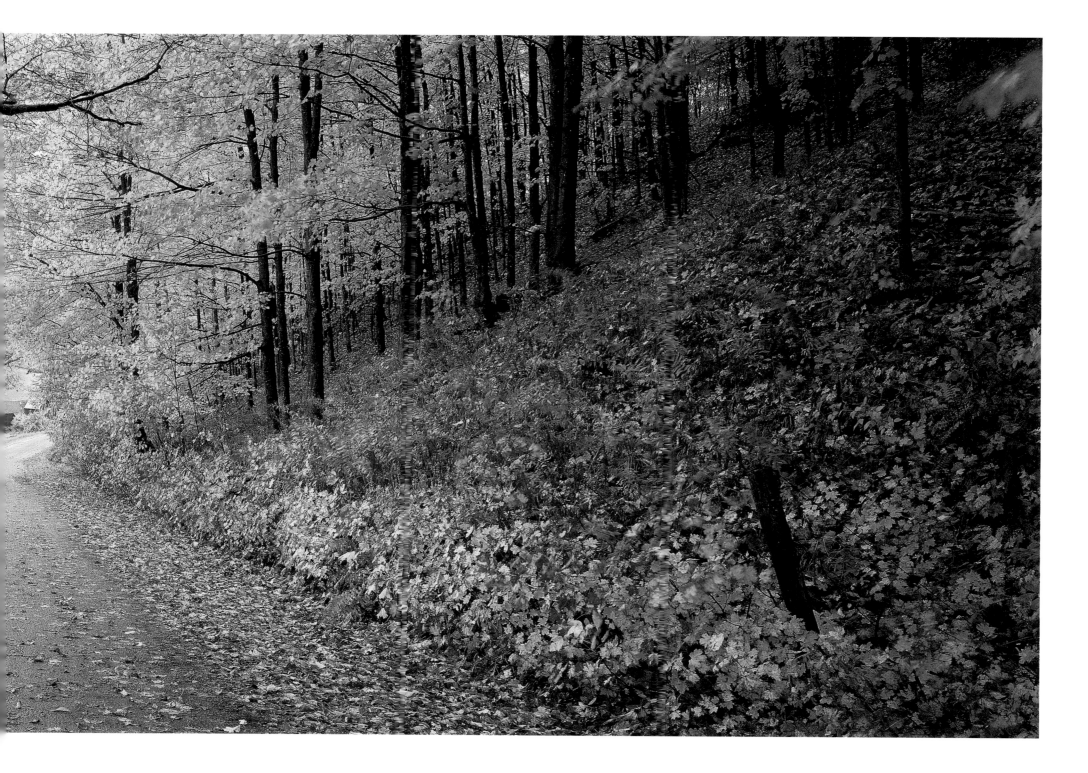

A dream takes on a life of its own. ROBERT H. SCHULLER **143**

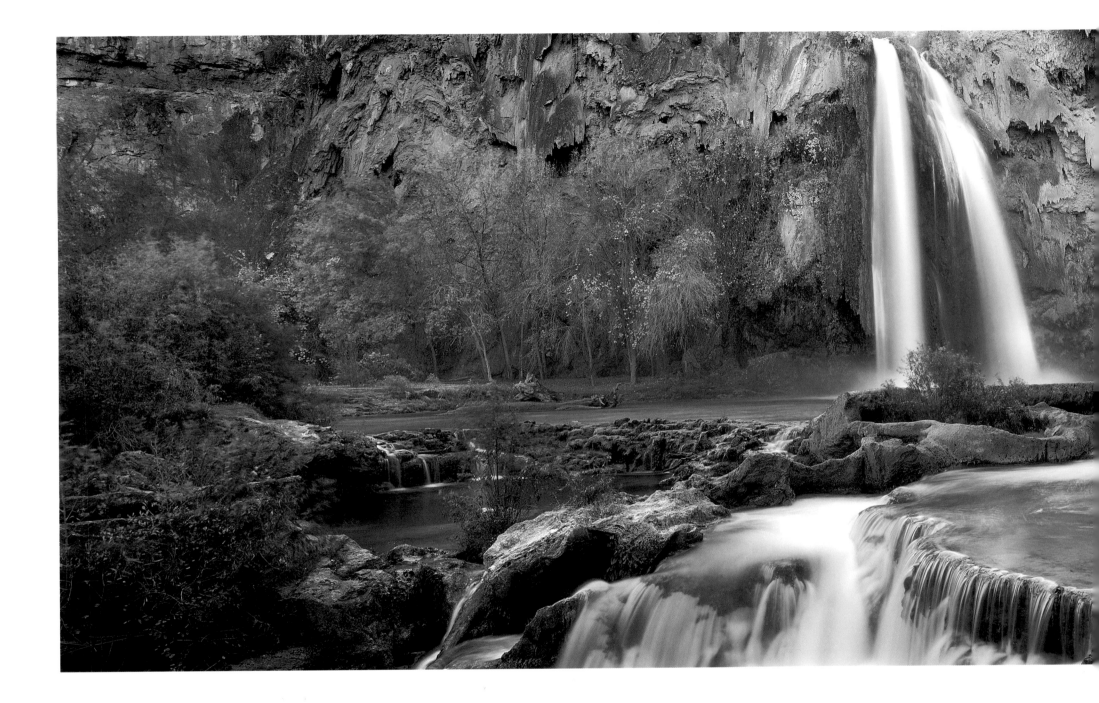

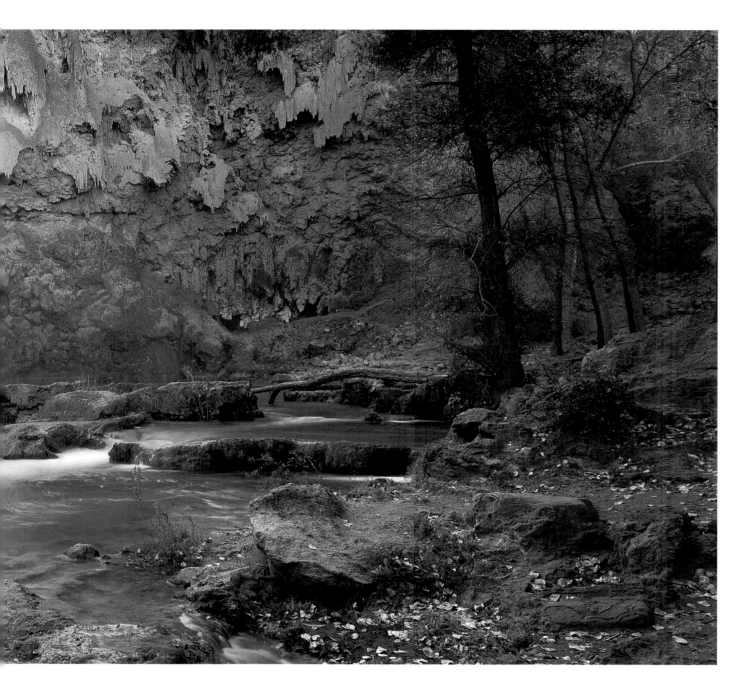

"If anyone thirsts, let him come to Me and drink.
He who believes in Me, as the Scripture has said,
out of his heart will flow rivers of living water."
JOHN 7:37-38

God's power makes His possibilities achievable!

Be anxious for nothing,
but in everything by prayer and supplication,
with thanksgiving,
let your requests be made known to God;
and the peace of God,
which surpasses all understanding,
will guard your hearts and minds
through Christ Jesus.

PHILIPPIANS 4:6-7

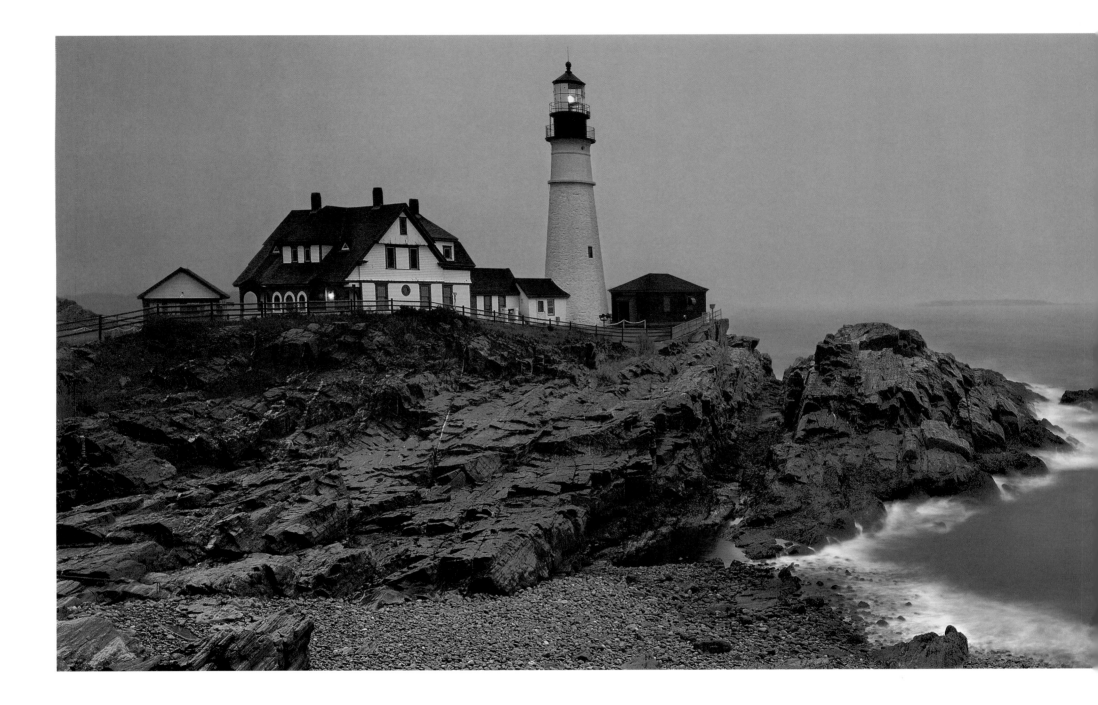

The law of the LORD is perfect,
converting the soul;
The testimony of the LORD is sure,
making wise the simple;
The statutes of the LORD are right,
rejoicing the heart;
The commandment of the LORD is pure,
enlightening the eyes.

PSALM 19:7-8

When you fail to plan, you plan to fail. ROBERT H. SCHULLER **149**

But as it is written:
"Eye has not seen, nor ear heard,
Nor have entered into the heart of man
The things which God has prepared
for those who love Him."

1 CORINTHIANS 2:9

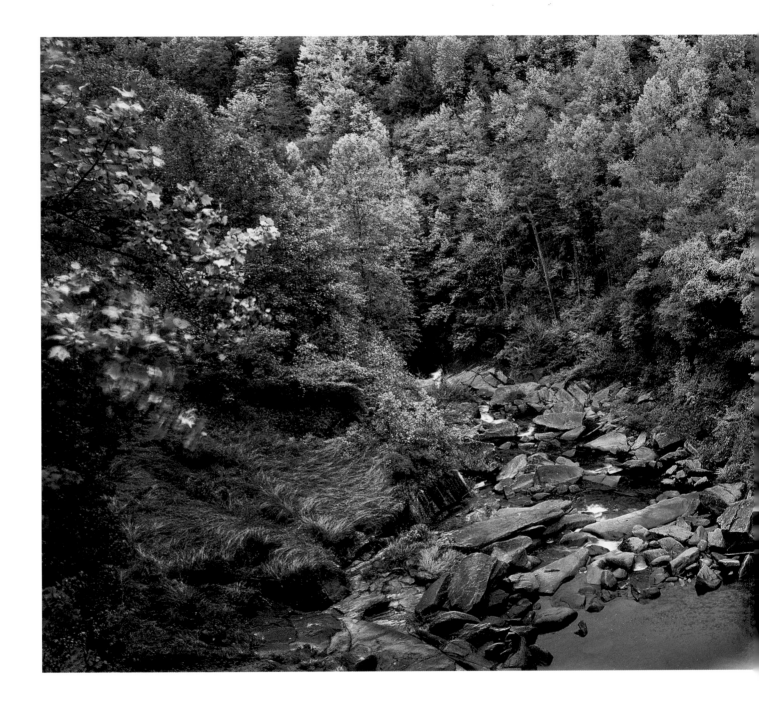

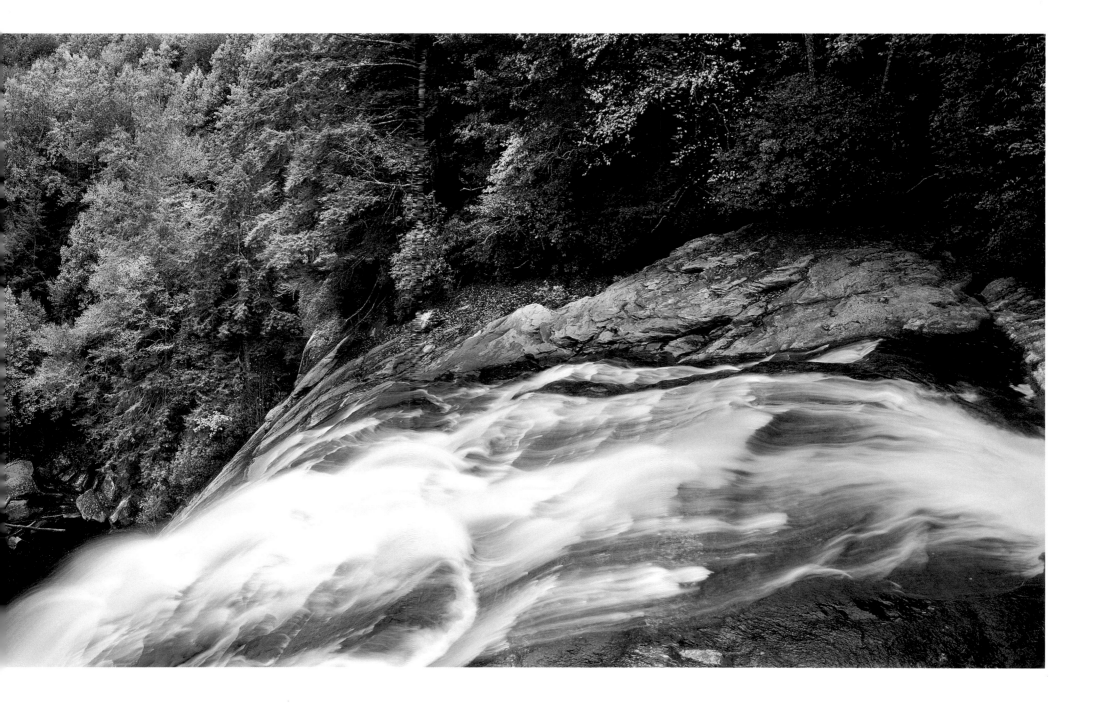

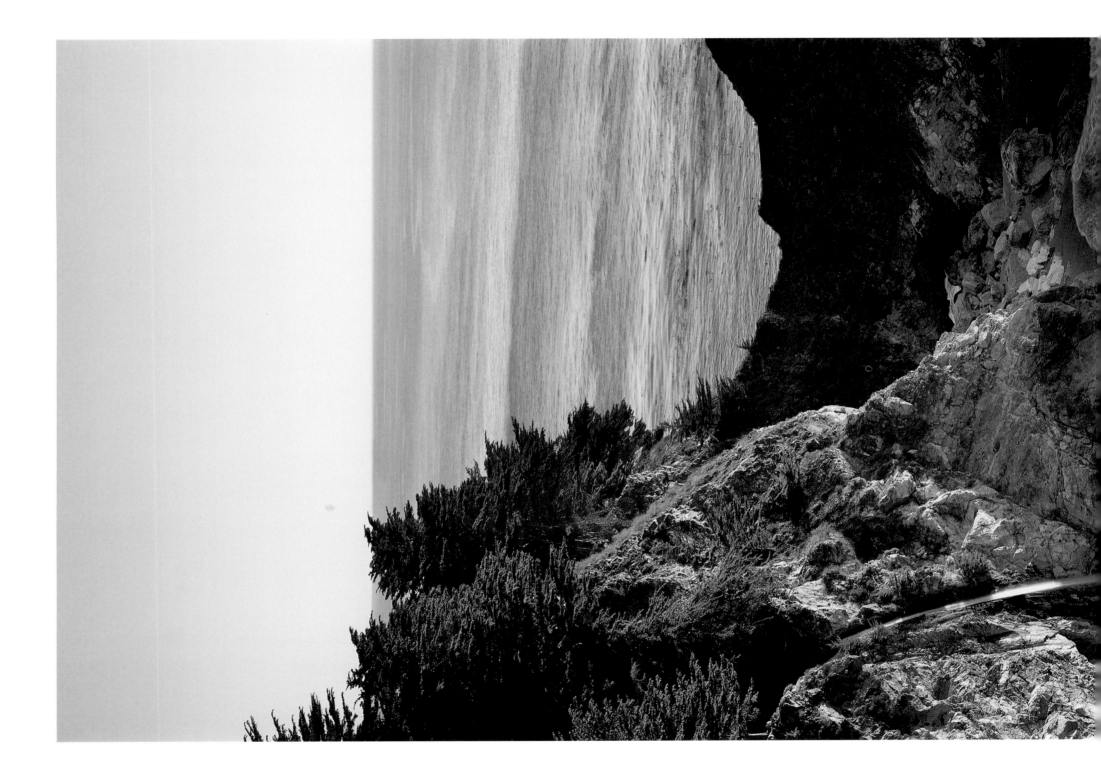

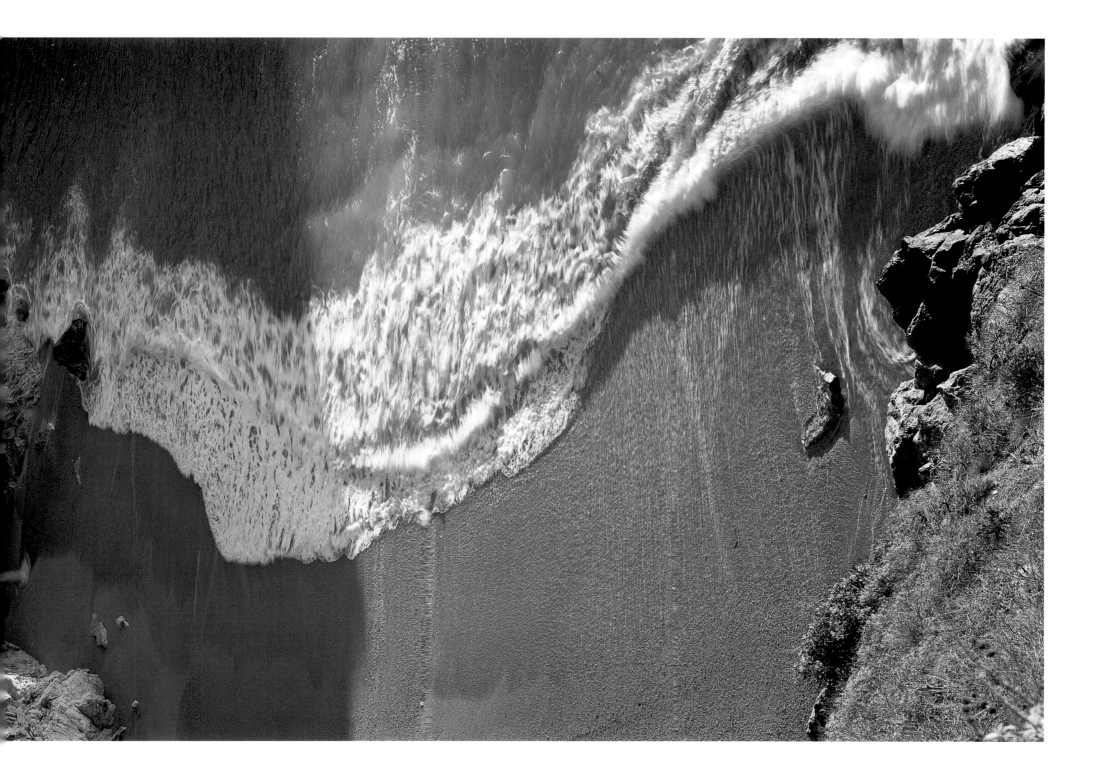

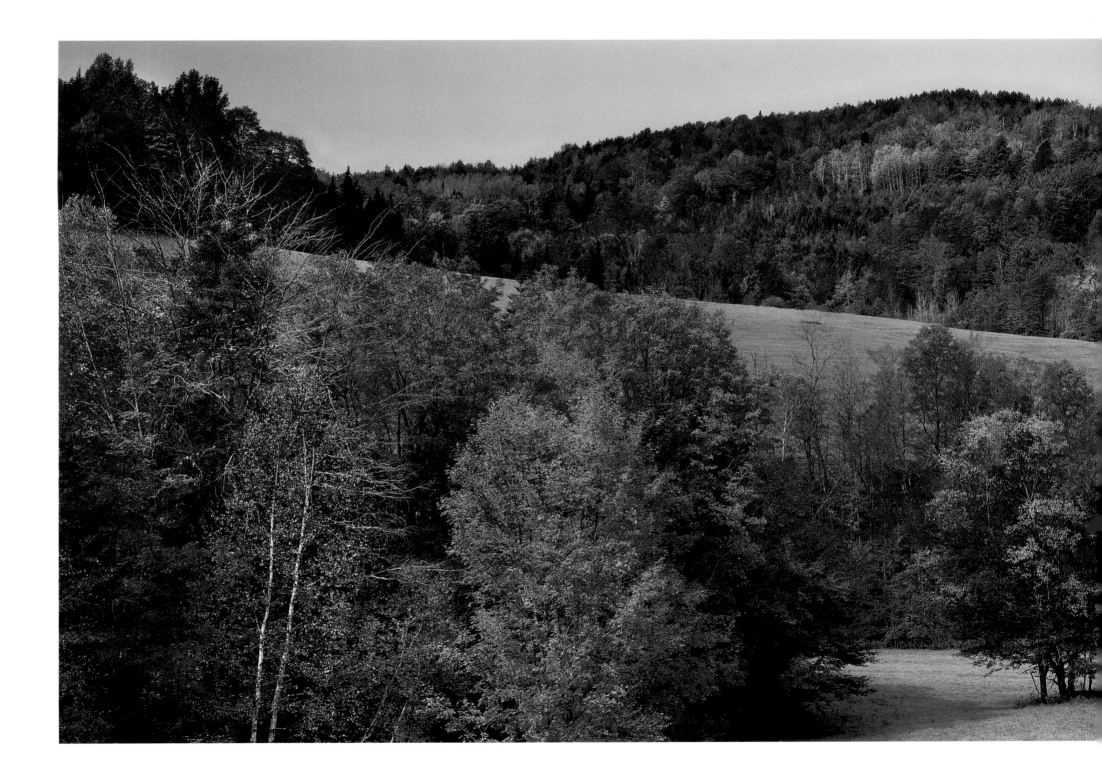

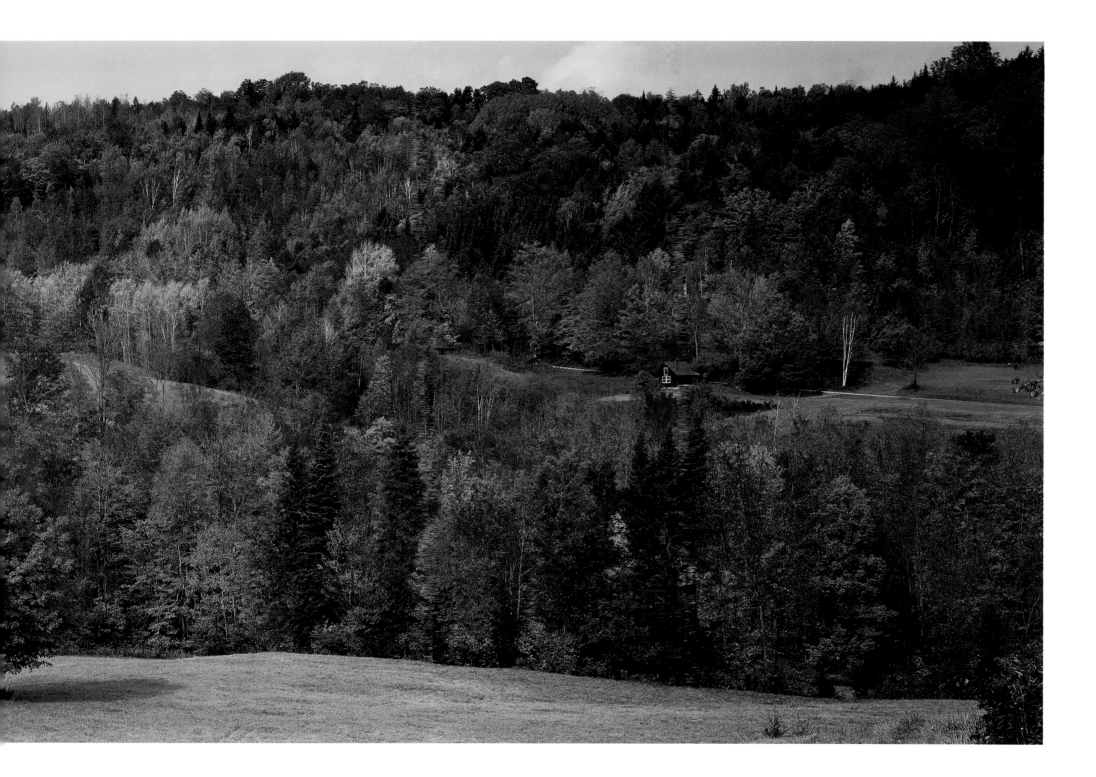

Every adversity holds within it the seeds of an undeveloped possibility. ROBERT H. SCHULLER **155**

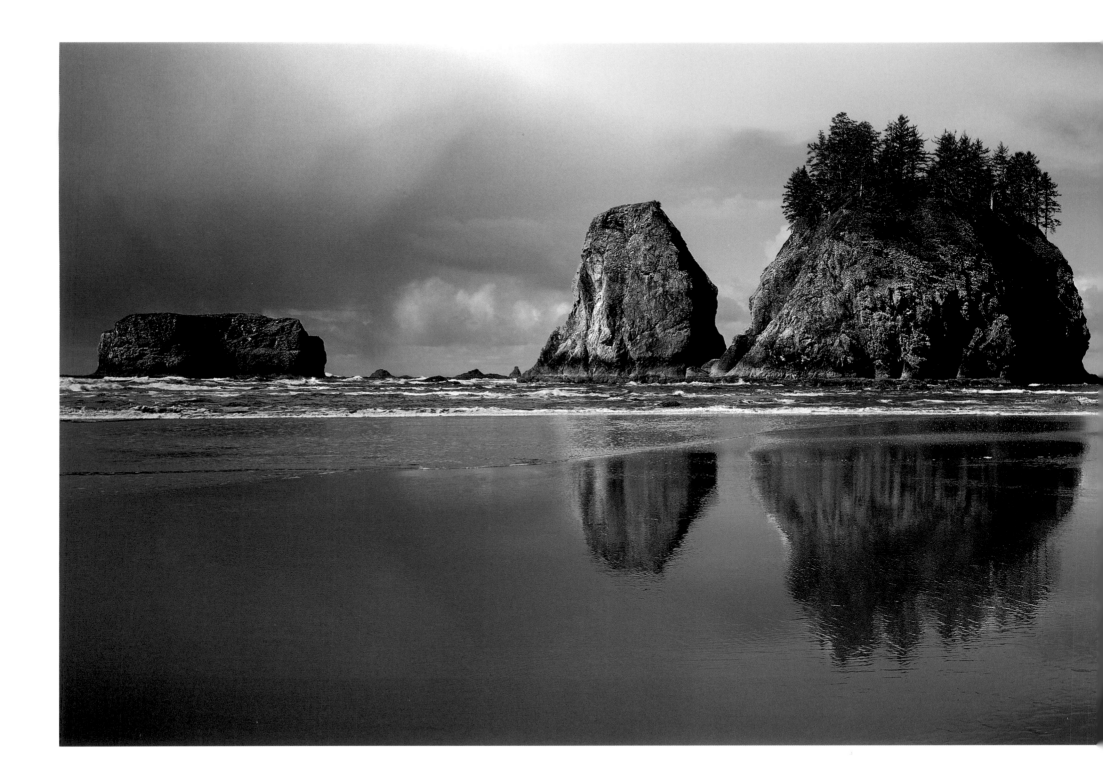

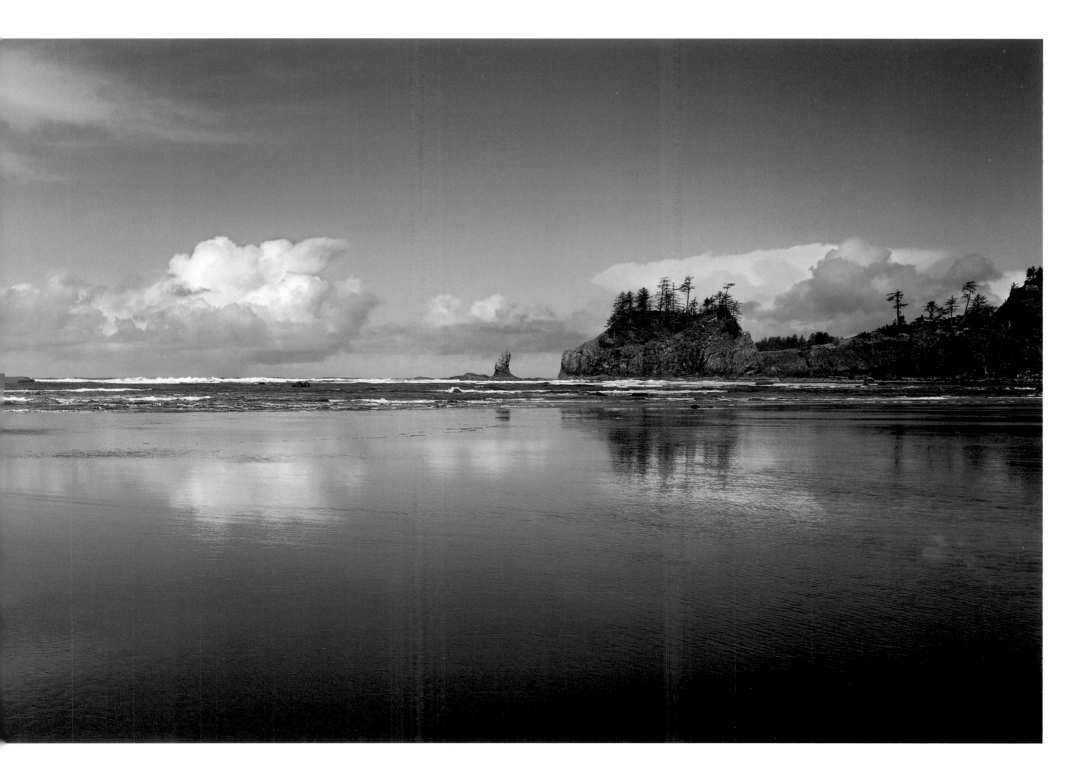

Achievement in spite of obstacles yields dignity and self-respect. ROBERT H. SCHULLER **157**

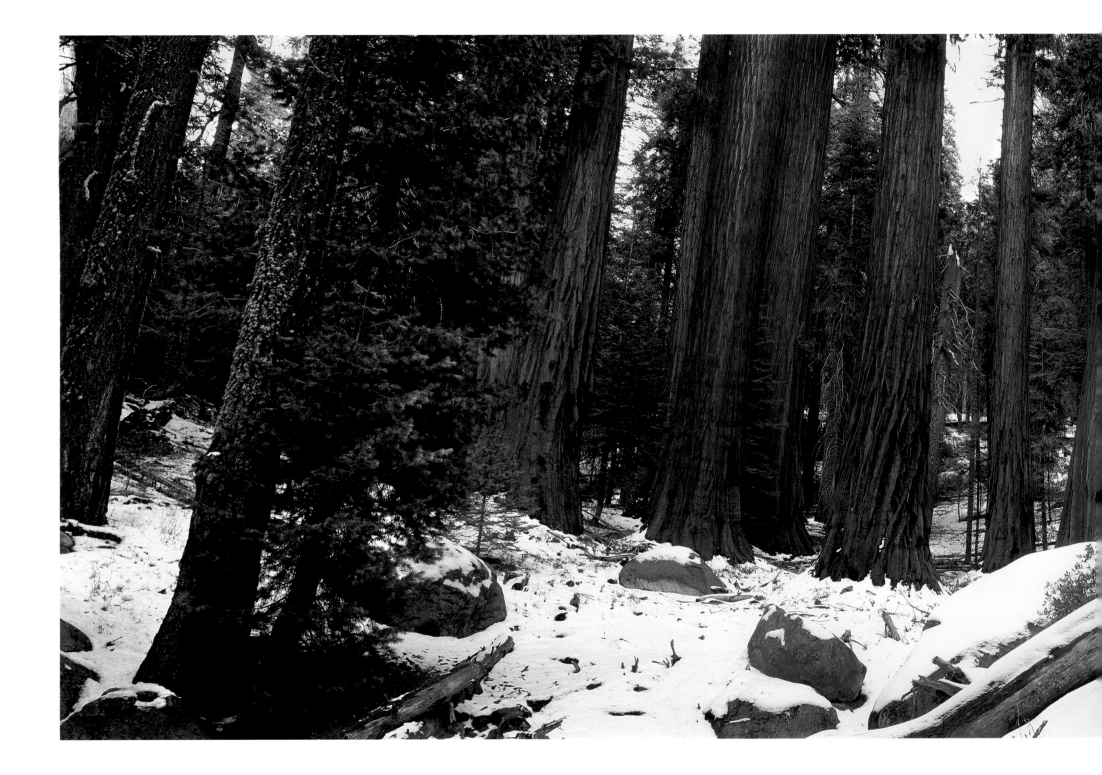

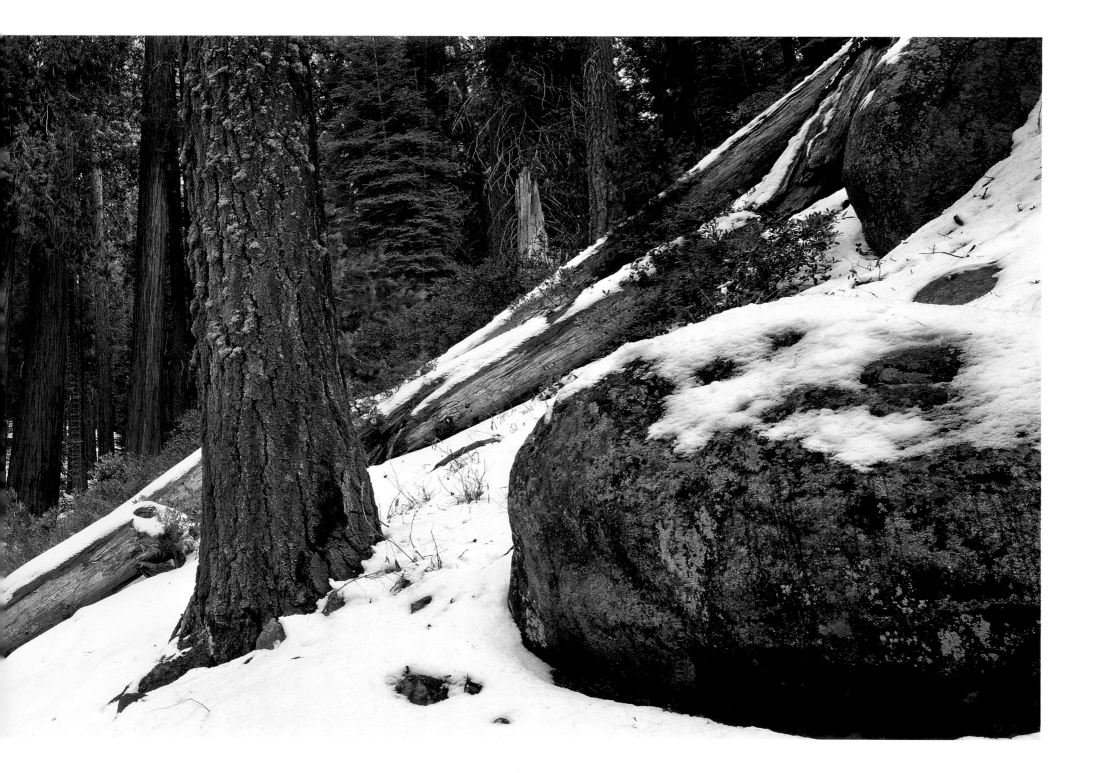

Make sure your dreams are big enough for God to fit in. ROBERT H. SCHULLER **159**

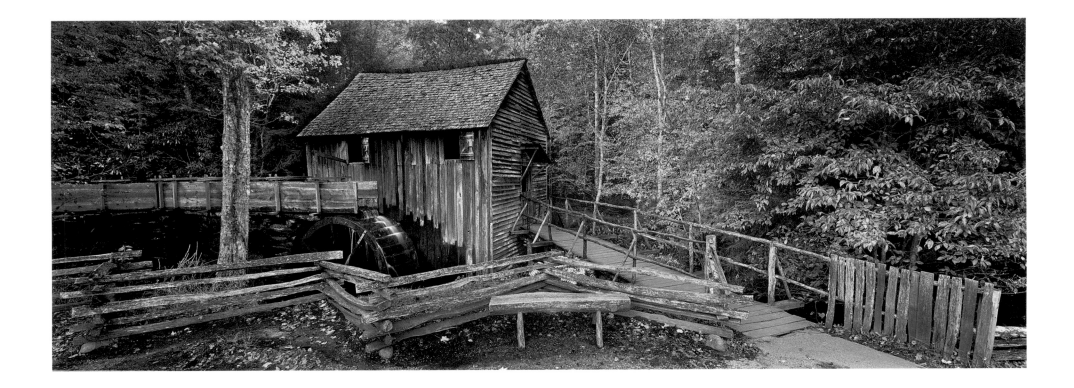

Trust in the LORD, and do good;
Dwell in the land, and feed on His faithfulness.
Delight yourself also in the LORD,
And He shall give you the desires of your heart.

PSALM 37:3-4

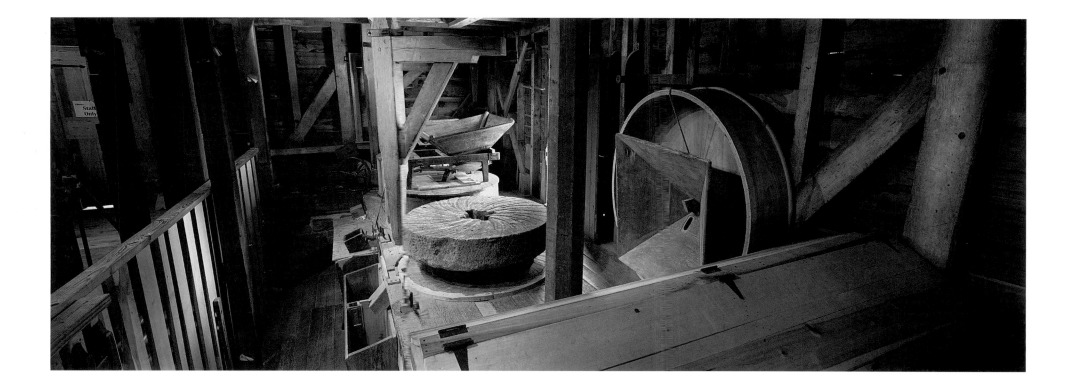

But He answered and said,
"It is written, 'Man shall not live by bread alone,
but by every word that proceeds
from the mouth of God.'"

MATTHEW 4:4

He loves righteousness and justice;
The earth is full of the goodness of the LORD.
By the word of the LORD the heavens were made,
And all the host of them by the breath of His mouth.
He gathers the waters of the sea together as a heap;
He lays up the deep in storehouses.

PSALMS 33:5-7

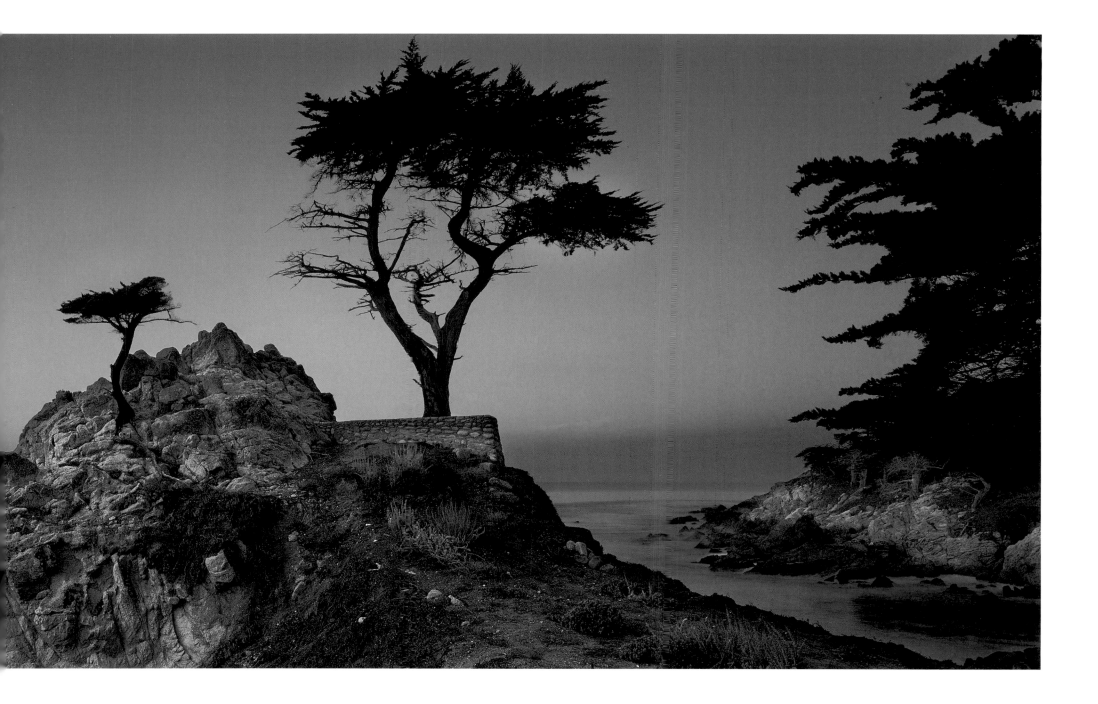

Trying times are times to triumph. ROBERT H. SCHULLER **163**

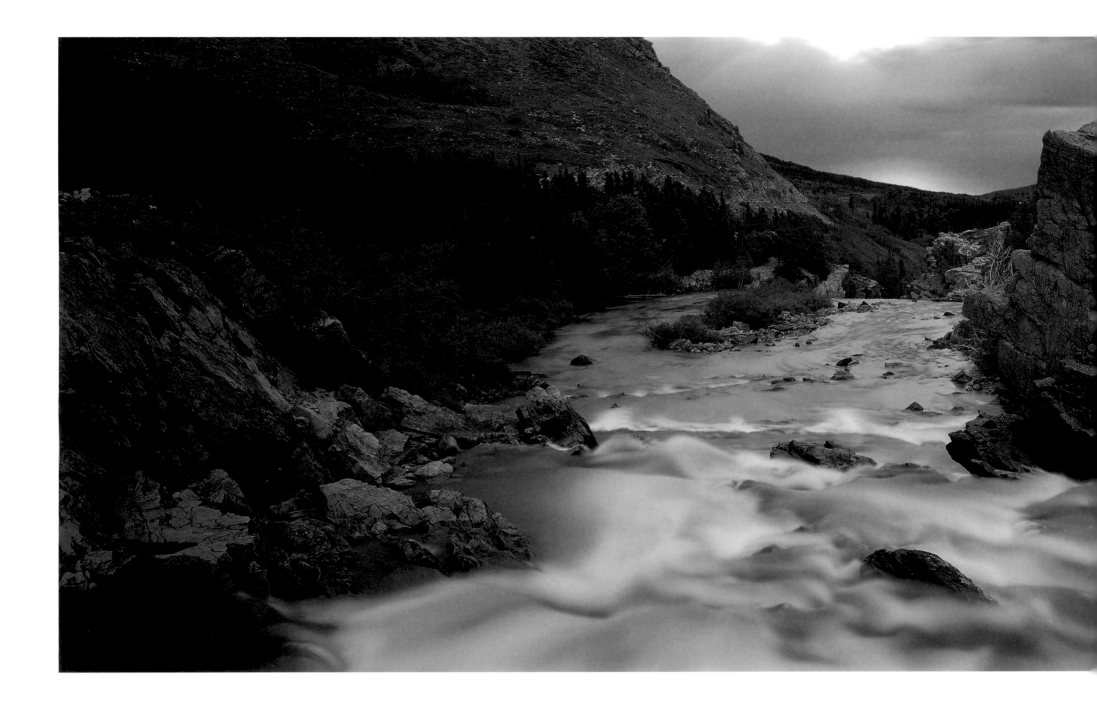

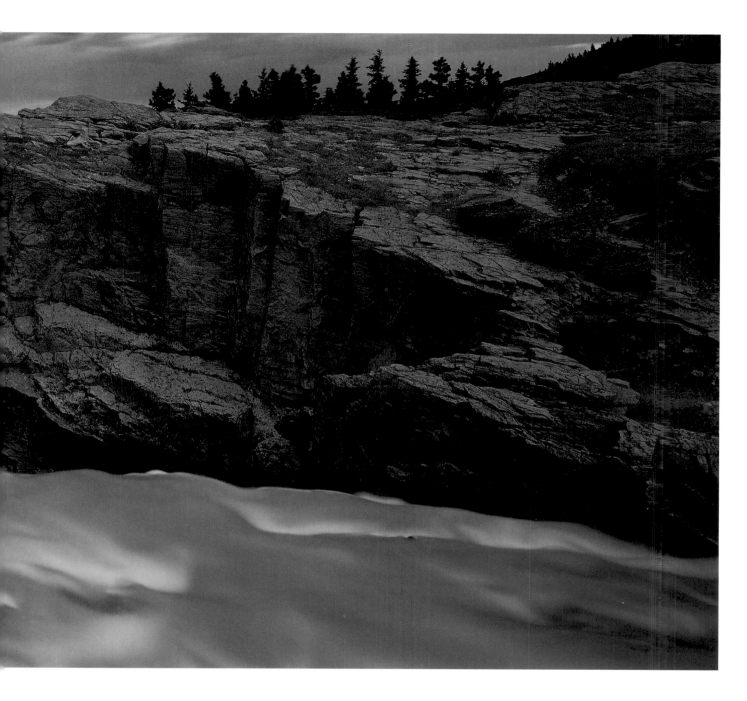

God is our refuge and strength,
A very present help in trouble.
Therefore we will not fear,
Even though the earth be removed,
And though the mountains be carried
into the midst of the sea;
Though its waters roar and be troubled,
Though the mountains shake with its swelling.
There is a river whose streams
shall make glad the city of God,
The holy place of the tabernacle of the Most High.
God is in the midst of her, she shall not be moved;
God shall help her, just at the break of dawn.

PSALM 46:1-5

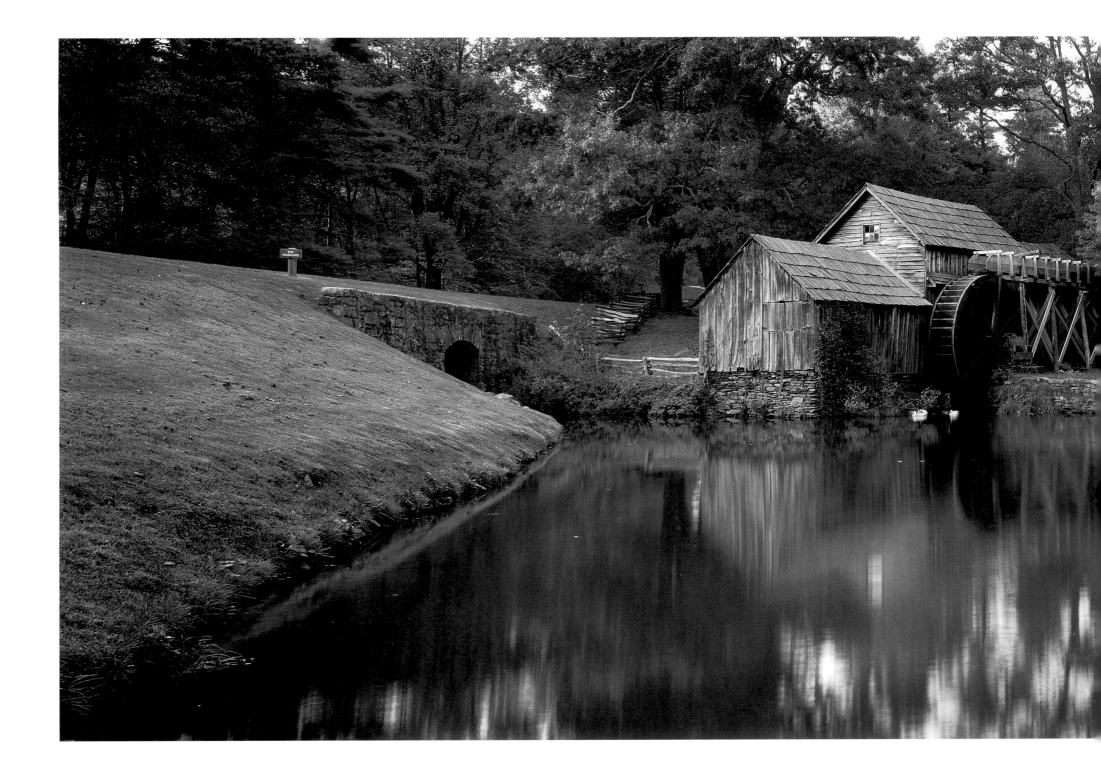

Your life can be the portrait of a survivor. ROBERT H. SCHULLER **167**

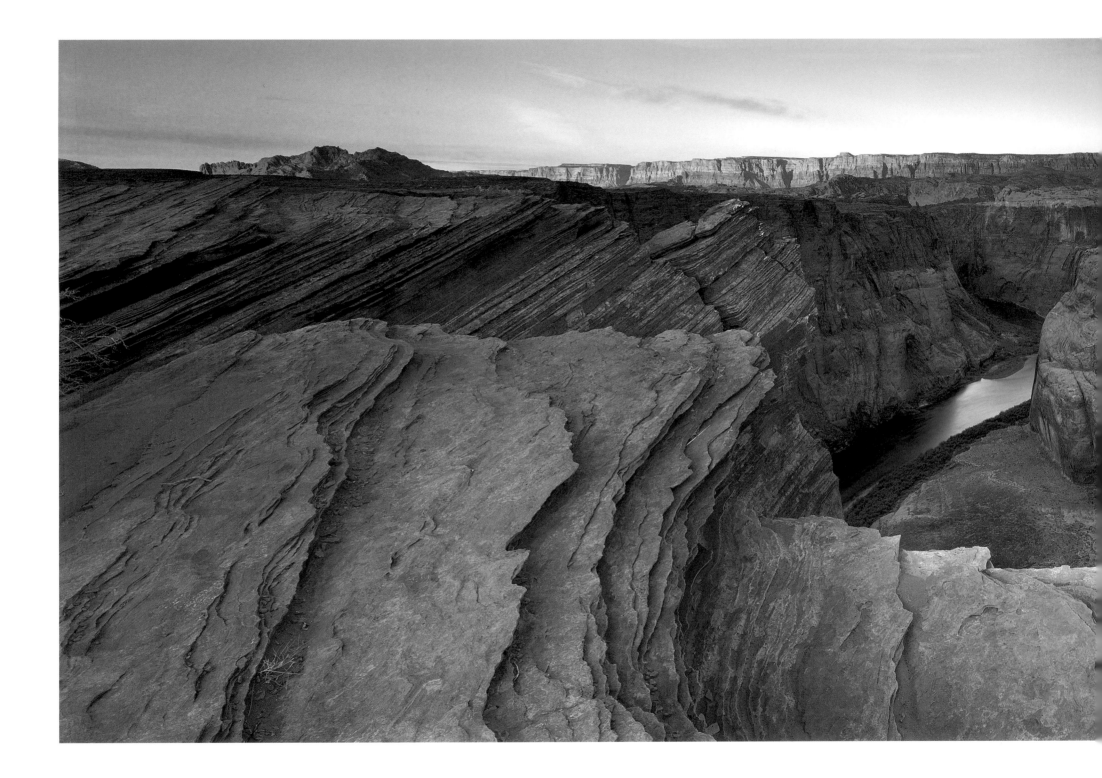

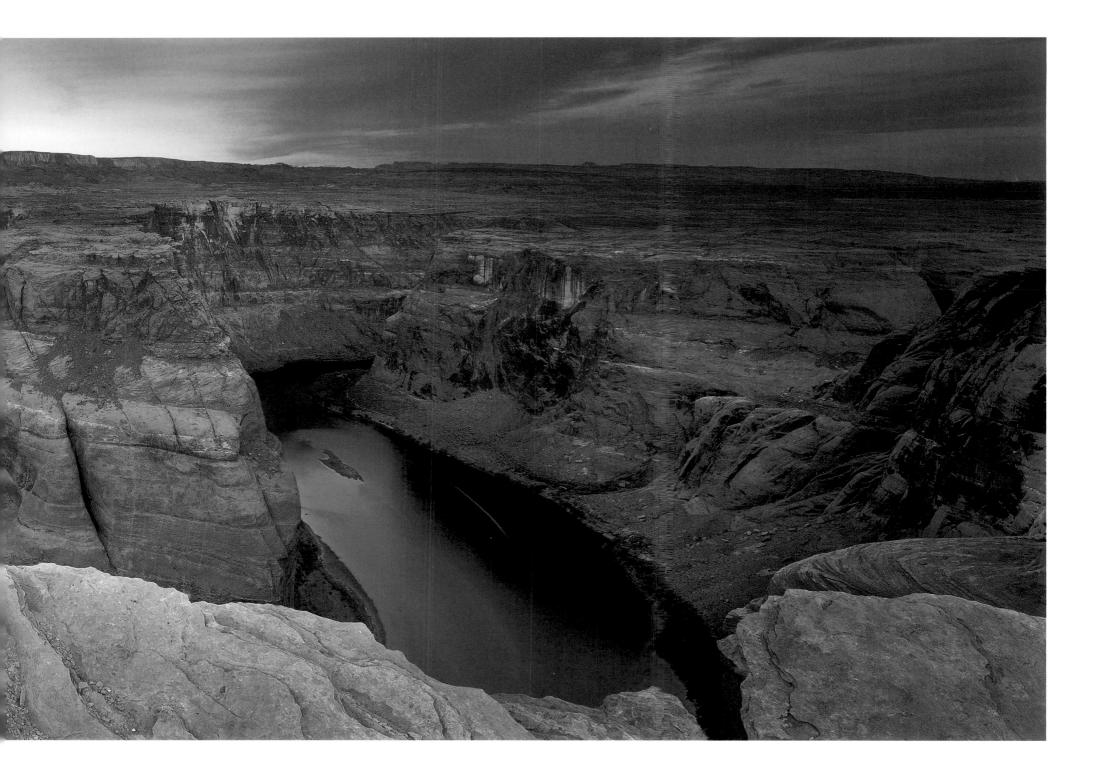

Nothing is impossible. Some things just take longer than others. ROBERT H. SCHULLER **169**

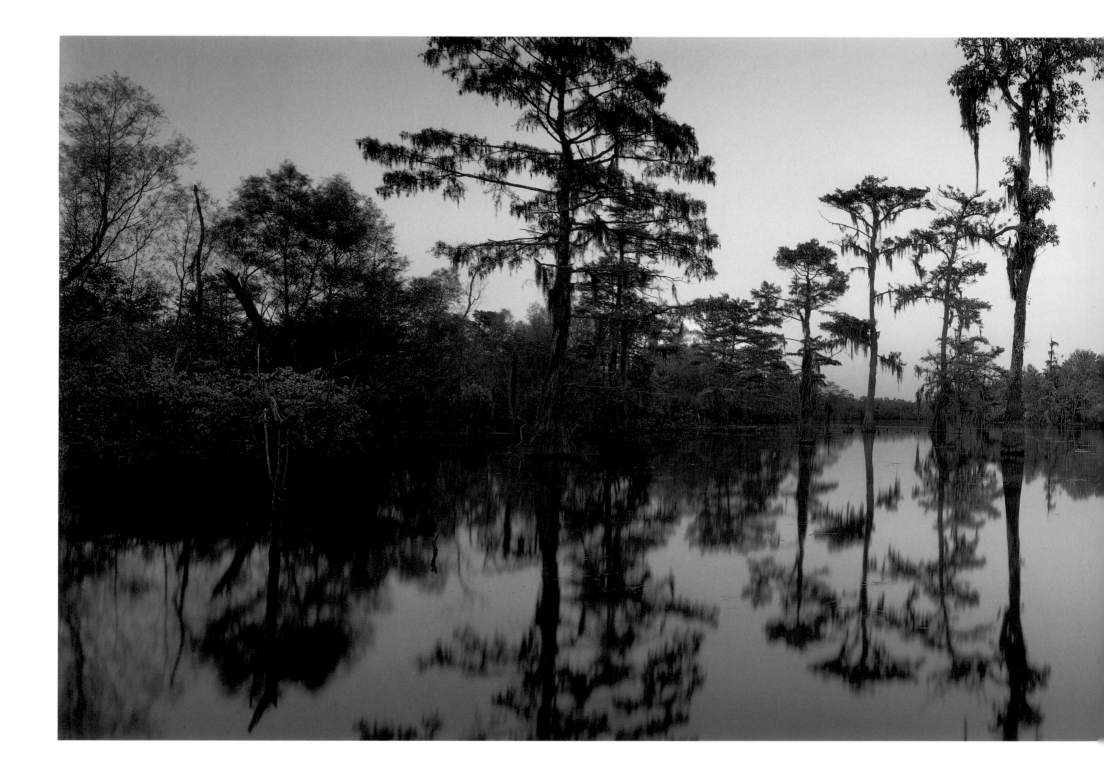

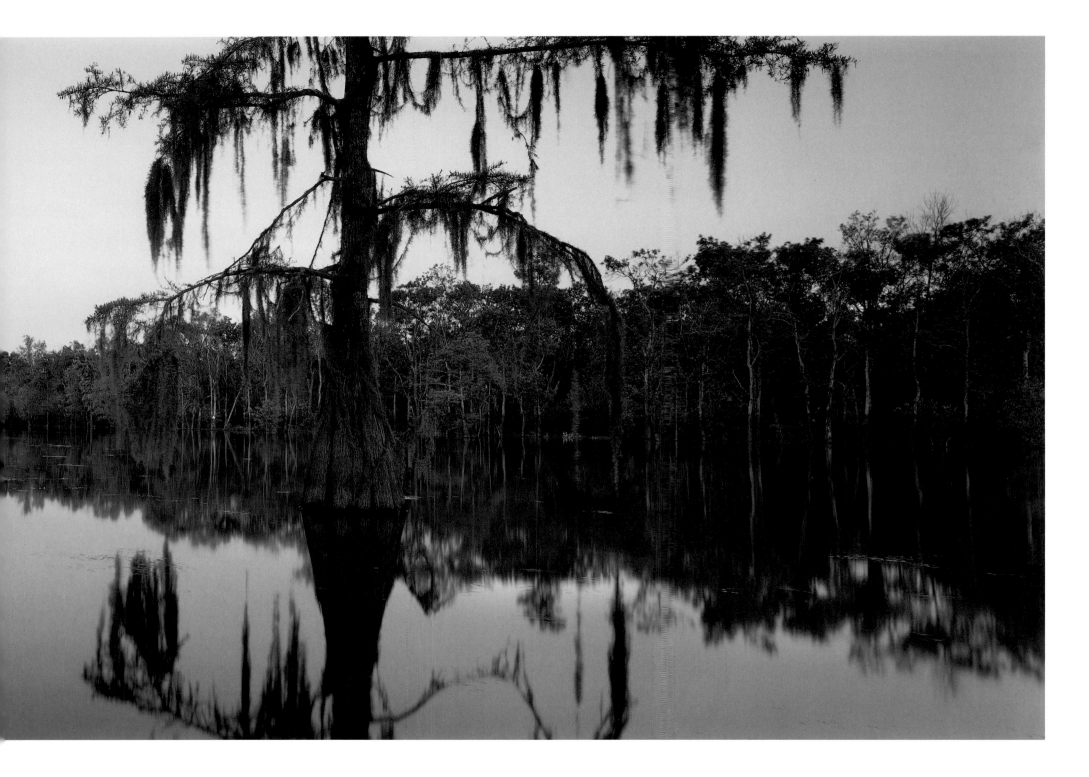

God's care will carry you so you can carry others! ROBERT H. SCHULLER **171**

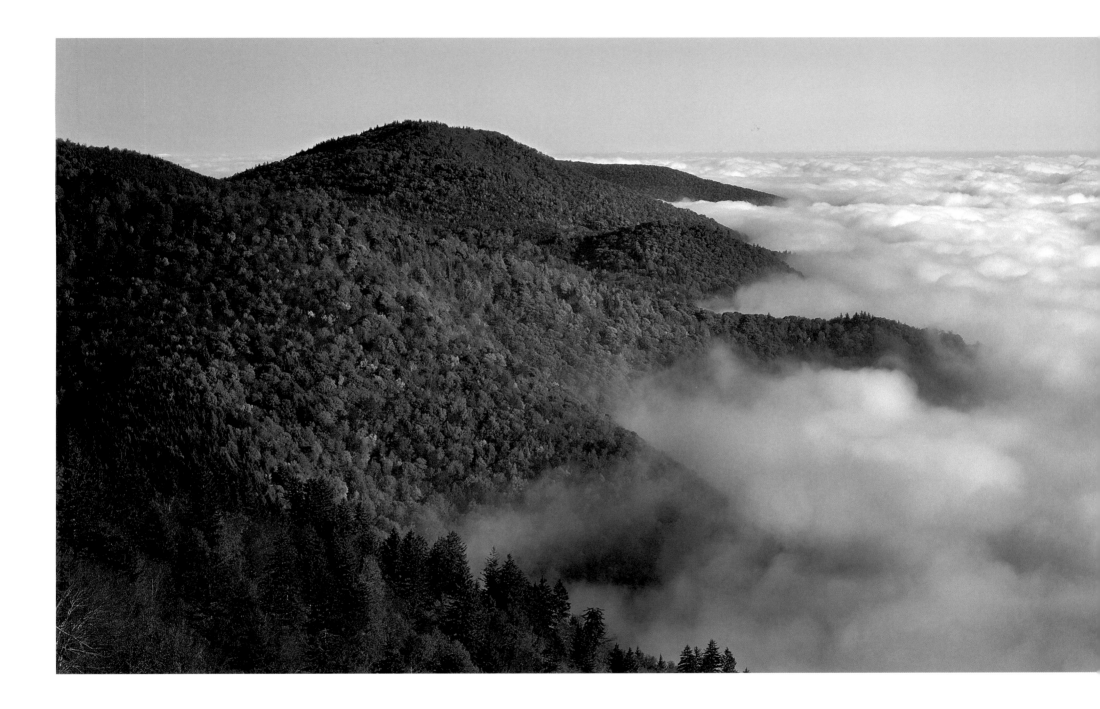

I will praise You, O Lord, among the peoples;
I will sing to You among the nations.
For Your mercy reaches unto the heavens,
And Your truth unto the clouds.
Be exalted, O God, above the heavens;
Let Your glory be above all the earth.

PSALM 57:9-11

The heavens declare the glory of God;
And the firmament shows His handiwork.
Day unto day utters speech,
And night unto night reveals knowledge.
There is no speech nor language
Where their voice is not heard.
Their line has gone out through all the earth,
And their words to the end of the world.
In them He has set a tabernacle for the sun,
Which is like a bridegroom coming out of his chamber,
And rejoices like a strong man to run its race.
Its rising is from one end of heaven,
And its circuit to the other end;
And there is nothing hidden from its heat.

PSALM 19:1-6

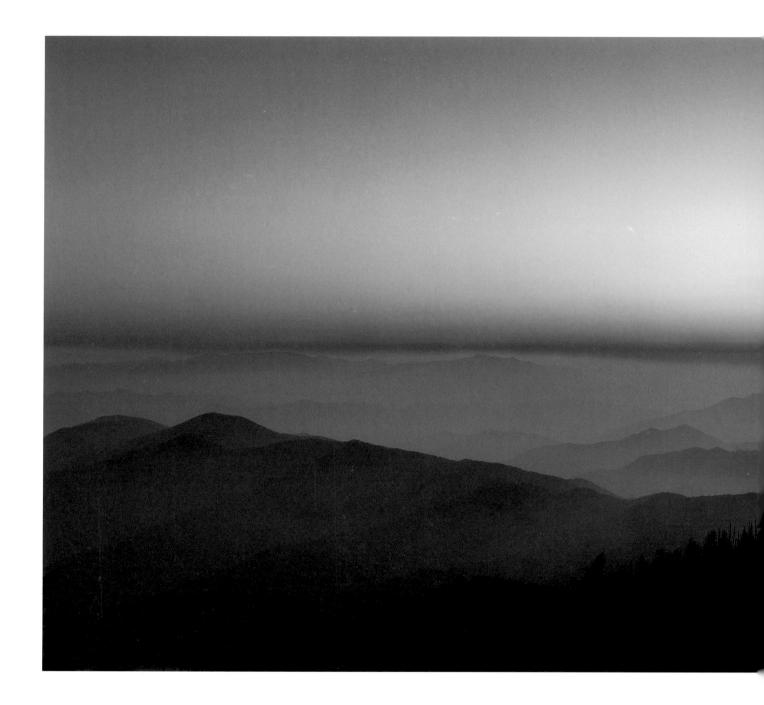

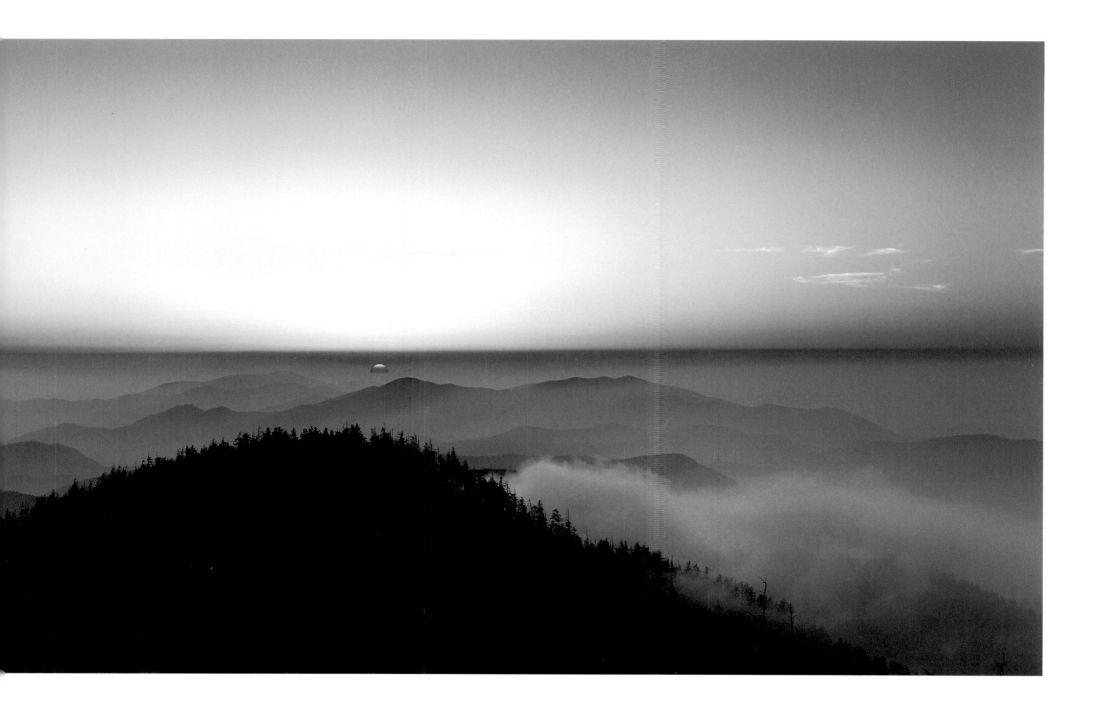

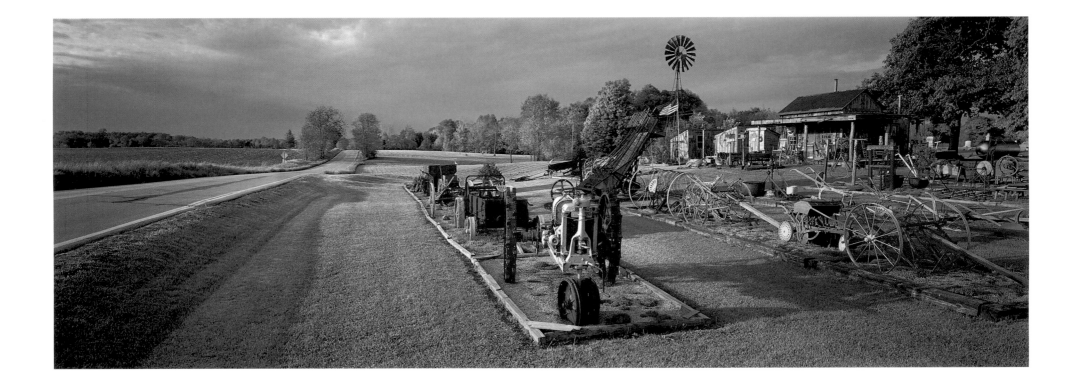

War & Peace

After hours of fruitless driving along back country roads in Indiana, I came upon this surreal farm scene. Sensing that much love and effort had gone into the development of this farmland fantasia, I felt there had to be an interesting story behind it. I located the farm's owner, Terry, and asked if I could take some photos. I found he was very open to sharing the joy of his creation with anyone who showed interest. We chatted while I waited for the late afternoon light, and I had the pleasure of getting to know a little of his background.

Terry is a veteran of the Vietnam War and saw a lot of action during his tour of duty. When he returned from the war, Terry – like many of his compatriots – found it very difficult to adjust to life in rural America. Not wanting to fall into the type of destructive behaviors that were consuming several of his friends, Terry realized he needed to do something constructive with his life. This was the naissance of his dream of building a replica of an old Kentucky shack. Terry's family history dates back to the American Civil War, and some of their old farm equipment became the foundation for his vision. As Terry began to build his dream, the dream began to build him and he found he was able to effectively work through some of the issues he had brought home with him from the war.

As he worked on his creation, many passers-by would stop and inquire what he was doing. His passion was contagious. As he shared the vision, others also got excited. People began bringing antiques and historic farm equipment to add to Terry's collection. Ancient relics would sometimes be left anonymously at night and he would arise in the morning to find a marvelous new addition to his collection. Normally people are very careful to lock up their treasure, but though Terry never bothered about security he found that people only added to his. Beautiful ideas attract beautiful people and it seemed many were inspired by his efforts.

Terry's rural artwork is now basically finished, although new pieces still keep turning up to expand the dream. Once underway, noble dreams have a habit of taking on a life of their own. But it requires someone to start. Through constructive action, Terry has built a sanctuary that has helped him overcome destructive thinking. His labor of love has helped him find his roots and regain his strength.

Although this is not Terry's permanent abode – he has a more modern home close by – his old Kentucky shack is the place he goes to when he needs a refuge away from the buffeting storms of life. On the front porch two old rocking chairs are lovingly placed, facing into the west. They seem to beckon anyone who is burdened with the cares of the world to come and sit, and to allow the beauty of the sun slowly sinking into the fertile fields to wash their troubles away. We all need an equivalent of this little old shack in our lives – somewhere we can go to find peace and regain our serenity. It's not really about the shack, or the rocking chairs on the porch – they are really just symbolic of our place of peace and refuge. It's about taking the time to remove ourselves from the hustle and bustle of modern living so we may find our place of refuge and sit long enough to enjoy the view.

He makes wars cease to the end of the earth;
He breaks the bow and cuts the spear in two;
He burns the chariot in the fire.
Be still, and know that I am God;
I will be exalted among the nations,
I will be exalted in the earth!

PSALM 46:9-10

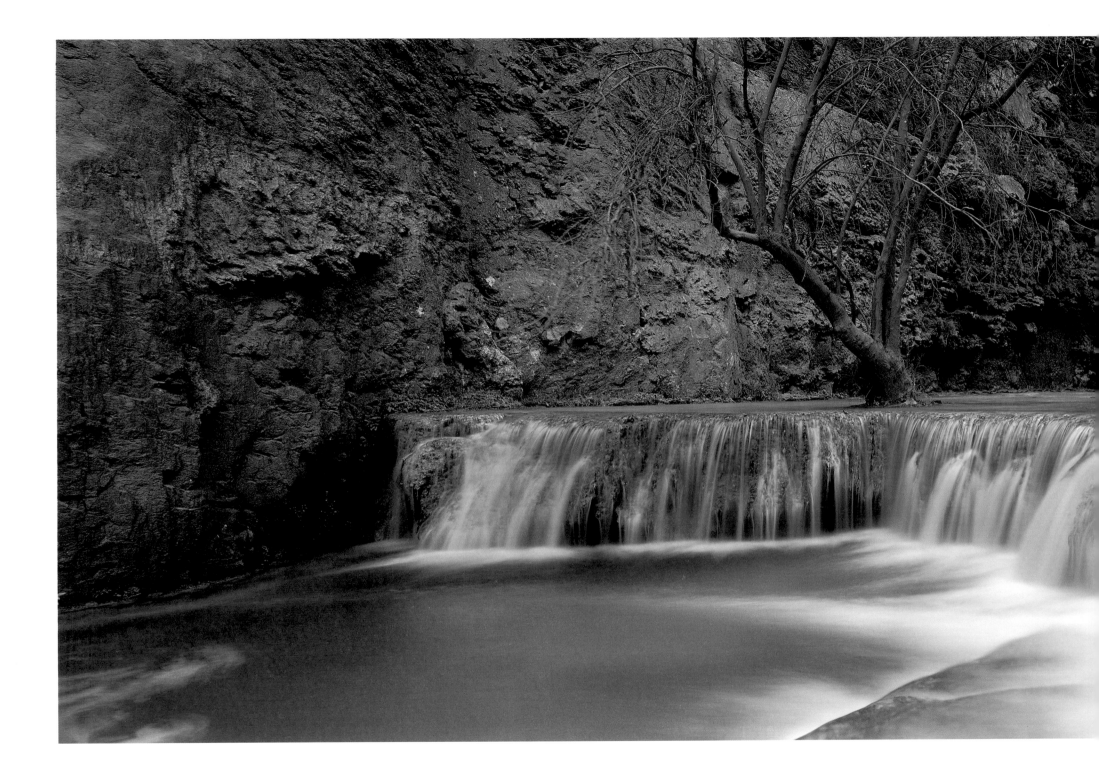

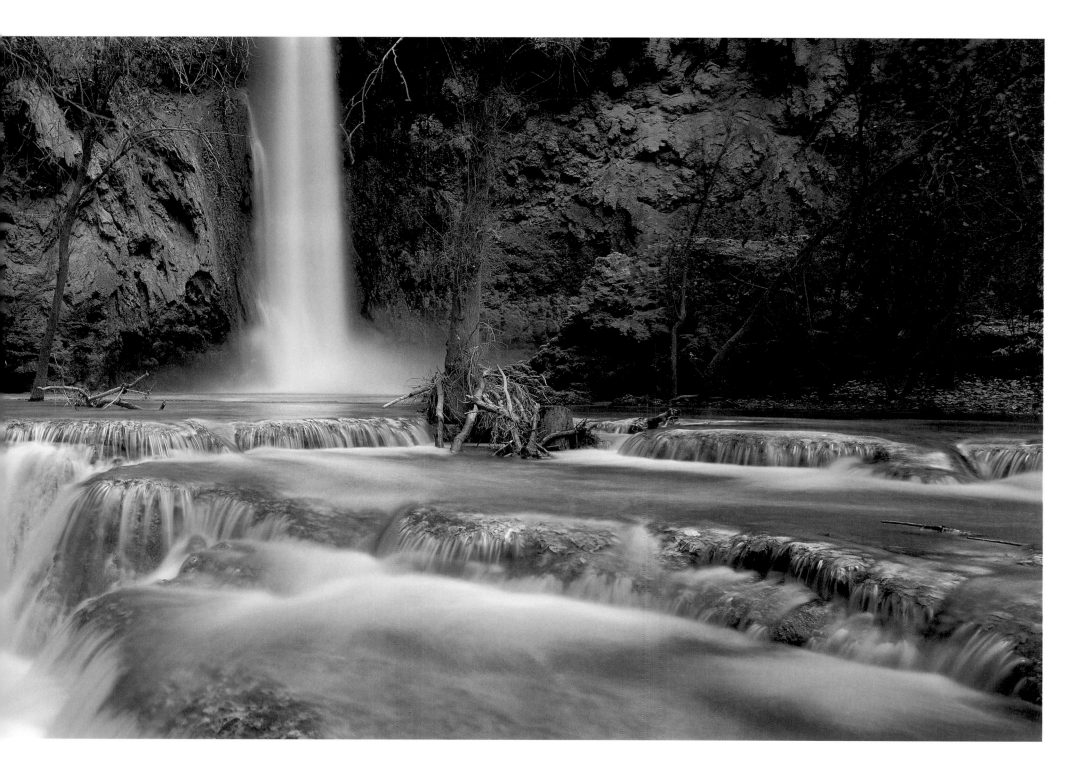

Dreams come true when I tap into God's power. ROBERT H. SCHULLER **179**

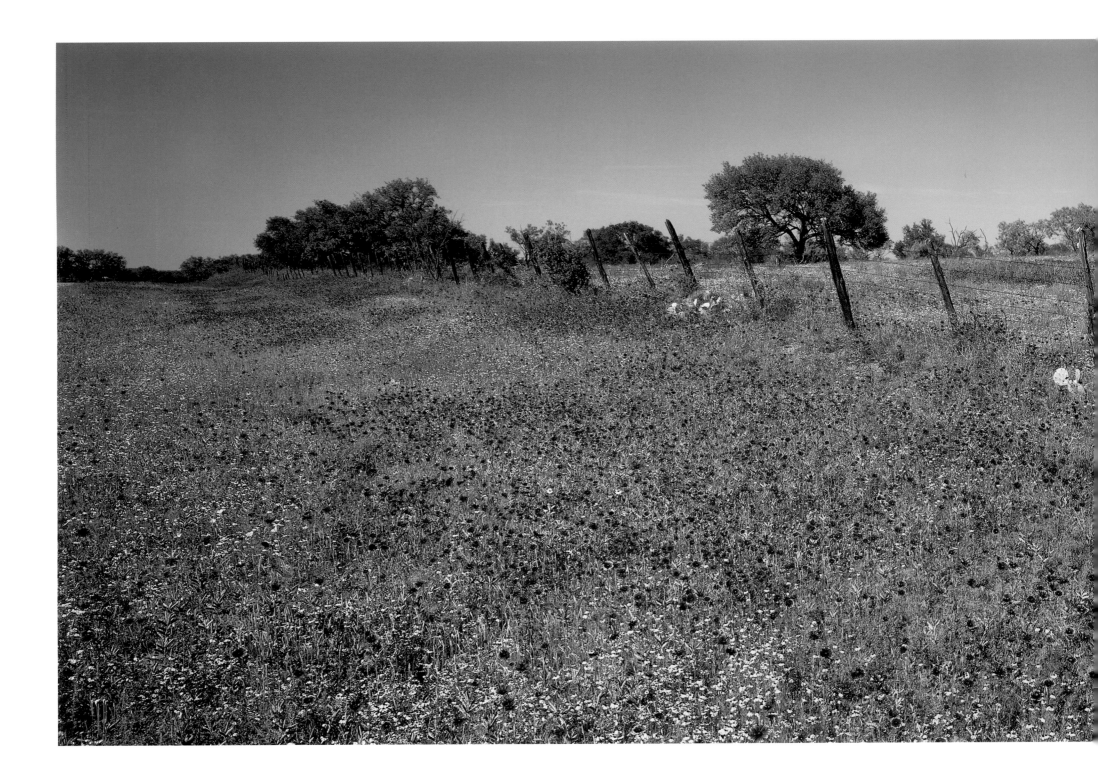

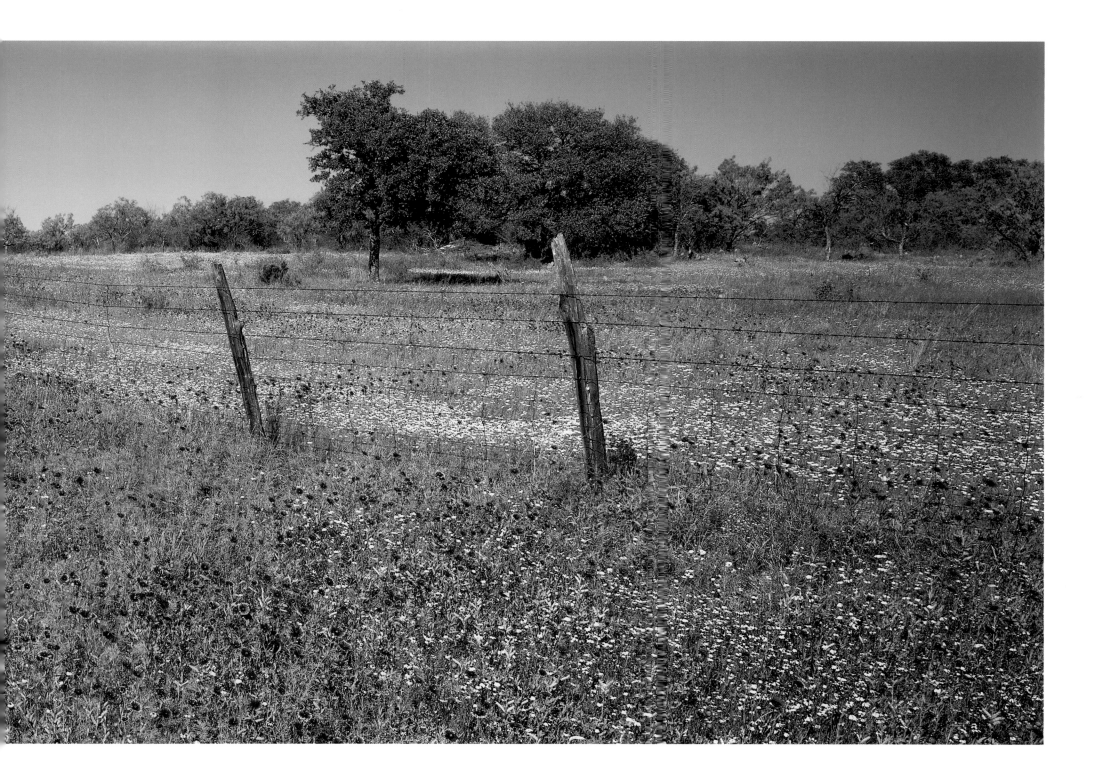

Real love produces real miracles. ROBERT H. SCHULLER **181**

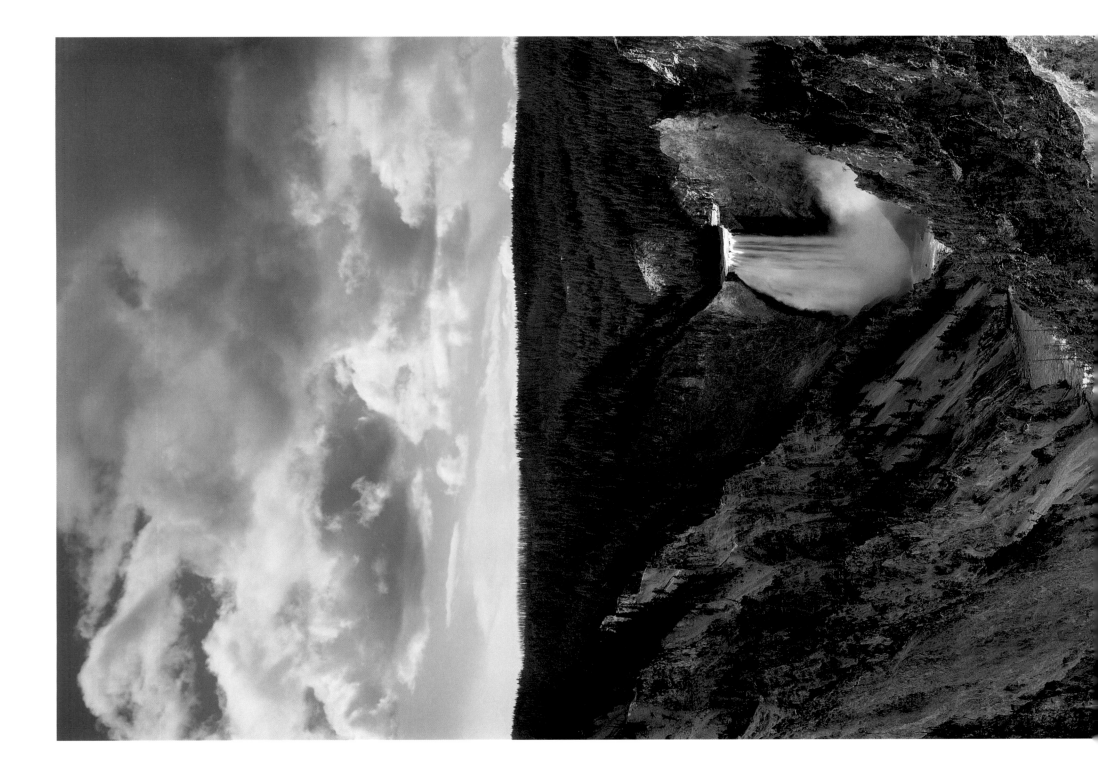

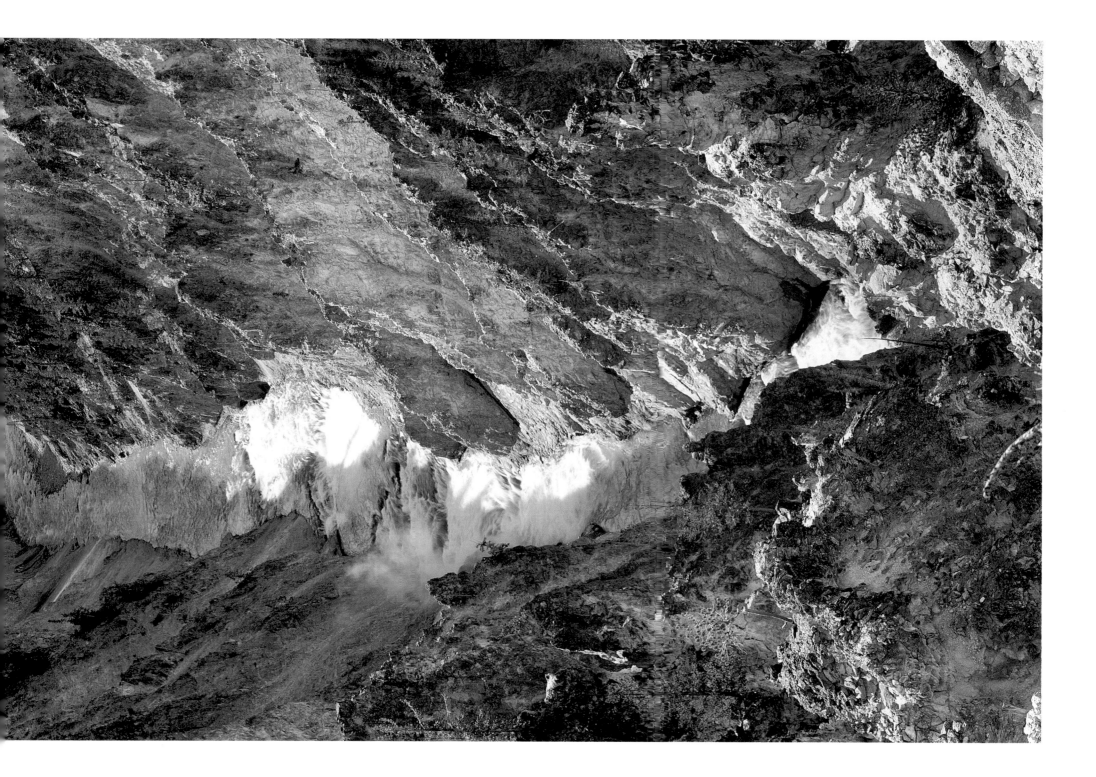

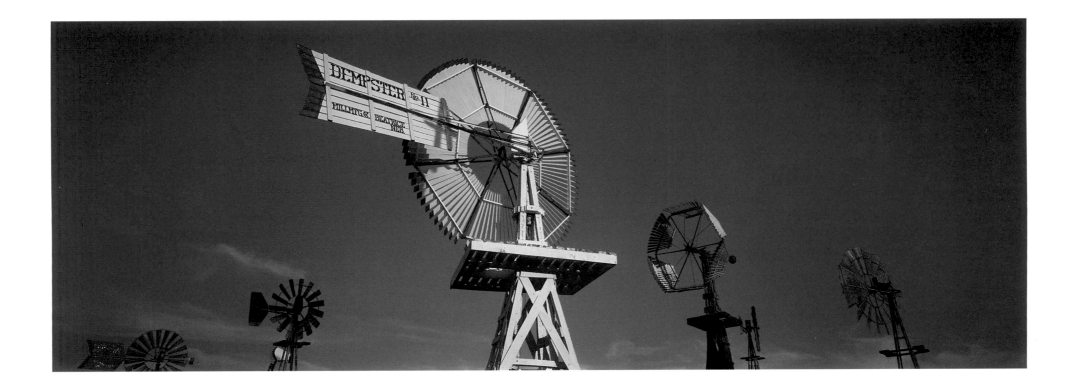

Curiosity leads to creativity.

ROBERT H. SCHULLER

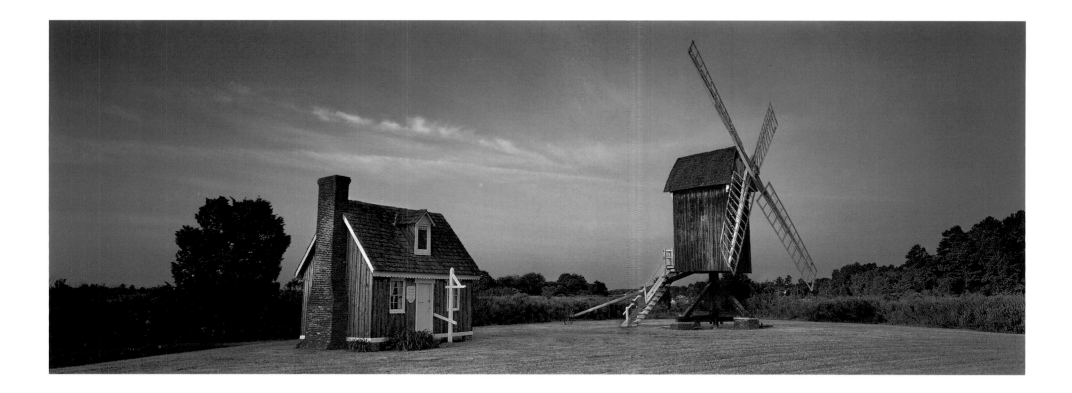

Build a dream and the dream will build you.

ROBERT H. SCHULLER

O God, You are my God;
Early will I seek You;
My soul thirsts for You;
My flesh longs for You
In a dry and thirsty land
Where there is no water.
So I have looked for You in the sanctuary,
To see Your power and Your glory.
Because Your loving kindness is better than life,
My lips shall praise You.
Thus I will bless You while I live;
I will lift up my hands in Your name.

PSALM 63:1-4

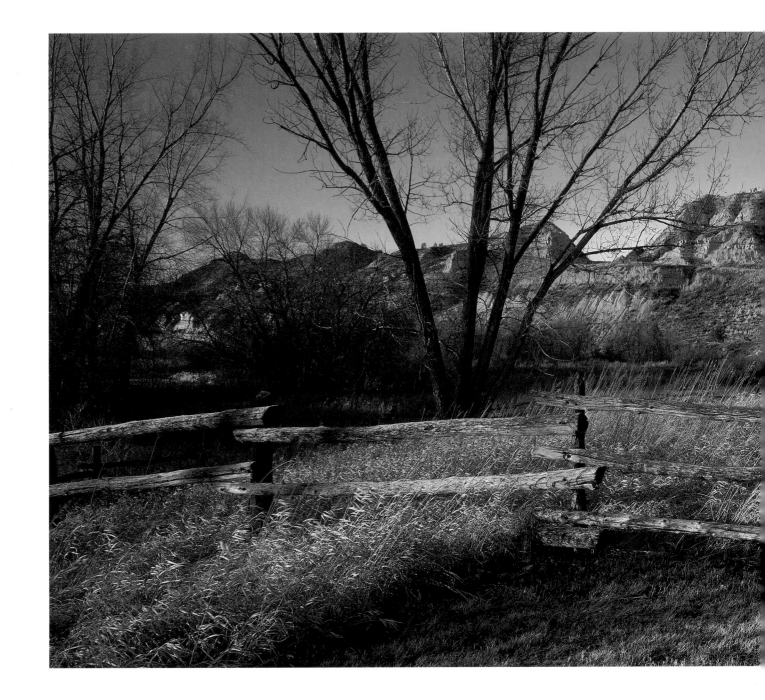

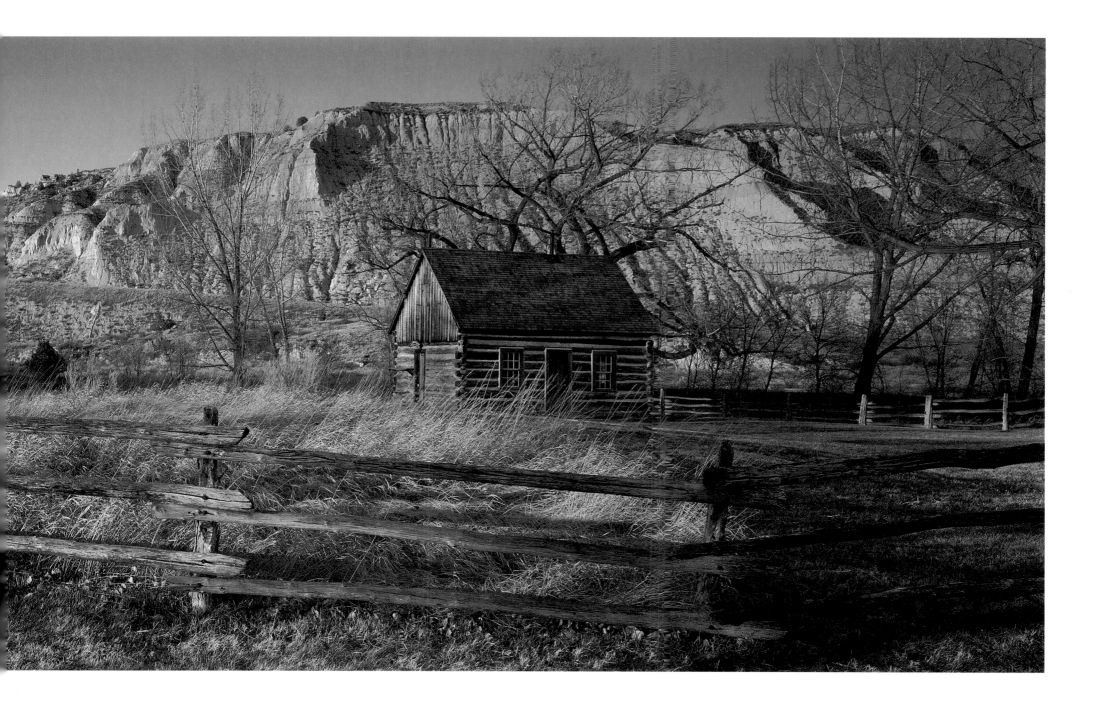

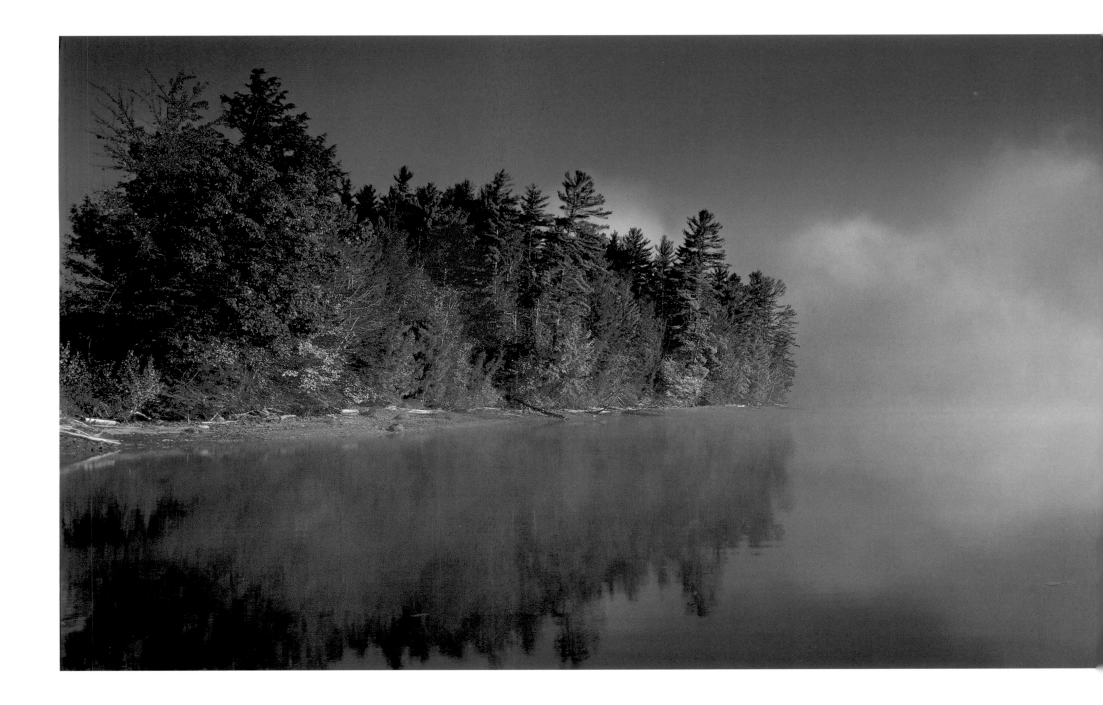

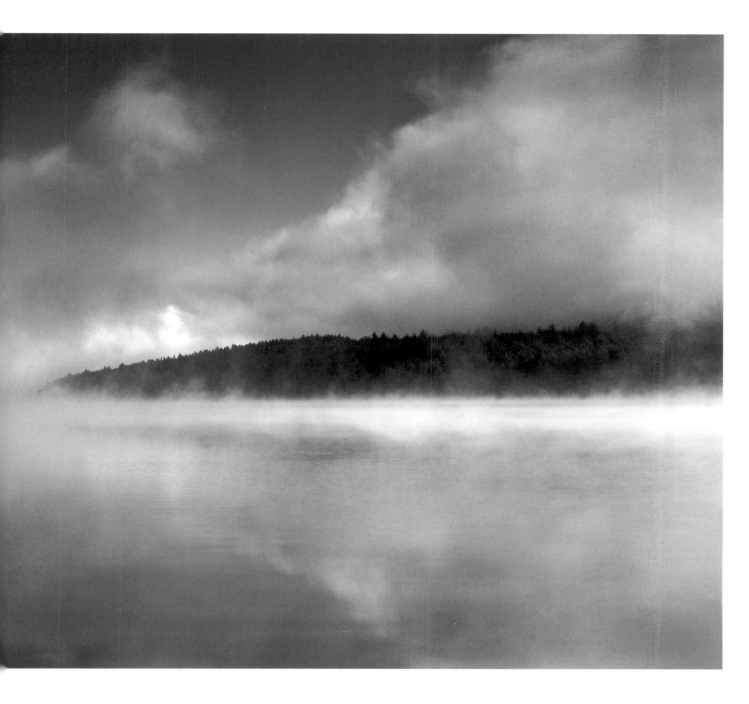

Through the LORD's mercies we are not consumed,
Because His compassions fail not.
They are new every morning;
Great is Your faithfulness.
"The LORD is my portion," says my soul,
"Therefore I hope in Him!"
The LORD is good to those who wait for Him,
To the soul who seeks Him.

LAMENTATIONS 3:22-25

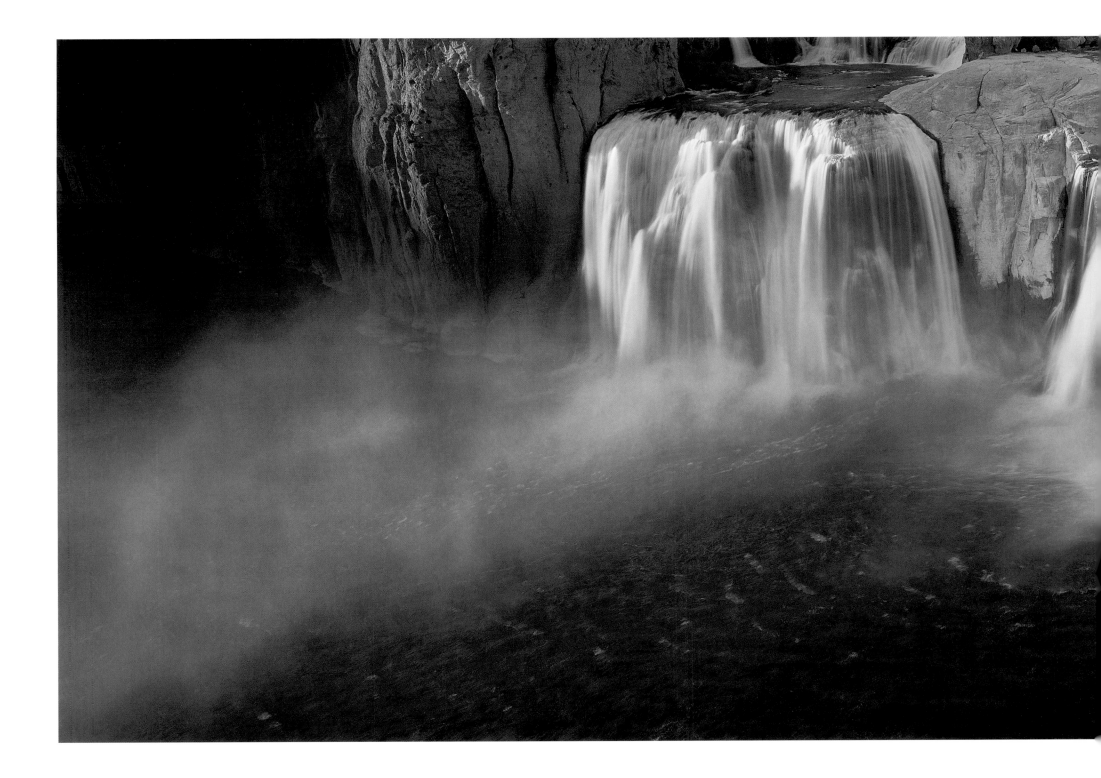

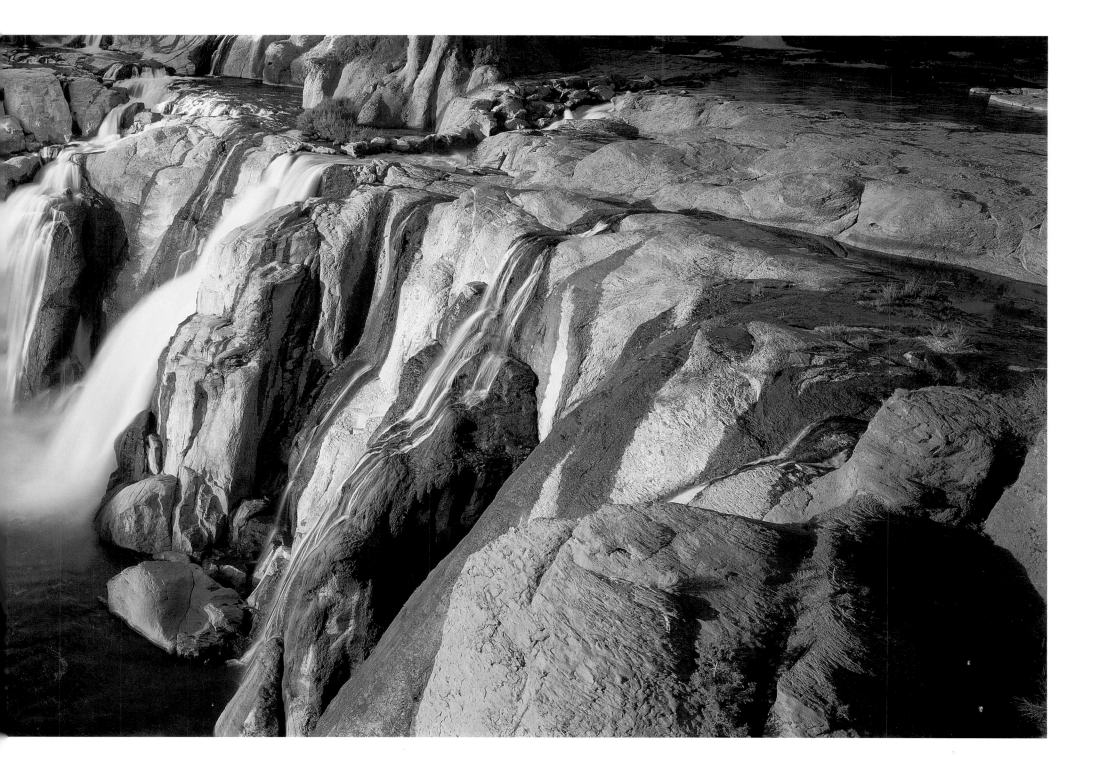

No person is too small for God's love, and no service is too insignificant for God's honor. ROBERT H. SCHULLER **191**

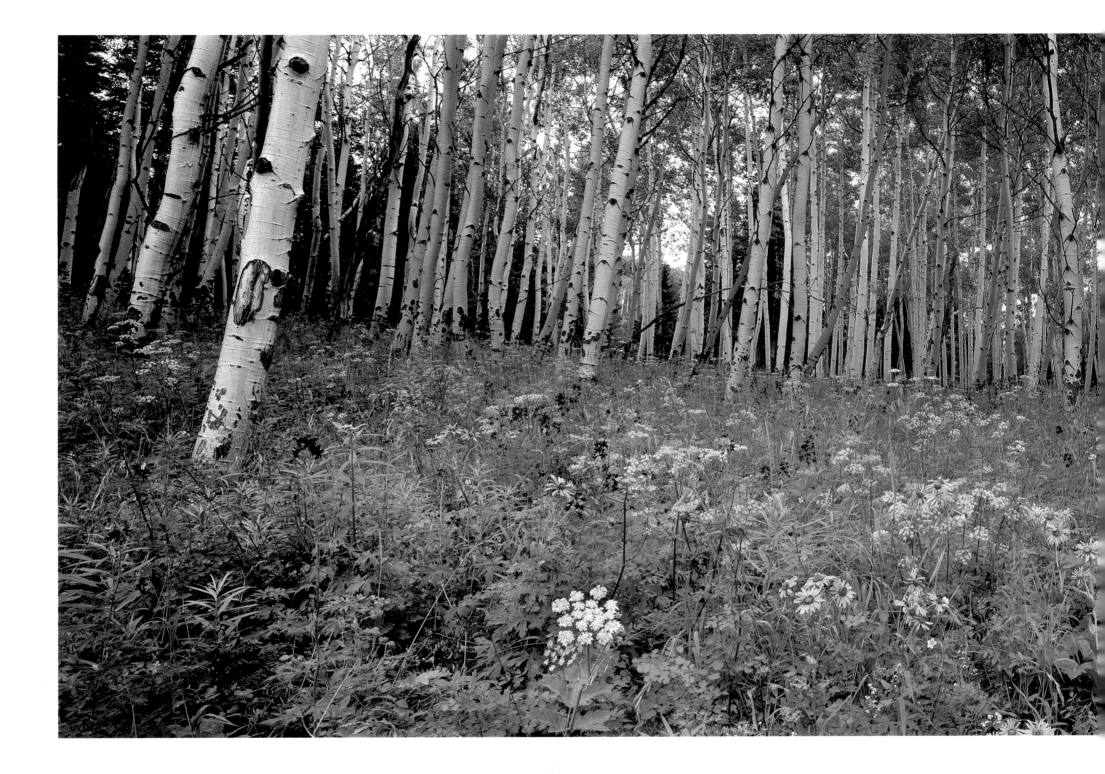

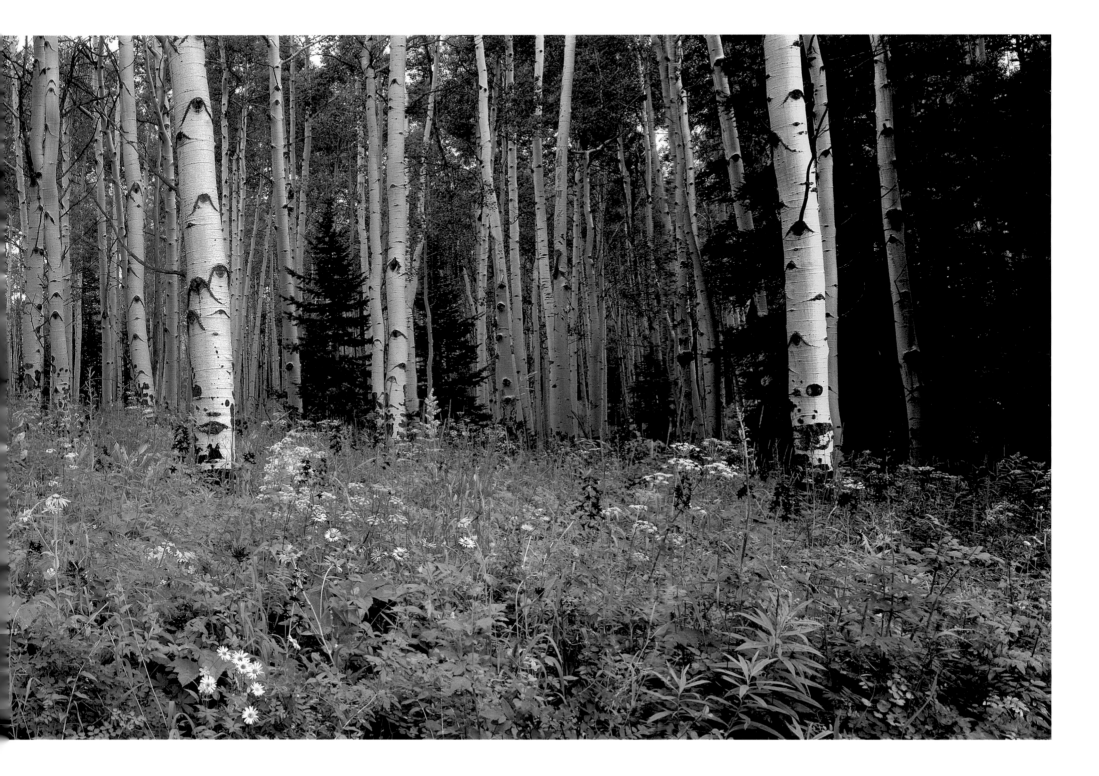

Tune in to God and tune in on life. ROBERT H. SCHULLER **193**

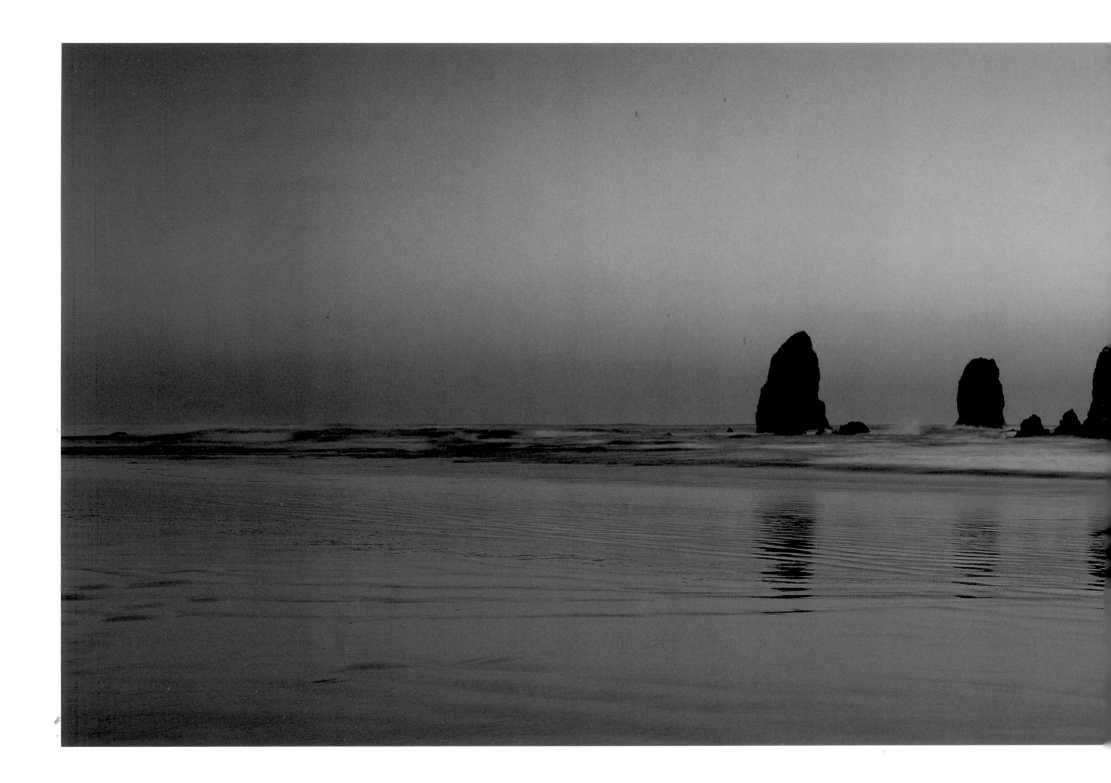

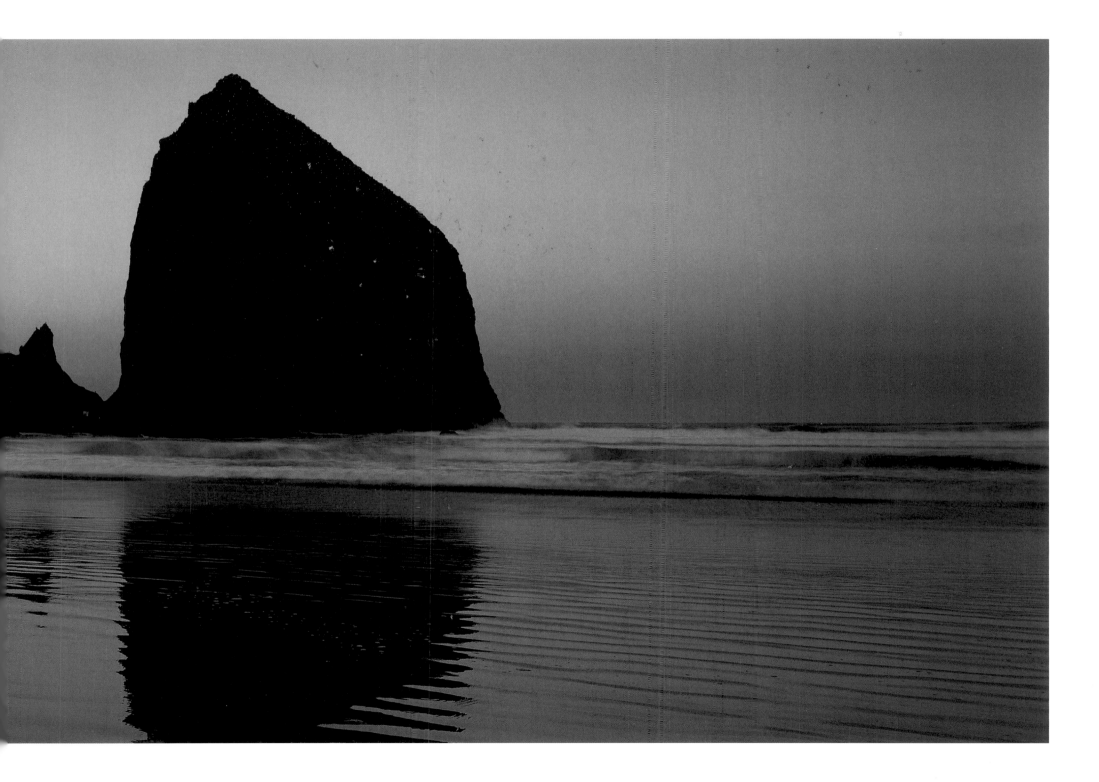

Always look at what you have left. Never look at what you have lost. ROBERT H. SCHULLER **195**

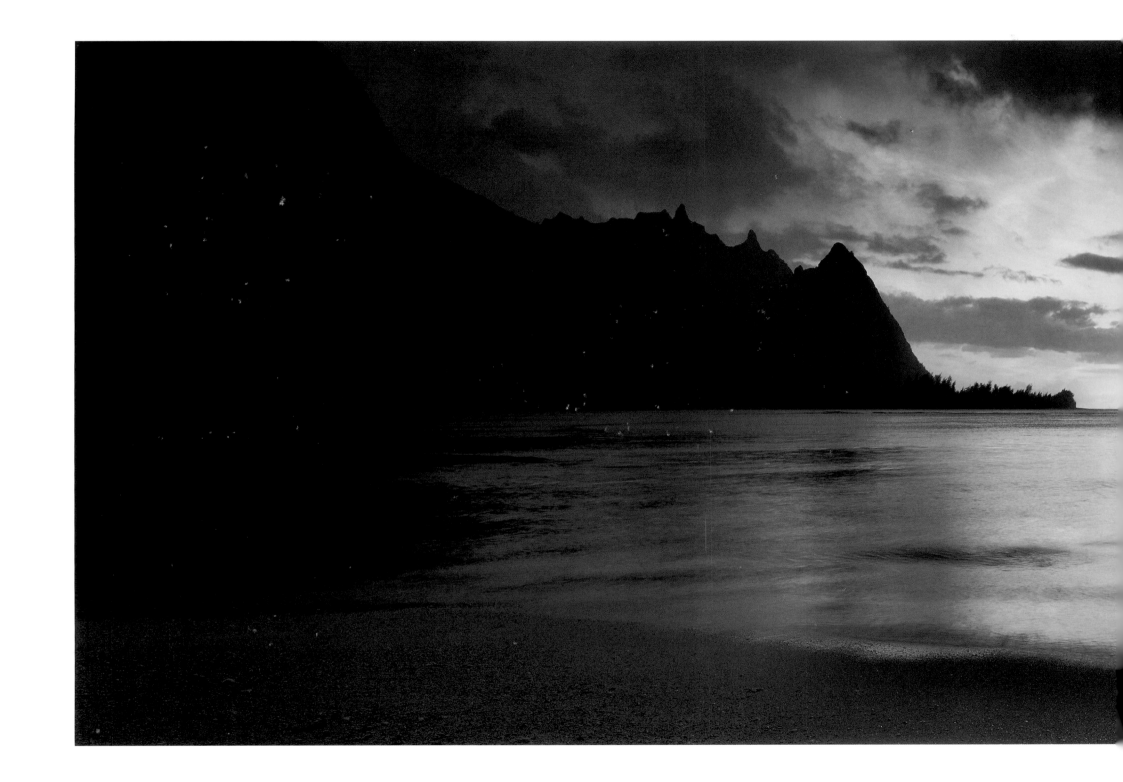

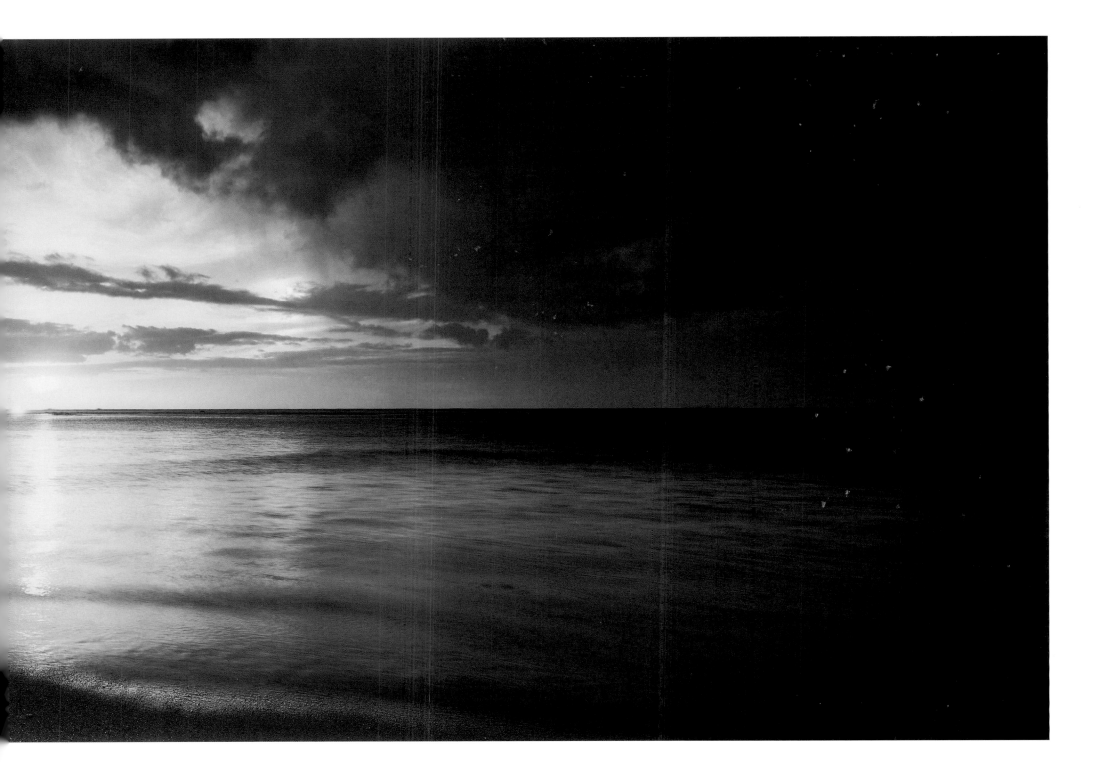

With God, all things are possible! ROBERT H. SCHULLER **197**

Photographer's Notes

SALLIE-ANN MACKLIN

Although people often contact me asking for photographic advice, I do not generally presume to tell anyone how to take photographs. I believe we all see differently and that is what gives each of us our unique style. When we follow our minds we are limited to our own understanding, but when we follow our hearts we see the bigger picture. Having said that, there are a few tips I can pass on.

BREAK THE RULES

The bottom line is: there are no rules. If an image works, it works; if it doesn't, it doesn't. At one of my exhibitions, a person with a doctorate in photography was looking at one of my shots and I could see she was puzzled. I asked if I could help. "I can't believe this!" she replied. "This guy has the horizon in the middle. It should be one-third sky, two-thirds foreground. But this really works!" The person didn't know I was the photographer, so I simply replied, "Isn't it lucky he doesn't know the rules, or this shot may never have happened."

There's only one essential: make sure you have film in your camera – although I once met a photographer who sometimes left the film out. He wanted to enjoy the privileged position of being a photographer without being disappointed with the results!

STOP TALKING AND START TAKING

One of the hardest parts of photography is getting out of bed. Just stick a film in your camera and get on with it. If you are going to eat an elephant, the way to do it is one bite at a time. If you sit back and look at how big the elephant is, you'll never finish the 'tusk' at hand! If you have a dream to shoot a book on America, you can think of the immensity of the country and be so overwhelmed that you never begin. Or you can pick somewhere to start and attack it one bite at a time. If you persevere, you'll reach your goal.

LOOKING PAST THE 'I'

Often the biggest thing blocking the light is our own shadow. We can get so locked into what we want to achieve or why we have gone to a particular area that we miss the very thing we are there for.

I believe there is a force at work much bigger than you or I. The key is to tap into the Creator's power rather than your own technical understanding, which by comparison is very limited. This is a hard pill for many to swallow (especially 'techno-heads') because people love to be in control. Personally, I would rather be out of control. I'm just an average photographer with a great God.

I have definitely not perfected this area of relinquishing control, but I'm working on it. It's exciting! How small we are and how big He is.

USING WHAT YOU HAVE

If you are not using what you already have, you won't use what you think you need. Many people think they need a better camera to take photos, and it certainly is nice to have a great camera. But the way to get it is by using the one you have now.

I started taking photos on my Dad's old Praktica, and my first book, *The Last Frontier*, was shot using second hand Widelux cameras that only cost $250. Talk about equipment with limitations – only three shutter speeds and constant breakdowns – but they did the job. The best understanding of your equipment comes from using it.

The technical aspects of a shot are secondary to capturing the spirit of a moment. Some years ago, at my sister's bidding, I judged a junior school photo competition. Some of the work was good; some was average. But there was one landscape shot which was just awesome. It had been taken at sunset by an 8–year–old boy, using a disposable camera through the window of a bus traveling at 60 miles per hour! Against all odds, this shot really worked. It certainly humbled me.

WILD LIGHT

Light is undoubtedly one of the most important things to consider. No light, no photograph! Different light conditions suit different subjects. For example, overcast light may not work for a summer beach shot, but it is great for rainforests, especially during or after light rain.

Early morning and late afternoon is generally the best time to take photographs as the

light has great warmth and softness. The mesas and buttes of Monument Valley in Arizona don't actually change color. It's the changing color temperature of the light that makes them appear so radiantly red at sunset.

One thing to be careful of is 'blue sky mentality'. Certain parts of America are blessed with lots of blue skies and this can sometimes become boring in photographs as the sky often accounts for a large part of an image. Cloudy light or wild, moody light can test your patience but when the break happens, you can get great emotion in a shot. Times of wild light are often when I speak to God asking (respectfully!) such things as, "What are you up to?" or, "Come on, give me a break – please!"

THE THIRD DIMENSION

Photography is a two-dimensional medium, so we sometimes need to create the illusion of a third dimension in our photographs – especially in landscapes – to give depth to the images. A simple way to do this is to use strong foreground interest. Another way is to use lines within the shot to draw the viewer in – a road, a fence, a curve of beach. Sometimes a good way to get better depth in a photo is to shoot from a higher vantage point. I often take shots from the top of my car or standing on my camera case.

PASSION

Passion is like an artesian well – when tapped, it brings life and energy to even the most barren desert. Passion, like attitude, is contagious and is essential for a project to succeed. Life is an adventure, not a worry, and if you want to pursue a dream, stumbling blocks must become stepping stones. Passion is a powerful thing and when directed properly it can help bring visions to reality.

PATIENCE

Photography is like fishing. While you wait, learn the benefit of relaxing and getting into the rhythm of what is happening around you. The fruit that keeps you going is that occasional big catch – a good photo. Patience is a discipline (shocking word) and when we learn to be still, blessings come our way. Once I was shooting in Yosemite National Park and I waited all day for the light to be what I considered 'just right'. Throughout the day, about five other professional-looking photographers came along. Each one pulled out his mega-expensive camera, tripod, the works, waited a couple of minutes, then clicked off a few shots before leaving. Meanwhile, I was still waiting, waiting, waiting - wondering if in fact I had missed something. Finally, right at the end of the day, when all seemed beyond redemption, the light began to dance and the scene came alive. I was the only one still there and I believe I caught the big fish. I hope those others enjoyed their sardines!

For more photo tips, visit my website **www.kenduncan.com**

THE EQUIPMENT I USE

• My main camera is a Linhof 617IIIS with three interchangeable lenses – 180mm, 90mm and 72mm. It uses 120 roll film and gives 4 shots to a roll with an image size of 6cm x 17cm. I believe this is the best medium-format panoramic camera on the market.

• I use a Manfrotto tripod with ball head and quick-release mounts. Nearly all my images are shot from a tripod and this one is quick to set up, which helps with urgent shots.

• For light readings I use a Sekonic spot meter as well as my trusty Hasselblad X-Pan camera which also allows me to grab quick 35mm shots along the way.

• I use Hi-Tec filters – specifically an 81B color correction filter (but not at sunrise or sunset) and occasionally a graduated neutral density filter to hold back the skies. I also sometimes use a graduated, slightly warming filter to help with the color on those really dull days. However, I use natural light wherever possible.

• The film I use is Fuji Velvia.

For information on Limited Edition Prints from this book, or other Ken Duncan Products, please visit the Ken Duncan Online Gallery: **www.kenduncan.com**

The LORD bless you and keep you;
The LORD make His face shine upon you,
And be gracious to you;
The LORD lift up His countenance upon you,
And give you peace."

NUMBERS 6:24-26

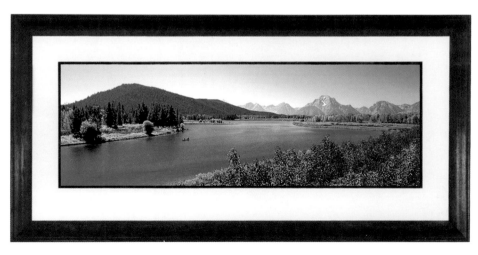

Index

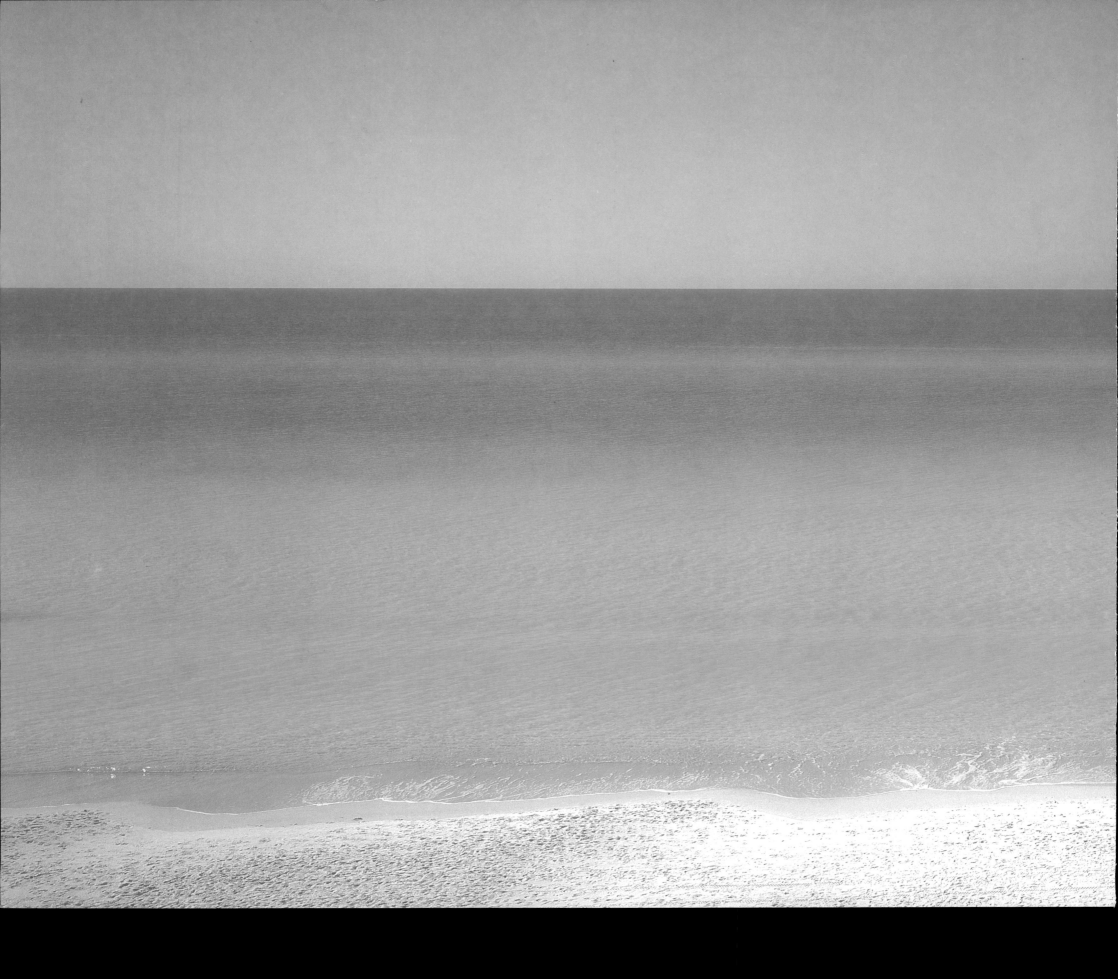